DIGITAL ART MASTERS

: VOLUME 5

DIGITAL ART MASTERS

: VOLUME 5

3DTOTAL.COM LTD

Focal Press
Taylor & Francis Group

NEW YORK AND LONDON

First published 2010
This edition published 2013 by Focal Press
70 Blanchard Road, Suite 402, Burlington, MA 01803

and by Focal Press
2 Park Square, Milton Park, Abingdon, Oxon OX14 4RN

Focal Press is an imprint of the Taylor & Francis Group, an informa business

British Library Cataloguing in Publication Data
Digital Art Masters.
Volume 5.
1. Digital Art.
I. 3DTotal.com (Firm)
776' .0922-dc22

Library of Congress Control Number: 2010924648

ISBN-13: 978-0-240-52210-4 (pbk)
ISBN-13: 978-0-240-52211-1 (ebk)

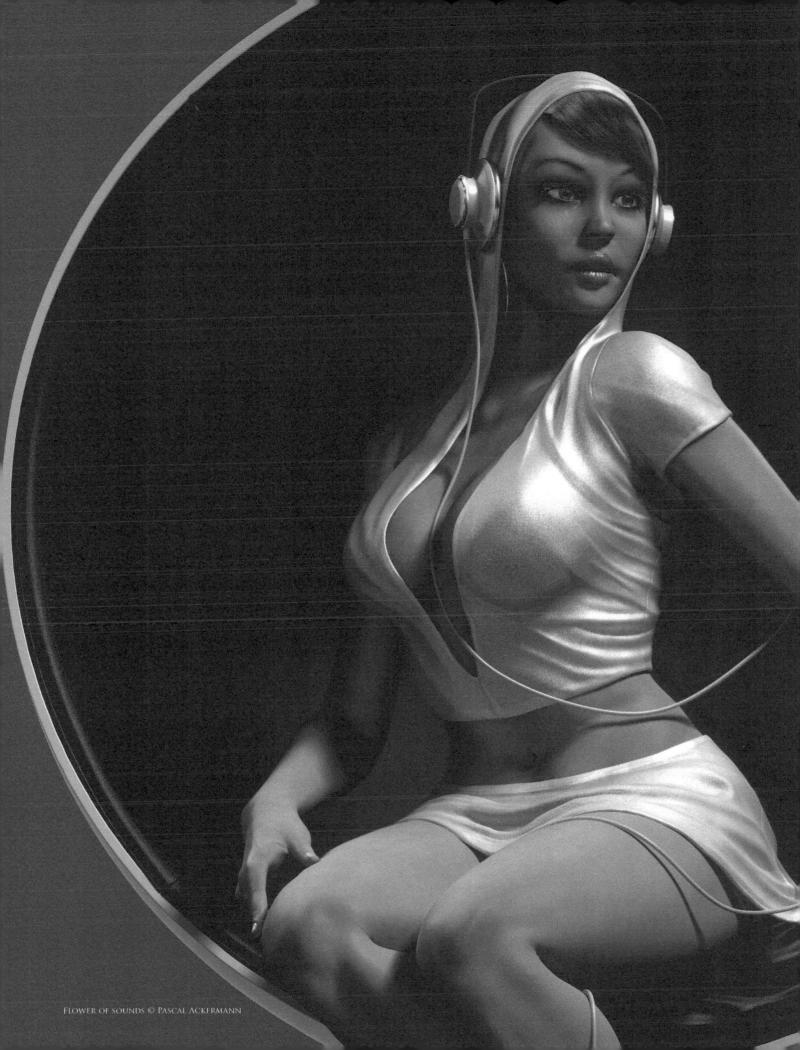

Flower of sounds © Pascal Ackermann

Contents

CONTENTS

 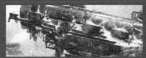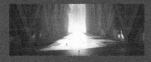 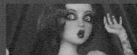 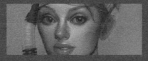

DIGITAL ART MASTERS

: VOLUME 5

COMPILED BY THE 3DTOTAL TEAM

TOM GREENWAY SIMON MORSE JO HARGREAVES CHRIS PERRINS RICHARD TILBURY

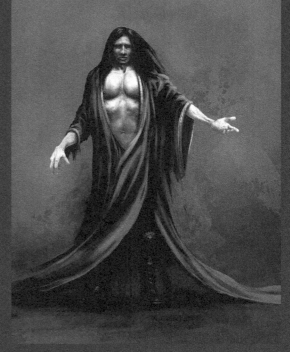

INTRODUCTION

Digital Art Masters is now into its fifth year and is a testament to the niche that it fills. Upon picking up the book, one is first struck by the caliber of work that adorns the pages and this does only apply to the principal pieces. Each artist has been afforded space to showcase a cross-section of their portfolio, meaning that while we are able to appreciate a single work of art we are also treated to a slice through a much larger picture. Arguably, the best selling point of these books is that they are a series of volumes aimed at those interested in the arts, and composed entirely by those people concerned. As such, we are provided with direct and untainted expression by the authors concerning their own methodology and approach to their work, as opposed to a critique.

Each of the five volumes is a record of the many nuances that affect the trends within the artistic community in both the world of 3D and for the digital painter. Artists naturally reflect the development of new software and the evolution of additional tools, and this book traces these fluctuations and mirrors some of the wider issues affecting the ebb and flow in the related industries. The boundaries between 2D and 3D have been slowly eroding over recent years and what this book shows is the ever-growing overlap and how artists are now embracing a more versatile set of tools.

Post-production has become more a part of the 3D fabric and programs such as Maya and 3ds Max are now often married to Photoshop in the path to producing final stills. The cross-pollination of what were once two distinctly separate disciplines shows that

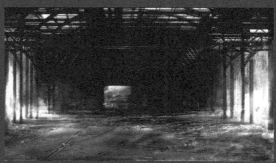

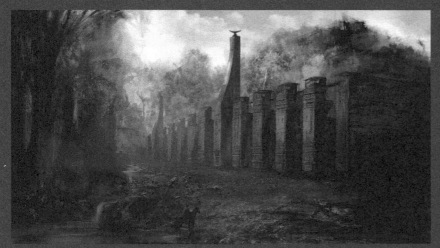

it is often difficult to unravel current processes and see the blueprints behind the final result. What this book provides is a firsthand account of the techniques used to produce a final composition and an informative look beneath the veneer, revealing the weave of the tapestry on display. It is the artists who grace these pages that ultimately provide the insight into their creative processes and provide an honest appraisal of what motivates and inspires them. It is this aspect that probably serves as the single most valuable part of this book and the Digital Art Masters series as a whole.

RICHARD TILBURY
Resident Artist – 3DTotal

Every effort has been made to locate copyright holders of materials included in this book in order to obtain their permission to publish them.
If you need to contact us, please email: dam@3dtotal.com, or write to: 3DTotal.com Ltd, 1 Shaw Street, 3rd Floor, Worcester, WR1 3QQ, United Kingdom

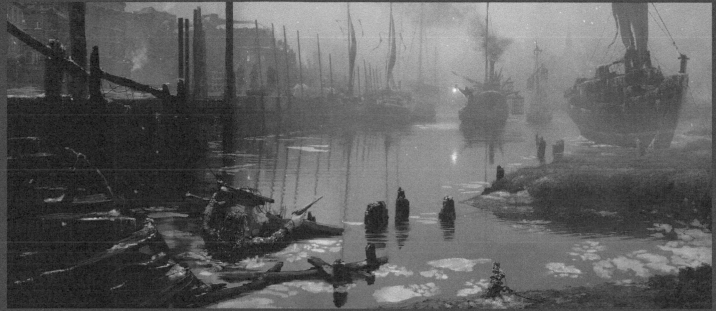

© TIM WARNOCK

FOREWORD

Albert Einstein once said, "Imagination is everything. It is the preview of life's coming attractions."

It is an instrument of incredible power that artists possess. The power to take people to other worlds, to weave stories and bring them to life; the ability to conceptualize complex ideas and make them reality; the power to persuade people and to provoke thought. Artists spend their days and nights piecing together sparks of creativity and fragments of dreams, pushing and pulling, and sometimes wrestling, them to the ground, all in the hopes of affecting the audience. It is a struggle sometimes. The work is demanding. The hours are long. I don't know anyone who is an artist nine to five. As I write this at 9:43 pm, having been up working on a painting until 2:00 am the night before, I think to myself "What am I doing?" But I know why. Because I can't shut it off. Because the impulse to create is part of what makes us artists; it's woven into our DNA. To us, imagination is everything.

The sheer number of unbelievably talented artists that exist all over the world is staggering. Each of us will be exposed to their work in various forms on a daily basis. Technology has played an invaluable role in the development of these gifts. What was once confined to a static page can now be experienced in a fully immersive interactive medium. The tools are faster, better and cheaper every day. We are at a place now with technology where it may even be safe to say that there isn't a dream or creative vision that is beyond realization. Movie audiences are spoilt for choice of artistic and technical

mastery that leaves them speechless. Video games today are simply mind-blowing, laden with lush graphics and technical innovation. It is truly amazing to see what comes of the best and brightest pouring their collective efforts into a singular vision.

The digital artist lives at the cutting edge, always changing, always evolving and always learning. Where a painter may spend their entire career using oils or watercolor, the digital artist will have their tools changed on a yearly basis. It is truly an existence of perpetual learning. This volume of Digital Art Masters features some of the most inspiring, captivating and challenging artwork of the past year. The artists who created these masterpieces travel a road marked by many late nights, trouble-shooting render errors, optimizing scenes and beating computer hardware into submission. In addition to mastering composition, lighting and perspective, they have spent countless hours sharpening their technical skills to an impressive standard. This collection of multi-talented artists have generously shared their creations with us; from a broad range of disciplines, they take us through the processes used to craft their work. In doing so they give back to the artistic community, from which each of us draws the potential to grow, create and hopefully inspire our audience, as they most certainly have. To each of you we say a sincere thank you, for the beautiful work that you do and the gift that it is to us.

TIM WARNOCK

Matte Painter | Concept Artist
http://www.thenextside.com

© TIM WARNOCK

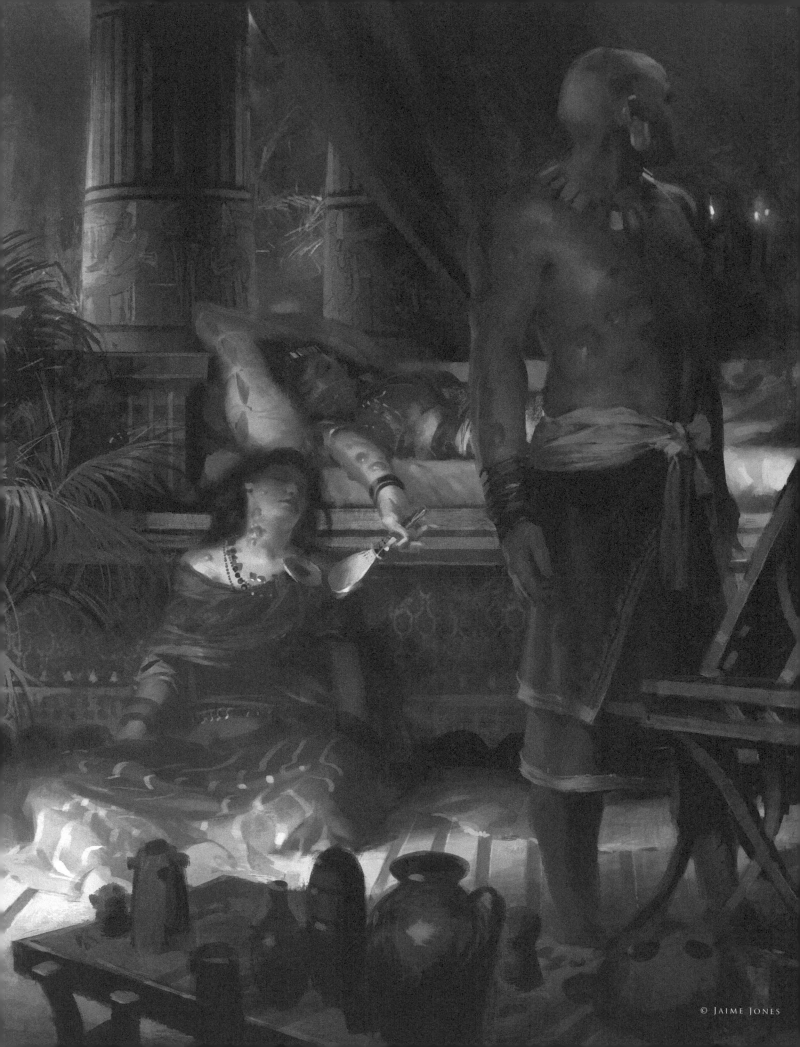

© Jaime Jones

SCENES

For me, a scene tells part of a larger story. When I see an image that does this successfully, I'm left with a combination of enthusiasm and curiosity about the world on display. I need enough information to care about the subject, but I'm most interested when questions are left unanswered. In this chapter you'll find some outstanding examples of scenes ranging in subject from the familiar to the imaginary and the historical. These are images worth spending time inside of, because they hint at stories worth knowing.

JAIME JONES

jaime@artpad.org
http://www.artpad.org/

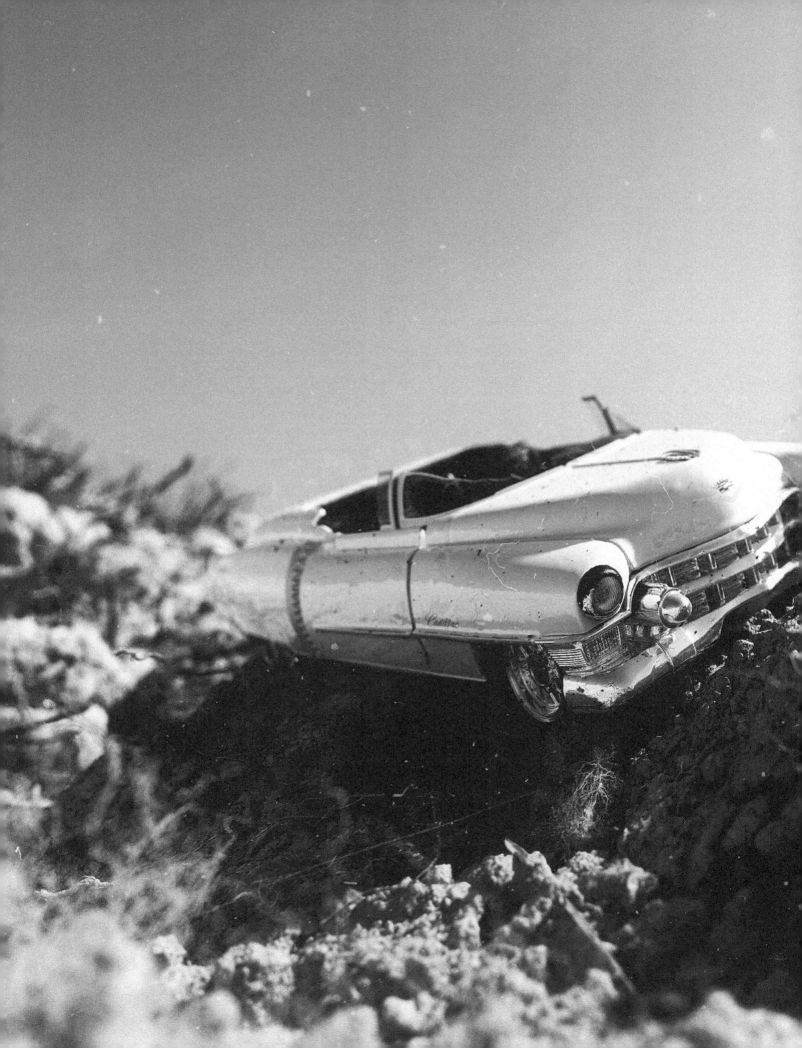

ELDORADO

BY MAREK DENKO

JOB TITLE: CEO - Noemotion s.r.o.

SOFTWARE USED: 3ds Max, V-Ray, Photoshop

INTRODUCTION

This image was my only personal project during 2009. It all started when I'd finished the *Armour Weed* project for a Canadian studio. In one of the versions, which wasn't approved by the client, the soil was really nice and so I kept it for future reference. When I had some free time, I started to add some extra features such as the grass strands, roots, leaves, and other small bits here and there. At the beginning I wasn't really sure what kind of object would be the hero of the shot. I considered an old tennis ball, a golf ball, a pack of cigarettes, a bottle etc., but in the end one little toy car won.

Here is why: while I was in Los Angeles in the first quarter of 2009, I bought lots of toys for my little son Adam. All those action figures from films like *Alien*, *Predator* and *Spawn*, along with cars like the Audi TT, Ferrari and a couple of smaller models, appealed to me, so I bought them. As the months passed by I started to find these toys in places all over the house and garden, almost destroyed by a 2 year old and a 28 year old boy. I took one of them and decided to put it into this environment composed of soil. It was one of the cars I bought simply because I liked it; the 1953 Cadillac Eldorado.

> ## " THERE ISN'T TOO MUCH THAT CAN GO WRONG IF " YOU FOLLOW WHAT YOU SEE IN THE REAL WORLD

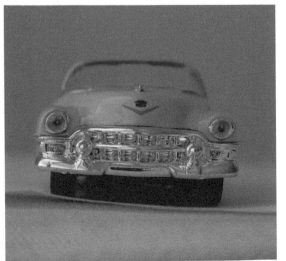

Fig.01c

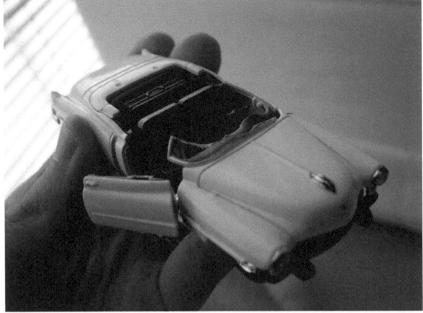

Fig.01a

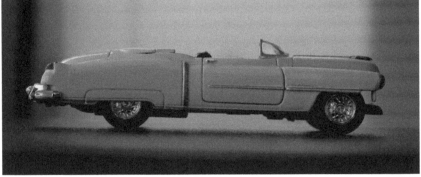

Fig.01b

In the following article I'll describe how I made it and show you readers some tricks I use in my everyday workflow, both professional and personal.

CONCEPT & REFERENCES

The main references came from the professional client that was involved with the original project, but I also took some photos of the soil. However, as I have not been able to find them since, they aren't included in this article.

For Eldorado itself, I used photos I'd taken of the white toy car. However, the original was damaged and missing the front chrome bumper, which didn't really work in the image as I had expected. So I had to order a new one to get a proper reference for the front bumper. Other inspiration came from just looking at the world around me.

I'll definitely be repeating myself for the third time in the Digital Art Masters volumes by stating that I always find sourcing references an essential part of my work. So, just look around and see how things appear. There isn't too much that can go wrong if you follow what you see in the real world (**Fig.01a – c**).

MODELING

All modeling work was done in 3ds Max 2009, with a little from the Polyboost plugin for the car modeling alongside a couple of Max scripts that I'll describe later. My usual modeling workflow is to start with a simple shape or object, converting it to an Editable Poly and using its most common modeling features such as Extrude, Bevel, Connect, Weld, etc. The modifiers I use most frequently are Turbosmooth, Displace, Noise and Symmetry. In the following paragraphs I'll describe some of the techniques I've used on several models in the scene.

Car chassis: I started by setting up planes with images of the toy car on them; notably the top, front and side views. Then I used an Editable Poly to create the basic model. Over this I applied the Turbosmooth modifier to add subdivisions to the mesh, followed by the Shell modifier to add a thickness to it. After the model had been subdivided and was dense enough I added the Noise and Displace modifiers with a little cellular map to add imperfections to the body in order to break up the reflection a bit. Most of the time it helps to add some deformation to the mesh to achieve more realistic results in terms of the shading (**Fig.02**).

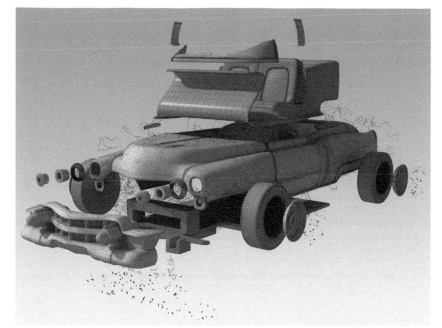

Fig.02

Car wheels: Modeling the wheels was quite easy. I started with a cylinder containing a certain number of radial segments. I deleted most of it and then used a few Symmetry modifiers to re-create the complete wheel. I had as few control points as possible, thus enabling a fast and easy method of achieving the desired shape (**Fig.03**).

Car glass: For the glass on the front of the car I again used polygonal modeling combined with the Turbosmooth and Shell modifiers. When I was satisfied with the result, I created an object to subtract it from the glass. For subtracting one object from another I usually use the ProBoolean compound object. After the Boolean operation I had to modify the mesh and fix some of the issues caused by the operation.

Car dirt: After I was done with the chassis of the car, I scattered several types of objects across it to create the effect of dirt. These involved an array of subtle stones, dust and hair (**Fig.04**).

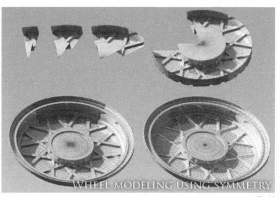

WHEEL MODELING USING SYMMETRY

Fig.03

Fig.04

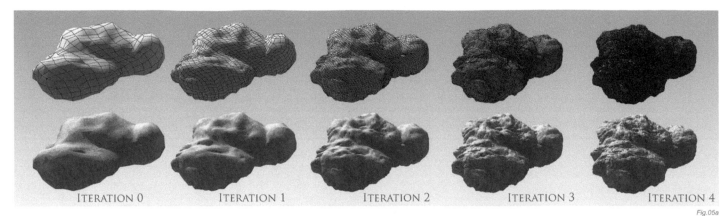

ITERATION 0 ITERATION 1 ITERATION 2 ITERATION 3 ITERATION 4

Fig.05a

Soil ground: For the soil I used a very dense plane with a lot of Turbosmooth, Noise and Displace modifiers applied. I took some time to experiment with the values and maps used for displacement in order to meet with my expectations.

Soil and rocks: I started with some primitive objects such as boxes. Then I converted it to an Editable Poly and modeled the basic shape of the soil. With the use of the Turbosmooth, Displace and Noise modifiers, I achieved the desired detail and surface quality. After achieving several soil and rock shapes, I cloned them using the Array tool and then randomized their transformations using a Randomizer script, freely available for download on the internet. When I had a nice chaotic distribution I used Glue (http://www.itoosoft.com/), a free utility, to stick the thousands of soil and stone objects to the prepared surface. Some of the rocks and soil objects were placed manually to achieve exactly what I needed (**Fig.05a – d**).

Roots: I started with a simple line shape consisting of many vertices. I used the Noise modifier and then cloned the spline several times, using the Randomizer script once again (**Fig.06a – b**).

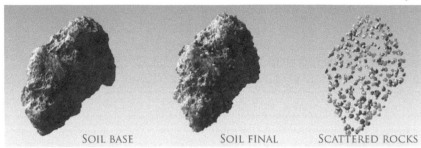

SOIL BASE SOIL FINAL SCATTERED ROCKS

Fig.05b

RANDOM PIECES OF SOIL USED FOR DENSE SCATTERING

Fig.05c

CUSTOM ROCKS

Fig.05d

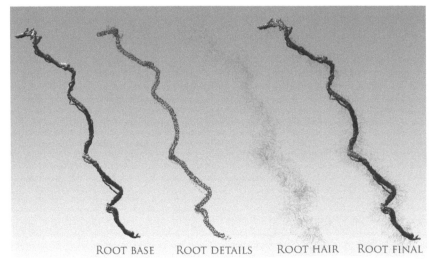

ROOT BASE ROOT DETAILS ROOT HAIR ROOT FINAL

Fig.06a

If you are a beginner in 3D modeling, you should read the manual and try to find out how your 3D package works. You can trust me when I say that modeling static objects is one of the easier parts of 3D. If you want to be a fast, good and precise modeler, you need to know your modeling tools as well as possible, so take the time to read about them and experiment.

TEXTURING & SHADING

There wasn't too much texture work in this project. All the ground and soil objects have the same tileable textures for the Diffuse and Bump maps (**Fig.07**). Eldorado itself only has a couple of very basic black and white mask textures, used to blend the car paint with the surface underneath to show the scratches.

Since I used V-Ray for this image, I used VrayMtl as a base shader for all of the geometry. For the car paint I used VrayBlendMtl to create two layers. The first layer is the white paint with matte reflections and the second is the Shellac layer with sharp reflections. To mix these two materials I used VrayBlendMtl with the additive (Shellac) mode enabled. Note that the Diffuse color of the Shellac layer has to be black to avoid adding more color from the paint material.

LIGHTING & RENDERING

For the rendering I used V-Ray from Chaosgroup. There are basically two lights in the scene. One is a directional light (key light) simulating the sun, with a yellowish color. The second light (fill light) is a Skydome using a V-Ray sky map. I also used Global Illumination bounces to produce a more realistic result. The image was rendered out as 5000 x 3118 pixels to an OpenEXR file format. The scene was really intensive and I had to use Dynamic BSP in V-Ray to enable me to render the whole image at once. It contains around 1.5 billion polygons, which I guess is my personal record.

RANDOM SPLINE BASED ROOTS
Fig.06b

Note: Dynamic BSP's trick is that it stores all instanced objects to memory once only and for the remaining instances only takes transformation information, which utilizes a fraction of the amount of RAM.

POST-PRODUCTION

For post-production I usually use Adobe Photoshop and Eyeon Fusion. I did some color correction in Photoshop and then moved to Fusion to add some extra effects such as Chromatic aberration. All of this was done in 16-bit per channel color depth to protect the color information as much as possible.

CONCLUSION

So that's it. It was not really hard to make this piece. The most difficult part was to find the will and time to complete it. I believe that if you have read all of this then you will understand some of my techniques and how I work. I'm not saying that my way is the only way or indeed the correct way. This was just a fun personal project done in my free time, of which I have less and less each year. It is dedicated to my wife Barbora and to my lovely kids Adam and Ivanka. I love you.

Fig.07

ARTIST PORTFOLIO

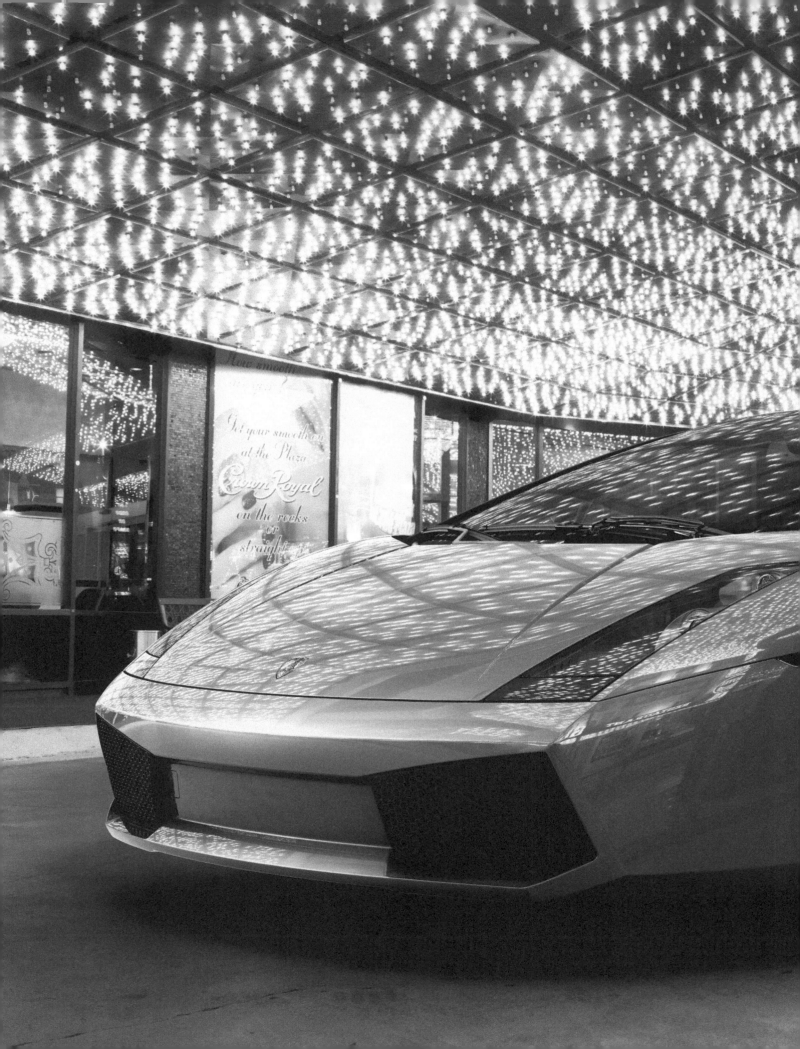

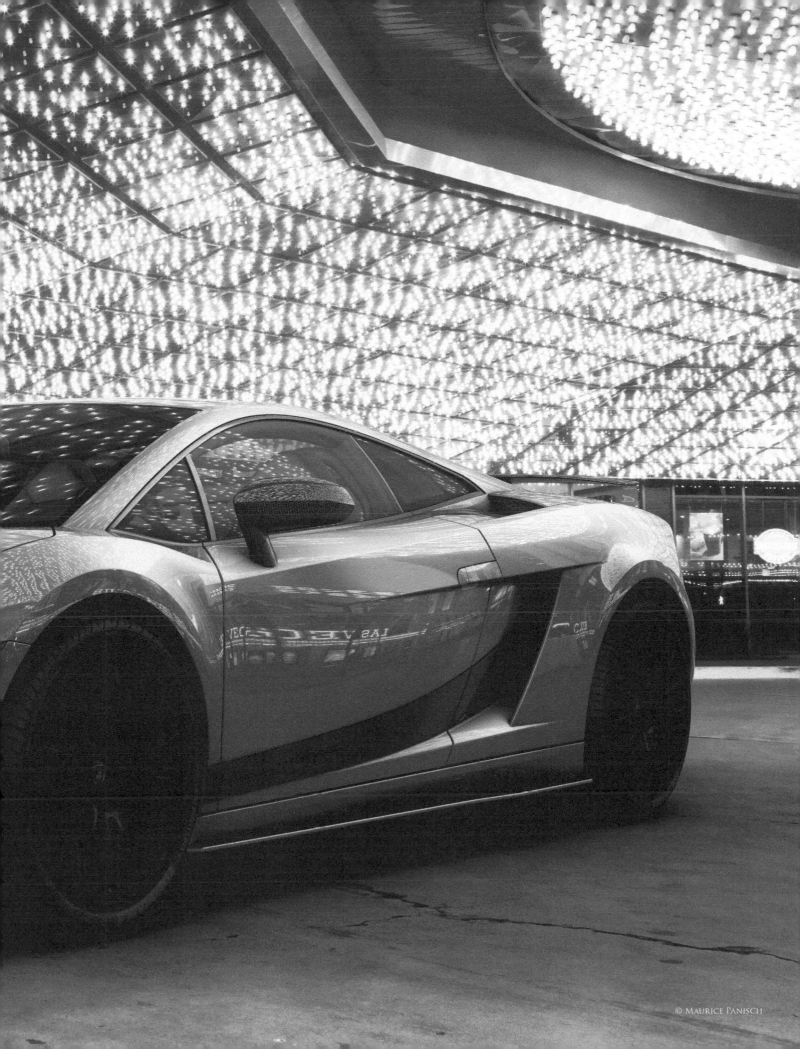

GOLDIE
BY MAURICE PANISCH

JOB TITLE: 3D Artist
SOFTWARE USED: Cinema 4D, Photoshop

INTRODUCTION

The initial idea for this image was inspired by a good friend of mine, Malte Bartjen, after he returned from a trip to Las Vegas. He's a photographer and took a lot of interesting pictures of cool locations there, as well as shooting 360-degree HDR images from them.

I saw this location (**Fig.01**) and thought, "Hey, you've got a Lamborghini model of the Gallardo Superleggera that would match this background perfectly with a gold paint finish!" Thus, the idea was born that it would shine like gold.

My aim was realism with a touch of surrealism, because the golden location with a golden super car would look somewhat far-fetched and yet still remain believable. It wouldn't be the typical car rendering you so often see in galleries, but would stand out from the masses.

WORKFLOW

The model of the car was an old one I'd made a while ago, before starting the *Goldie* image, but I'd never managed to use it as I had intended. So this was my chance to do something special with it and recycle it from my hard disk.

The shading wasn't that difficult for me because I have been making 3D cars for a long time now and it is one of my biggest passions. For metallic car paints I normally render out a pass with the clearcoat reflection (**Fig.02**) and for the metallic effect I composite it with a well balanced Specular layer (**Fig.03**) and a blurred Reflection layer (**Fig.04**). You can easily achieve metallic car paint with short render times and control the overall look during the compositing.

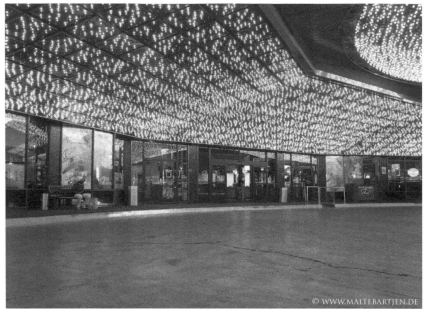

© WWW.MALTEBARTJEN.DE

Fig.01

Fig.02

Fig.03

For a nice car paint shader it is very important to add a Fresnel in the Reflection slot. I normally work only with Blinn shaders because they create more realistic specular highlights.

For the lighting I employed a more classic light set up because I prefer using a more traditional approach for cars. Global Illumination isn't as crucial in this instance as, say, compared to architectural subjects. Hence,

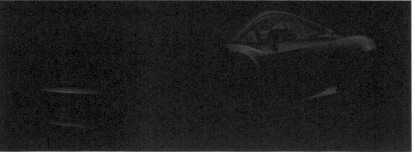

Fig.04

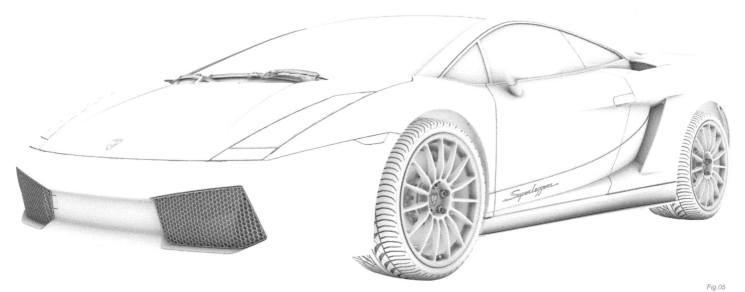

Fig.05

the car was lit by ten Area lights – some for the diffuse lighting and some extra ones for the specular highlights. For diffuse lights it is necessary to lower the contrast in the detail setting to around -35 – 50% so that they create a nice diffuse light. Regarding the specular highlights, I normally employ Point lights that are set to Specular only, giving the car some nice extra highlights and accents to the shape of the chassis.

I also rendered out an Ambient Occlusion pass (**Fig.05**) for a little bit more depth in the shadows, which I carefully overlaid over the rendered image in Photoshop using Multiply as the blending mode.

For the master reflections I used the HDRI sphere (**Fig.06**) generated from the location photographs taken by Malte. I retouched it a little bit, adding some color

> " I LIKE TO RENDER OUT MY IMAGES WITH A FLAT LOOK AND A MORE DIFFUSE LIGHTING SO I CAN EASILY PLAY WITH THE CURVES DURING THE COMPOSITING STAGE "

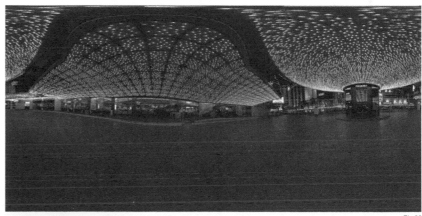

Fig.06

correction until it matched the backplate and was able to cast nice reflections across the car. In Cinema 4D I applied it to a huge sphere that wrapped around the whole scene and rotated it until it matched the backplate. In this way you get the same reflections as if you were taking a photo at the actual scene.

I like to render out my images with a flat look and a more diffuse lighting (**Fig.07**) so I can easily play with the Curves during the compositing stage. When you render out your images with too much contrast, you cannot color correct them in the same way because there aren't that many mid-tones to play with. I also work with 16-bit/ floating point color space to ensure I have enough color information in the image to avoid it becoming damaged when the Curves are pushed too far in Photoshop.

Next I added a little bit of the separate reflection, specular, color and shadow passes over the image to enhance the overall look (**Fig.08**).

Fig.07

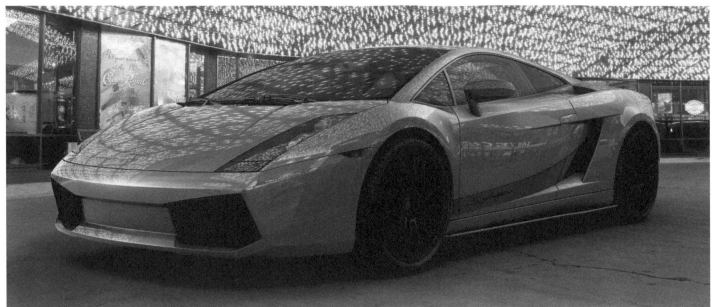

Fig.08

Finally I made any necessary color corrections to different parts of the image with the help of a lot of masks I'd rendered out using the multipasses generated in Cinema 4D. Normally they are only black and white, so I made a color example here to show them in a single image (**Fig.09**).

At the end I made the final color corrections for the whole image using the masks and some gradients. Here is a Photoshop screenshot (**Fig.10**). Normally I do a lot more color work and also a lot of retouching to the car renderings, but I wanted to retain a more natural look with this image. I mixed in a few blue tints and added a slightly yellow hue to give the picture a slight tungsten or Polaroid look, which fits the overall golden theme and adds that extra touch.

CONCLUSION

In the end I was very happy with the result and it is also one of my favorite car renderings. Because it isn't the typical car rendering you see so often I believe it stands out and carries something special for me.

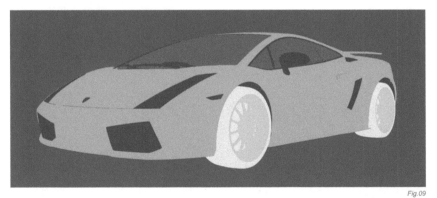

Fig.09

Fig.10

THE RETREAT
BY RODRIGO LLORET CRESPO

JOB TITLE: Senior Texture Artist

SOFTWARE USED: Maya, Mental Ray, BodyPaint, Photoshop, Combustion

INTRODUCTION

Everybody asks me why I always make images about WWII fighters and my answer is: "Because I can't avoid it; I love it!" When I see a photograph or a film about WWII fighters, something awakens in me. For this reason my latest image is about the Mitsubishi Zero, a legendary Japanese WWII fighter.

As I had already made a P-40 fighter for other projects, I thought that the final image could show a battle between both of them.

In this project I wanted to achieve everything that I had failed to do in my older projects due to my inexperience and an inferior computer. I had a hard job in front of me.

> " WHEN THINKING ABOUT WWII FIGHTER SCENES, I LOVE EXHILARATING COMPOSITIONS WITH A SENSE OF DRAMA AND AN UNUSUAL PERSPECTIVE "

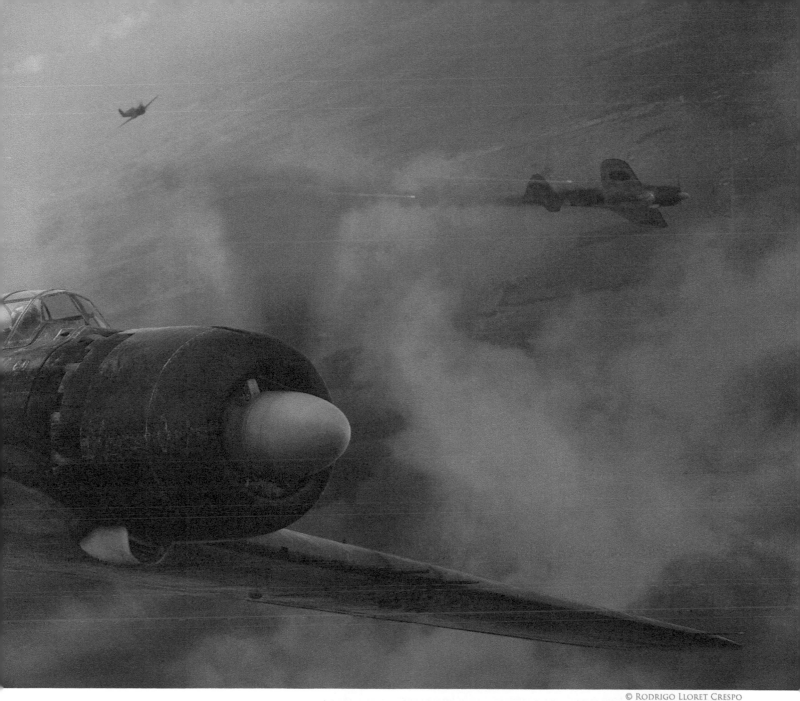

COMPOSITION

When thinking about WWII fighter scenes, I love exhilarating compositions with a sense of drama and an unusual perspective.

Whilst creating the composition I performed a lot of tests using rendered alpha channels as they allowed me a better understanding of the positive and negative spaces in the picture, as well as affording me the freedom to work quickly. This technique also avoids any distractions caused by model details as they only appear as shapes on the paper.

The scene had to show an airborne battle between Zeros and P-40s. The P-40s would be attacking and outnumber the Zeros, which would be making a retreat. One thing

Fig.01

that I love about the Zero is its engine. I tried to show it as best I could, but this enforced many restrictions on the available composition. After all the tests I selected this particular composition for its strength. The diagonal line (red) of the first plane overlaps the triangular formation in yellow and two further triangular compositions, which can be seen in blue and black, relate to the other fighters. The angle of the principal plane (red) also intersects the diagonal of the horizon line (green) (**Fig.01**).

I undertook numerous tests with different lenses; e.g., 35, 50, 70 and 85mm, and ultimately chose the 85mm camera lens because I love the proportions it achieves. For me it's very important to have some knowledge of photographic lenses in order to develop a successful composition.

COLOR

In other images I used desaturated colors to achieve the feeling of war, but this time I wanted to try and use color for this purpose. As the Zero is a dark green, the cold colors helped in this respect, but, in contrast, the colors of the P-40s are warm. I eventually decided on a contrast between the cool and warm colors, resulting in an image with more strength.

> **THE MOST IMPORTANT CONSIDERATION WHEN TEXTURING IS TO ACHIEVE THE MAXIMUM AMOUNT OF DETAIL PER PIXEL**

The cool colors were restricted to the Zero because the dark green color of its metal and the blue reflected from the sky on the black metal worked wonderfully. The warm colors were focused in the areas occupied by the P-40s because these are made up of desaturated brown metals and the red of the shark's mouth.

When I want to know whether the color and the contrast of a composition are satisfactory, I pixelate the image using Photoshop's Mosaic filter. With this technique you lose the detail of the image and reduce it to the dominant colors and contrast (**Fig.02**).

TEXTURING

Everybody asks me about the size of my textures and how I make them. For this image I divided the UVs of the Zero into three 4096 x 4096 textures. There was one for

Fig.02

Fig.03

Fig.04

the fuselage (the main body, wing, cover engine, flaps and tail), another one to eliminate the mirror of the first and a final one for the remaining smaller pieces.

The most important consideration when texturing is to achieve the maximum amount of detail per pixel, so you mustn't make too many textures for the same model. To be successful, you must work with good and clearly defined references and you can store a lot of detail when you work with them in Photoshop using modifiers and effects. Photographs of metals usually have a lot of noise because the metals are rough or dirty.

Fig.05

Fig.08

Fig.06

Fig.09

Fig.07

Fig.10

This doesn't help you to create the final texture and so I prefer to make them in stages, step by step.

For example, to make the top of the Zero's wing (**Fig.03**), I first of all made the color base (**Fig.04**), after which I painted in the lines between the metal panels (**Fig.05**).

I then added a light layer of dirt so that the texture looked more interesting (**Fig.06**) and emphasized the panel lines with dirt (**Fig.07**), bearing in mind the influence of airflow over the wing and the direction in which the dirt is dragged. I then add more defined dirt marks, ranging from bright through to dark, which added a further level of detail (**Fig.08**).

I clearly defined the rivets and scratches because these elements added the most important detail to the texture (**Fig.09**). I then created the machine gun smoke before finishing off the texture by highlighting the initial panel lines defined earlier (**Fig.10**). I now had a texture with a lot of detail that was varied and devoid of any noise apparent in the original photos.

Another frequent question I get asked concerns the Bump maps I created for the metal. Initially I considered making an irregular metal through displacement, but after a few tests I noticed that the bump would be too small. In the end I decided to use Photoshop to make the bump from various photos as it was easier and quicker.

Fig.11

Fig.12

After comparing a wealth of photos of the Zero I understood that the irregular bump had to be elongated instead of being composed of simple "circular" dents. I looked for many references until I found a few photos that had this quality. Using the metal panels that I had defined earlier, I added different parts from the photos. I changed the tonal range of the panels to provide a little variety and then added the rivets. Later on I noticed that I needed to add one more thing to the metal. When the metal panels are fixed, the rivets add "circular" dents and so I added this effect (**Fig.11 – 12**).

RENDERING & ILLUMINATION

I used Mental Ray to render because the newest MIA shader gives you complete control over all of the material properties and works very well on metal and glass. I undertook

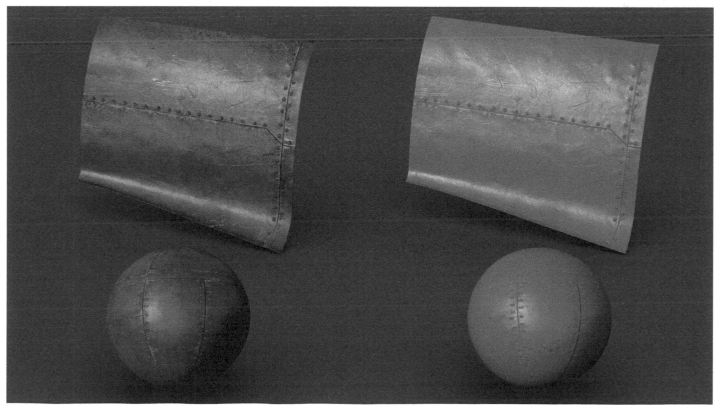

Fig.13

Fig.14

Fig.15

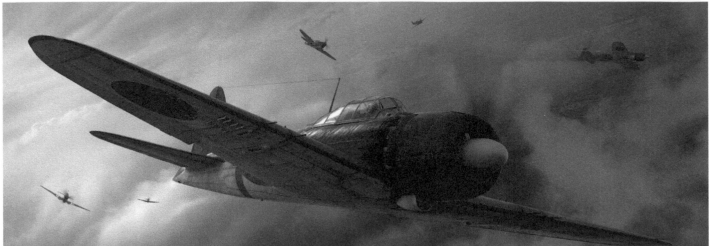

Fig.16

a lot of tests until I achieved the most appropriate reflection on the WWII fighter, which turned out to be a soft reflection. The glossiness values (0.25-0.35) and the values of the BRDF ensured that the metal didn't reflect along the perpendicular (0.05) or reflect too heavily when parallel to the camera (0.9). If you want to achieve good results you must remember that the reflections always depend on glossiness and Bump maps (**Fig.13**).

I love photos with a high contrast and so chose dusk as the time of day to obtain this effect. I tried to use the HDRI but it didn't create good reflections and highlights, so I chose Mental Ray's Physical Skylight using a blue ground color. This color tinted the white panels and more successfully integrated the plane with the background.

I divided the scene into three parts: the main Zero, the Zero on fire and the P-40s. I rendered the propellers using 3D Motion Blur and then composed all the layers together with the background in Photoshop.

To suggest more depth in the image, I used a blue colored layer, because things tend to gradually adopt a more bluish tint as they recede into the distance. I added this layer over each fighter with different opacities depending on their distance from the camera.

When I started to make the fire and smoke, my first thought was to use particles in Maya, but as this would be in the middle distance I chose to build the fire and smoke up using several photos in Photoshop instead. This method yielded the same result but proved to be much faster (**Fig.14 – 15**).

POST-PRODUCTION

I used Combustion in the post-production because I like its color correction. It's very versatile and you have clear and precise control over the image.

In Combustion I began with the image before it was composited in Photoshop and, hence, without any of the layers. I used the Color Correction operator to retouch the color and then added the noise and created the highlight effect across the wing of the main Zero using Sapphire Glint, trying not to abuse the effect (**Fig.16 – 17**).

Then, in Photoshop, I used the incredible plugin DOF Pro to take care of the focusing and to add the Chromatic aberration effect. This effect helped improve the sense of realism and integrate all of the scene elements.

CONCLUSION

What have I learned from this project? The most important thing is to have a clear idea when starting an image. You need to see the final picture in your mind and then must try to embody it on the digital canvas. Many things will change during the process but the soul of the image comes from this first idea. Another important lesson gained from this project is that you must learn from your mistakes and use them to improve your next work.

Fig.17

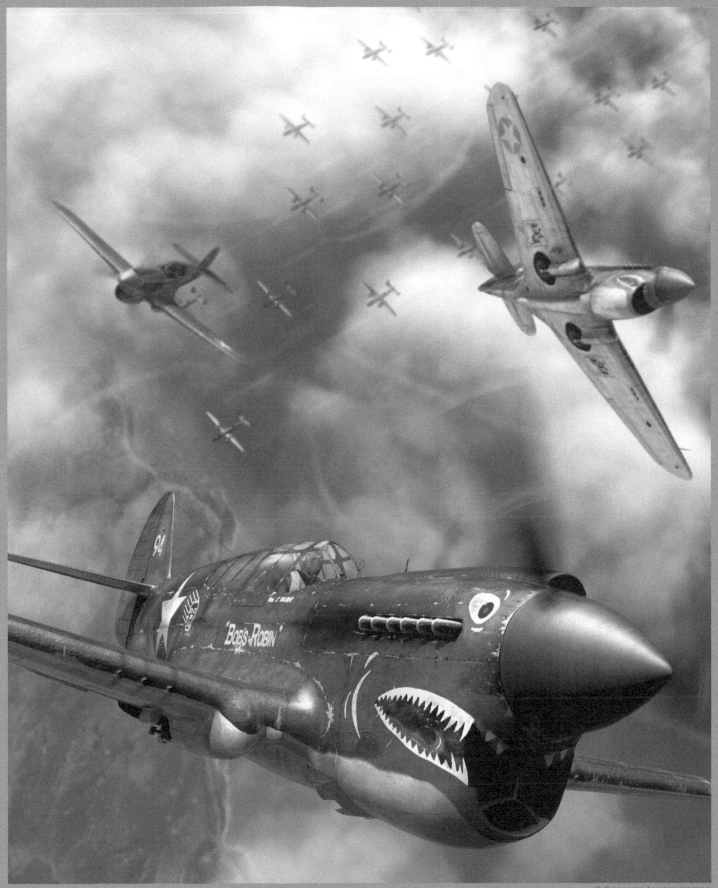

© Rodrigo Lloret Crespo

CONTROL PANEL
BY ANDREW FINCH
JOB TITLE: Environment Artist
SOFTWARE USED: 3ds Max, Mental Ray, Photoshop

INTRODUCTION

I wanted to break free of the restrictions of game creation, which is my day job, and make something small and interesting. I'm interested in lighting and texturing so these were the most enjoyable parts of this project. The whole image took about a week to make in my lunch hours and was created using 3ds Max 2009 and rendered using Mental Ray. Textures and post work were done using Photoshop CS3.

MODELING

The scene was reasonably simple and modeling didn't take too long. The shelf and walls were created using a simple plane, and extruded edges to create the detail. I used Booleans to carve out the holes in the shelf and a little tidy-up was needed to create a nicer curve around the edges. The buttons were cylinders that I extruded and beveled to create the desired shape. Every object in the scene was created using these techniques; I didn't want to over-complicate the modeling phase as I wanted to concentrate on the lighting, texturing and rendering of this project.

> ## ❝ I FIND THE TRICK WITH LIGHTING IS TO KEEP IT SIMPLE ❞

Fig.01 shows a wire frame render of the scene.

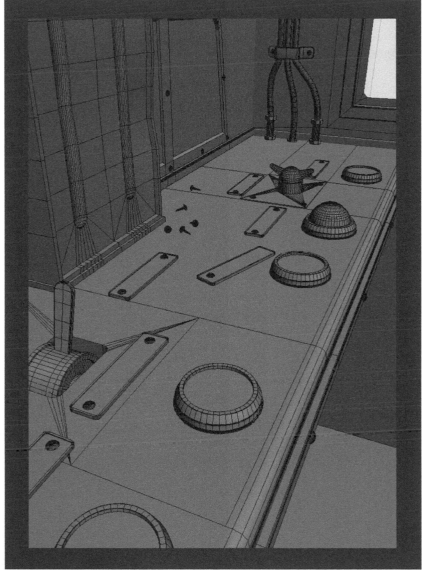

Fig.01

Fig.02

I decided to move on to the lighting at this point to establish the mood I wanted to set. This would aid me with texturing later on.

LIGHTING

I find the trick with lighting is to keep it simple. With this in mind, I only used three lights for the whole scene. I used MR Area Omni lights; this would give me the feathered shadows I wanted. **Fig.02** shows my entire lighting rig, consisting of three lights.

The main light in the window was going to act as the sunlight and so needed to be fairly strong; **Fig.03** shows

the settings I used for this light. Due to the angle of the camera and the positioning of this light, I knew I would be able to get a good response from the specular settings of the materials, allowing the metals to really pop out where needed.

The second light was a small blue Omni light placed just above the blue light. This would give me a blue bounce light created by sunlight hitting the blue object. I could have let the Mental Ray renderer calculate the bounce light for me, but I wanted more control over it and knew that using an Omni light would give me artistic control over when this bounce light would start and finish. **Fig.04** shows the settings I used for this light.

> I WANTED TO CREATE THE MOOD FIRST USING LIGHTING, WHICH WOULD BE FURTHER TWEAKED AFTER THE MATERIALS AND TEXTURES HAD BEEN CREATED

After some render tests I saw that there was a problem with the far left of the image being too dark. To resolve this I added a third Omni light and **Fig.05** shows the settings for this light.

Fig.06 is a clay render, just showing the lighting. Producing this allowed me to notice any issues without being distracted by textures or materials.

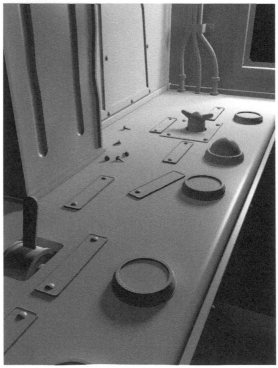

Fig.06

Fig.03

Fig.04

Fig.05

This was not the finished lighting set-up. I wanted to create the mood first using lighting, which would be further tweaked after the materials and textures had been created.

TEXTURING

I used the Mental Ray Arch and Design material system for this project, as they are very good at portraying metal materials. The Arch and Design materials have some good preset settings with which to create all sorts of realistic materials and are a good starting point from which to create your custom set-ups. I also used an HDR image in the reflection map slot, which helped greatly in achieving realistic metals instead of relying only on the environment reflections. The Arch and Design materials dramatically

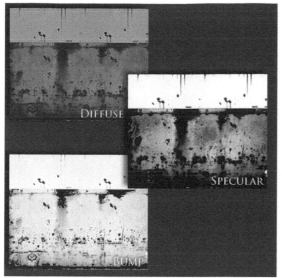

Fig.07

increased the render times, but I think the end result was worth the wait. **Fig.07** is an example of the Diffuse, Specular and Bump maps I used.

Fig.08 is an example of a material set-up I used for these textures.

Fig.08

> I SET MY RENDER TESTS
> TO A VERY LOW QUALITY.
> THIS IS ALWAYS GOOD
> PRACTICE AND WILL SPEED
> UP YOUR WORKFLOW

RENDERING

Because the materials were quite complex and took a long time to render, I set my render tests to a very low quality. This is always good practice and will speed up your workflow; the last thing you want to be doing is waiting around for test renders.

I used the default Draft settings for the tests and kept the render size small. Once I was happy with my render and the lighting, and the texturing looked reasonable, I moved on to a larger render. This render had slightly increased settings such as Bounce and Final Gather rays cast. Once this was completed and I was happy with the result, I added some render elements to help me in the post-production stage of this project.

RENDER ELEMENTS

I rendered out two elements as well as my final render image. I then imported these elements into Photoshop to help add polish to the image and get it finalized. You may find that you don't need to use some of the render elements you create, but it's always good practice to have them saved just in case you need them.

Fig.09

Here are the render elements I used:

- **Beauty render** – This is the actual render from Max.
- **Shadows** – This is a render of the shadows in your image. You can use this to adjust the shadows and add more depth to an image.
- **ZDepth** – This is a render of the depth in your image. You will be given a black and white gradient render, white being closest to you and black furthest away.

With all the elements set up, I moved on to my full-sized 100% quality render. You must be sure you're happy with all your tests before you do this as your PC will be rendering for quite some time! I think the render time for my full image was about 45 hours straight (good job I have a laptop!). **Fig.09** shows the settings I used for the final render.

Fig.10 shows the final render from Max.

POST-PRODUCTION

With the final render done and all the render elements saved, now it was time for Photoshop!

I always consider the render from Max to be just the start of the final stage. It would be very difficult and time-consuming to get a good result directly from the Max renderer so I used Photoshop to add color correction, adjust brightness and contrast, and to add atmosphere effects and depth of field. All these corrections can be done in Max, but, like I said, it would take a lot of time and test renders to get a decent result and is just not worth it – Photoshop will give you much more freedom and control over your image.

I started by adjusting the levels to bring out the darks. I then adjusted the Color Balance to achieve the desired effect, which in this case was photorealism. I wanted a warmer feel compared to the original render, so I added more red; this helped to bring out the rust. Using the Shadows element render I set the layer to Multiply and adjusted the opacity to get a good result. I then added depth of field using the ZDepth element; this stage is quite important to get right because it adds so much to the photorealism that I was looking to achieve. Photoshop CS3 has a very good Lens Blur filter effect, which adds the nice little details that you get from photography, such as noise and hexagonal

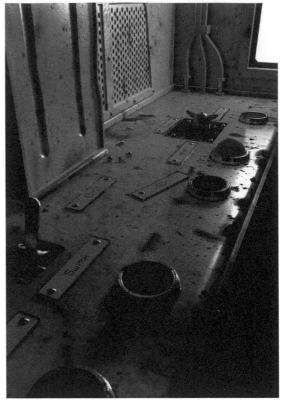

Fig.10

shapes created by blurred specular highlights. So, using the ZDepth image, I copied and pasted it into the Alpha channel of the Photoshop layer and applied a Lens Blur filter. **Fig.11** shows the settings I used for the filter. As you can see, it is quite a powerful filter!

Now for the Lens flare. I know it is often considered a cheap and tacky addition to any image, but, used correctly and in moderation, it can add a lot to your image. In a new layer I added a 105mm Prime Lens flare in the top right corner. I think it's the circular discs that get positioned across the screen that cheapen the image, so I erased them to about 20%. The main focus was to get a strong glare from the window. I added a small amount of noise to the whole image to give it that photographed feel. I then gave it one last adjustment pass of Levels, Curves and color correction to achieve my final image (**Fig.12**).

CONCLUSION

So that's it! I set out to create an image that was as close to being photorealistic as I could, and I think I came close. It was nice to break free of the restrictions I have in my game art and create something a little more complex. Because of this image I learned how to use the Mental Ray Arch and Design material system and will continue to use it in my future works. I hope my descriptions were easy to follow and gave you a helpful insight into how I created this image. Any questions, please get in touch.

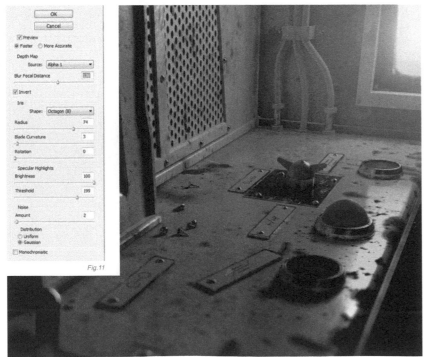

Fig.11

Fig.12

SCENES

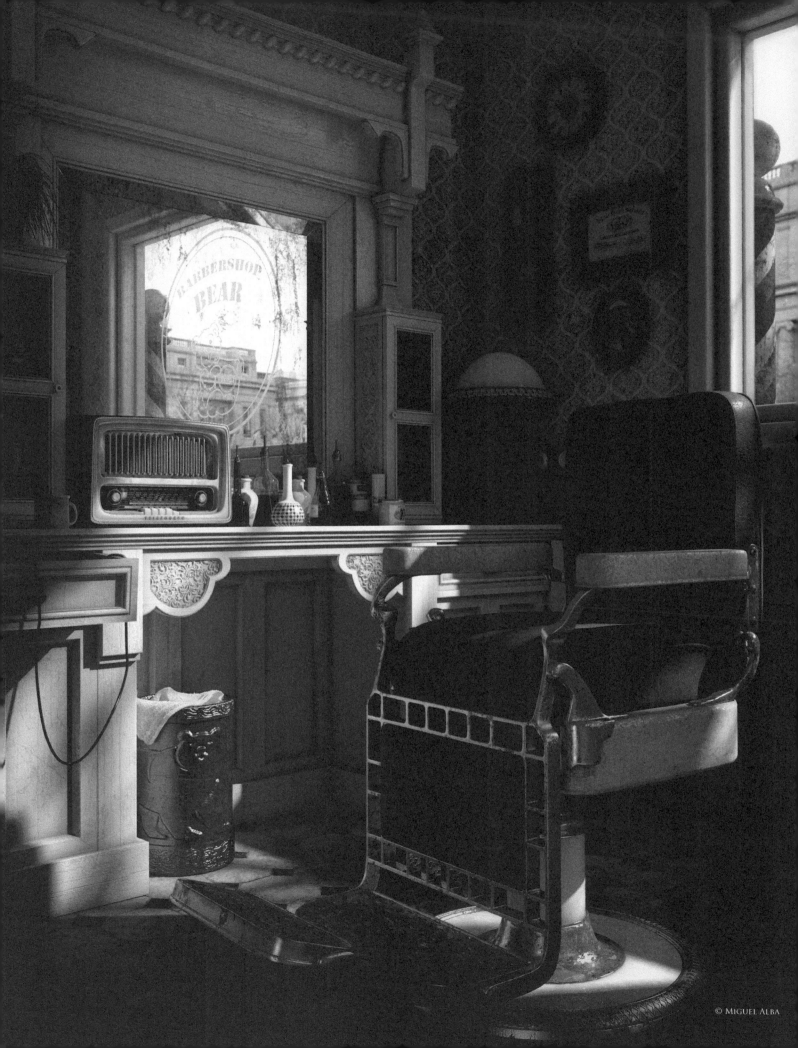

BARBERSHOP BEAR
BY MIGUEL ALBA GUTIÉRREZ

JOB TITLE: Freelance 3D Artist
SOFTWARE USED: 3ds Max, Photoshop, V-Ray

INTRODUCTION
The concept for this project came to me during one of my trips to Oporto. Whilst on a walk with my partner through some of the old streets, I took a photograph of an old barbershop. It gave me the idea to make my own style barbershop and see what new techniques I could learn.

I wanted to focus more on improving my compositing knowledge and so, with this in mind, I dedicated less time to the 3D software than to trying to produce the final image by making all the necessary changes and render corrections using Photoshop.

MODELING
I found it a bit hard to find useful references for this project. I wish I had found blueprints for the main objects

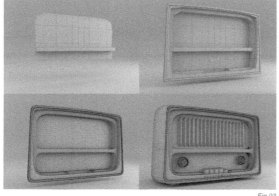

Fig.02

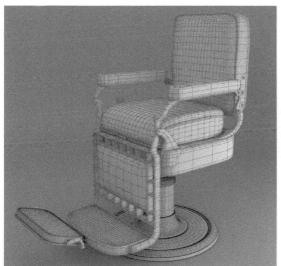

Fig.03

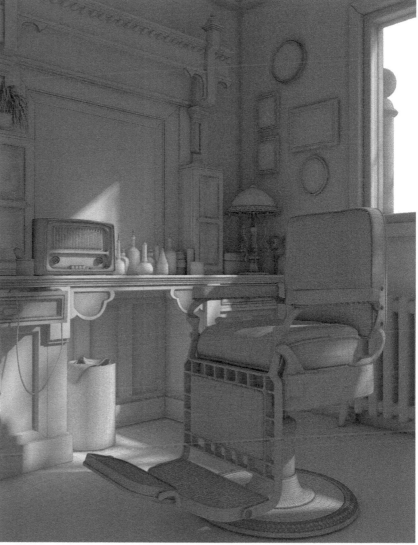

Fig.01

> NORMALLY I LIKE TO MODEL AS MUCH AS I CAN AND TRY TO USE DISPLACEMENT MAPS AS LITTLE AS POSSIBLE, AS THESE CONSUME A LOT OF MEMORY

in the scene, but I had to use some old photographs I found on the internet, which lengthened the duration of the modeling phase. All modeling work was done in 3ds Max (**Fig.01**).

Most of the objects in the scene began as primitives with some basic modifiers applied to them. The most complex models were the seat and radio, for which I used poly modeling (**Fig.02 – 03**).

Normally I like to model as much as I can and try to use displacement maps as little as possible, as these consume a lot of memory. However, this time around I had a

time limit and so it was quicker to use displacement as I already had some maps for this sole purpose. Therefore, I used displacement for some parts of the main furniture, for example the effect of carved wood (**Fig.04**).

TEXTURING

When texturing I usually search for textures either in my own library or on the internet, or I try and paint them in Photoshop. In the case of the leather texture for the seat, I couldn't find a nice texture or find a photograph of any good leather so instead I used some photographs of old waste cardboard and added some scratches and dirt to simulate old leather. I used this texture as the diffuse map of the leather material and then I added bump and glossiness reflections with Fresnel reflection activated to achieve the final result (**Fig.05**).

It can be very helpful to use the VRay dirt on some materials to create dirt around the crevices and corners, and I did this on the main furniture to highlight small details.

LIGHTING & RENDERING

For this work I used VRay to both render and set up the lighting. I used two VRayLight planes to simulate the light from the window and open door, and one VRayLight sphere for the sun (**Fig.06**).

The final render was far too yellow because of the saturated color I'd used for the sun, but I didn't worry

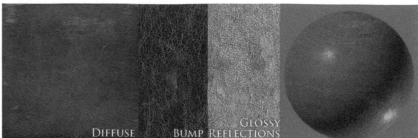

DIFFUSE BUMP GLOSSY REFLECTIONS

Fig.04

DISPLACEMENT MAP

Fig.05

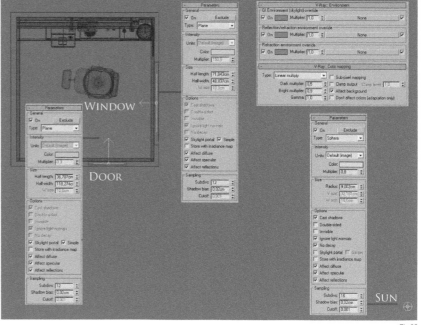

WINDOW

DOOR

SUN

Fig.06

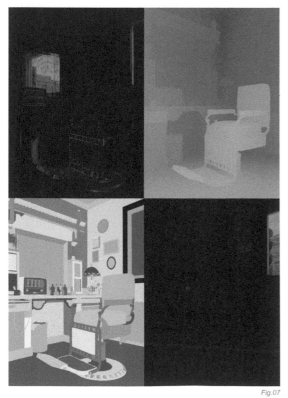

Fig.07

about this as I was going to correct it later during post-production. The main objective was to obtain a nice light distribution that displayed good contrast and shadow projections.

In addition to the final RGB render, I added some other channels in order to use them in the post-production phase. For this work I rendered the following channels: ZDepth, Reflection, Refraction and Render ID (**Fig.07**).

Another useful render pass is Ambient Occlusion (**Fig.08**).

In this case I overrode all the materials in the scene with a VRayLightMtl and applied a VRay dirt map to the color slot. By controlling the radius of the VRay dirt map, you can achieve shadows that range from soft to hard.

SCENES

POST-PRODUCTION

As you can see, the final render I obtained was dark, yellowish and also too saturated. It really needed some corrections and effects to make it look more artistic. You can see the changes I made between the render and the final image in **Fig.09**.

I adjusted the Color Balance by reducing the amount of yellow and desaturating the color. As the image looked, dark it was time to play with the Curves and exposure to increase the light intensity and better control the balance between the light and dark areas in the image. I highly recommend using high-depth color images to preserve more color information. In this case I saved my render as an OpenEXR format with a 16-bit per channel depth color.

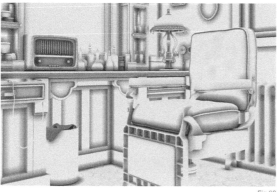

Fig.08

I then added the occlusion pass to increase the depth of the corner shadows; it was pasted into a new layer with the blending mode set to Multiply and Opacity set at 25%. I also added some vignette and chromatic grain to lend it a more photographic look. To create the vignette effect I added a layer with the blending mode set to Soft Light and then painted a non-uniform shadow around the corners. To produce the chromatic grain, I first created a new layer, filled it with a solid grey color and set the blending mode to Overlay. I then added color noise with a Gaussian distribution. To reduce the sharpness of the noise I then applied some Gaussian blur.

CONCLUSION

After finishing this piece I felt happy with the results and the experience I had gained. Even though the steps to producing this image were simple, the process nevertheless gave me the opportunity to discover where to improve on my workflow. I still need to work on my skills in creating better textures and lighting and, as I said in my introduction, I want to improve on my compositing. I hope you have gained some useful information from my working methods.

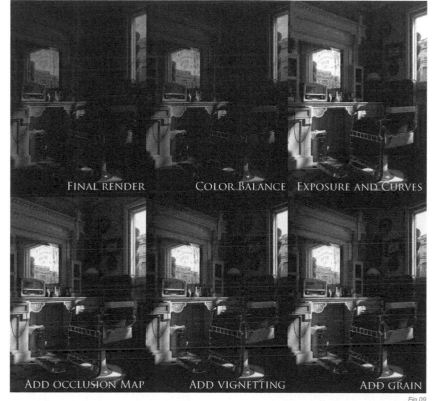

FINAL RENDER — COLOR BALANCE — EXPOSURE AND CURVES

ADD OCCLUSION MAP — ADD VIGNETTING — ADD GRAIN

Fig.09

ARTIST PORTFOLIO

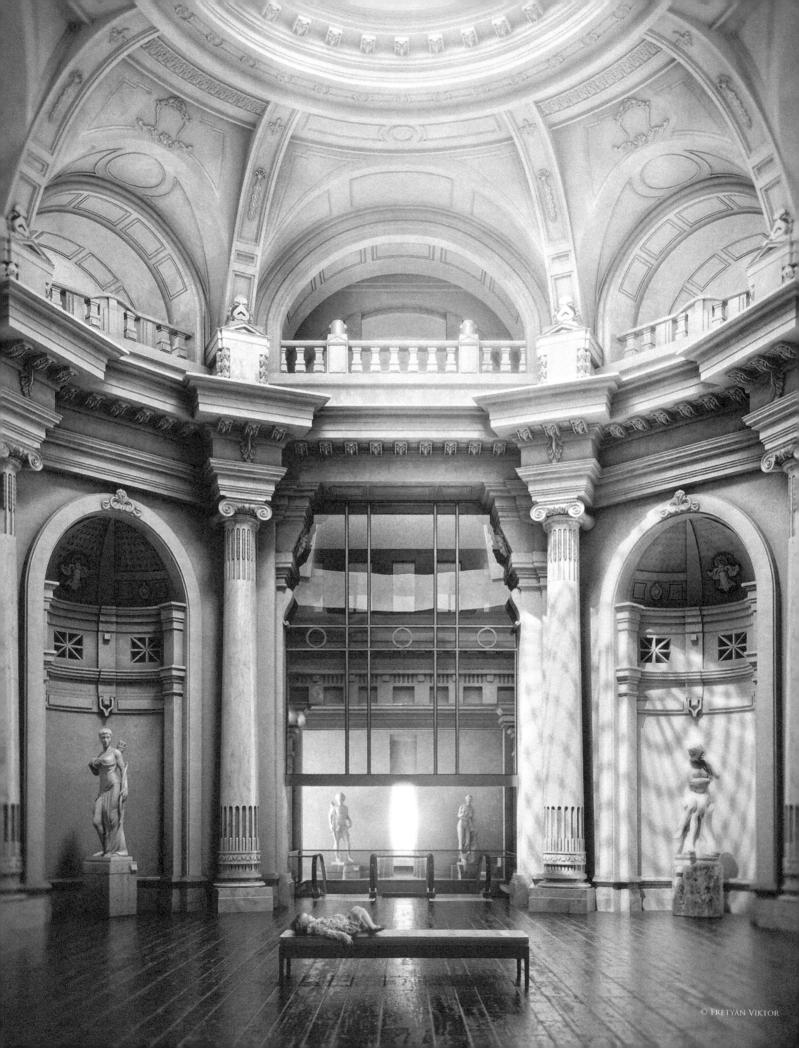

In Waiting...
By Viktor Fretyán

JOB TITLE: Visualizator – Tippin Corporation
SOFTWARE USED: V-Ray, 3ds Max, Photoshop

INTRODUCTION

This is a project I have been working on for the past year. It is the Exchange Palace at Budapest, and it is going to be rebuilt completely by the Tippin Corporation, a firm I am currently working for. I was really glad I could contribute to the project and I hope that soon I will actually be standing in the middle of this rotunda.

After completing the renderings for Tippin, I decided to make my own version of the main aula, or atrium. Here are some of the original renders of the building (**Fig.01a – b**).

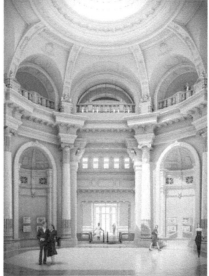

Fig.01a

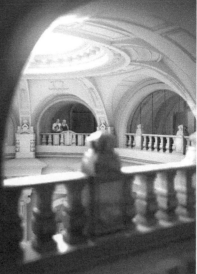

Fig.01b

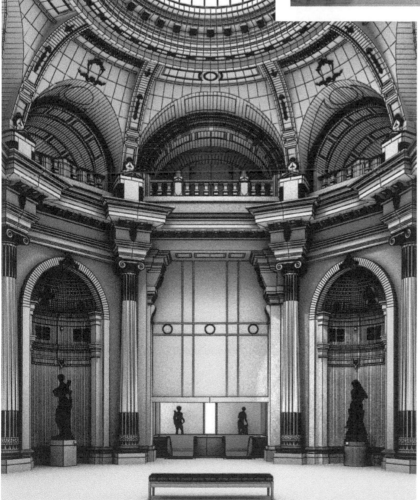

Fig.02

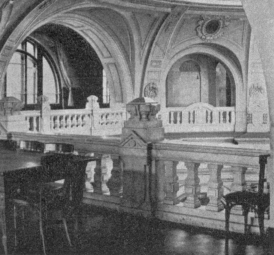

Fig.03a

MODELING

My friend Koroljov Ilja helped me a great deal during the modeling phase (mainly with the ornaments, which were the hard parts!) (**Fig.02**). We had to model everything from old photos (**Fig.03a – b**).

Basically everything was modeled from primitives. Because of the symmetrical nature of the entire room, the Symmetry tool was mandatory in the modeling process, as were other modifiers such as Lathe and Sweep. When I started a new part, I usually drew a section of it using a spline. I extruded it (or used Sweep, Lathe, etc.) and converted it into an Editable Poly to be able to edit it (**Fig.04 – 05**).

The scene as a whole looks very sophisticated, but if you take a closer look at things you will find that all the details were pretty easy to model. The complicated models were done by my friend, Ilja. I must admit that, in general, the modeling stage is the least interesting for me and is the area in which I am also the least qualified.

TEXTURING

This stage was a lot more fun! **Fig.06** shows some of the interesting materials in the scene.

Fig.06

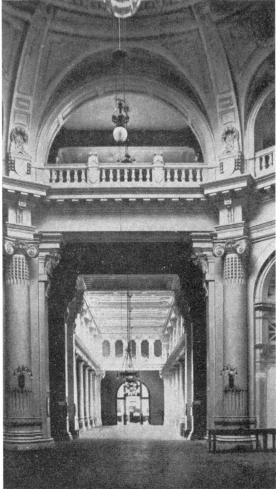

Fig.03b

Fig.04 Fig.05

I used dirt maps for all the Diffuse maps to make the scene less clean and neat.

LIGHTING

I deliberately left the lighting until after the materials had been set up. I had of course set up some temporary lighting to check the materials, but the fine tuning was left until now. I first of all created the main ambient light with a VRay plane that was slightly tilted toward the direction of the sun (**Fig.07**).

I included several other VRay spheres with a radius of around two meters, the positions of which are clearly visible.

For the sun I used a VRay sun (**Fig.08**).

RENDERING

There is nothing special to mention with regards to rendering, but **Fig.09** shows the basic parameters I used.

POST-PRODUCTION

Fig.10 shows the original render.

The first step was some color balancing and exposure control. I went to Image > Adjustments > Exposure and set the gamma to 1.2-1.5. The image then turned very bright and lost its contrast, but I didn't worry because the next step was to adjust the Color Balance. I wanted to create a different mood; a darker, more uncomfortable, and maybe even disturbing color scheme. For this I used the settings shown in **Fig.11**.

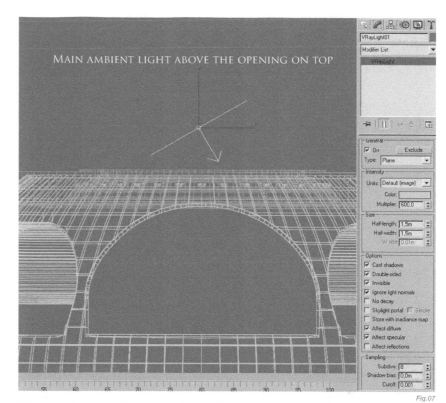

MAIN AMBIENT LIGHT ABOVE THE OPENING ON TOP

Fig.07

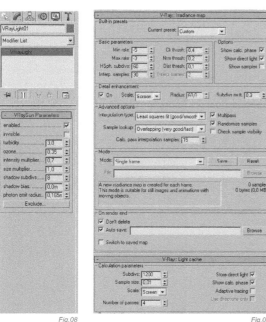

Fig.08

Fig.09

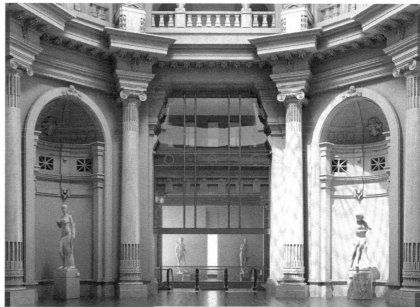

Fig.10

Fig.11

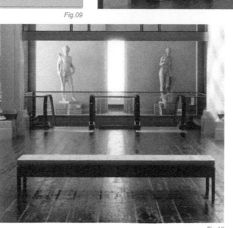

Fig.12

Light bloom: Following this I made a new layer, placed it below all the others and painted it plain white. I then color-selected the white areas in the render with a very small value range. With the brightest areas selected, I then went back to the white layer and pressed Ctrl+J to make a duplicate of the selection. I brought this new layer to the very top and made yet another duplicate. I then applied a Gaussian blur to both, one with a radius set to around 1 and the other with a radius of 7 (**Fig.12**).

Finally, I added a magenta/blue lens flare effect using Knoll Light Factory. **Fig.13** shows the result so far.

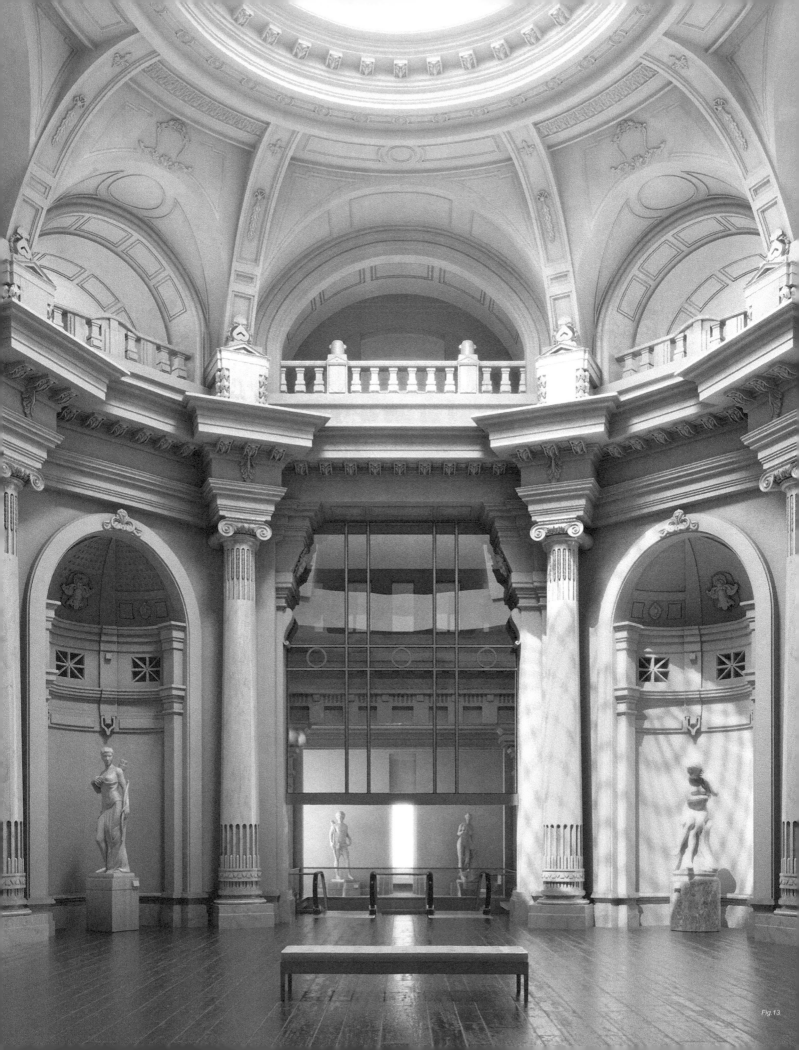

Fig.13

The next stage concerned the volumetric lighting. First of all I made a new layer and placed it at the top. I created an appropriate selection area (**Fig.14**) and then filled it with pure white, which was followed by some radial blur (**Fig.15**).

I then used the Eraser tool with a really high radius and a Hardness of zero and erased the bottom section (**Fig.16**).

The layer was then set to Overlay with opacity around 30-40 percent and a duplicate layer set to Normal.

The girl was based on a photograph of a close relative's child, Lil. I put her on the bench by simply using the Eraser tool and making some minor adjustments to better integrate her into the scene (**Fig.17 – 19**).

Fig.20 shows what the image looked like at this stage, with only the effects left to do.

Color balancing: For this I needed to make the scene a bit brighter. I used gamma adjustments and after that the Color Balance tool. I pulled the dark tones to the red-yellow areas and the mid-tones to blue-cyan-magenta.

Fig.14

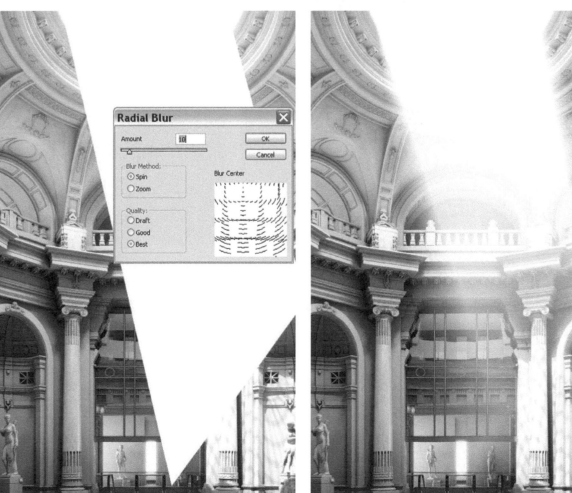

Fig.15

Fig.16

Depth of field: This was achieved through Alien Skin's Bokeh plugin, using a planar setup. There are other plugins like this but I prefer Alien Skin's because I think it makes a better Bokeh effect than the others.

Chromatic aberration: This was done using a 55mm film tool that I tried to keep as subtle as possible. I see a lot of images that are destroyed by the abuse of these effects (most of which are mine ...). My advice is to keep it low.

Vignetting: This again was done with a 55mm film tool, but there is little to write about here as it is more a matter of taste, I guess.

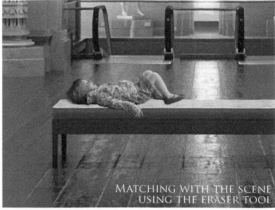

MATCHING WITH THE SCENE USING THE ERASER TOOL

Fig.17

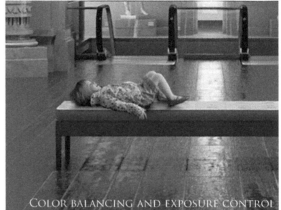

COLOR BALANCING AND EXPOSURE CONTROL

Fig.18

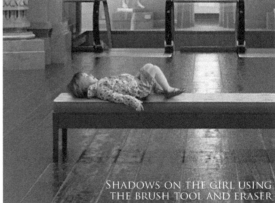

SHADOWS ON THE GIRL USING THE BRUSH TOOL AND ERASER

Fig.19

Film grain: To create the grain I used the NIK Color Effects tool. It is restricted to a separate layer that is created automatically by the plugin. It was set to between 50-75 percent with the Eraser tool used to limit the effect using a high radius, a Hardness of zero and a 10 percent flow to clear any unwanted grain; e.g., from the picture's focal point, the gate and the girl. There is in fact a lot of grain on the image overall to help fit the mood.

And then I had the final result – the completed image!

I hope you have found these few pages useful. I am currently working on an animation of this building and can't wait to see this scene come to life!

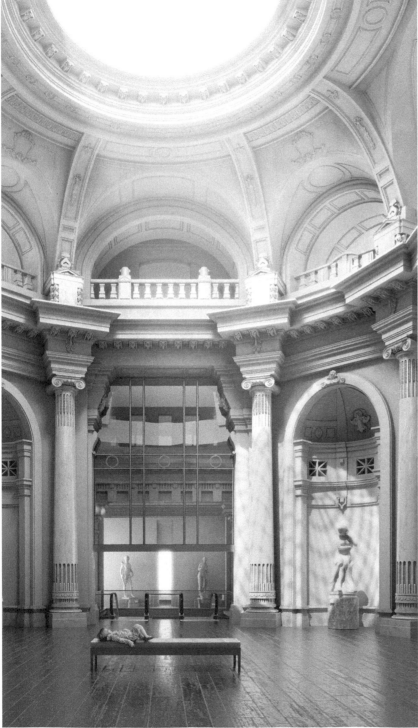

Fig.20

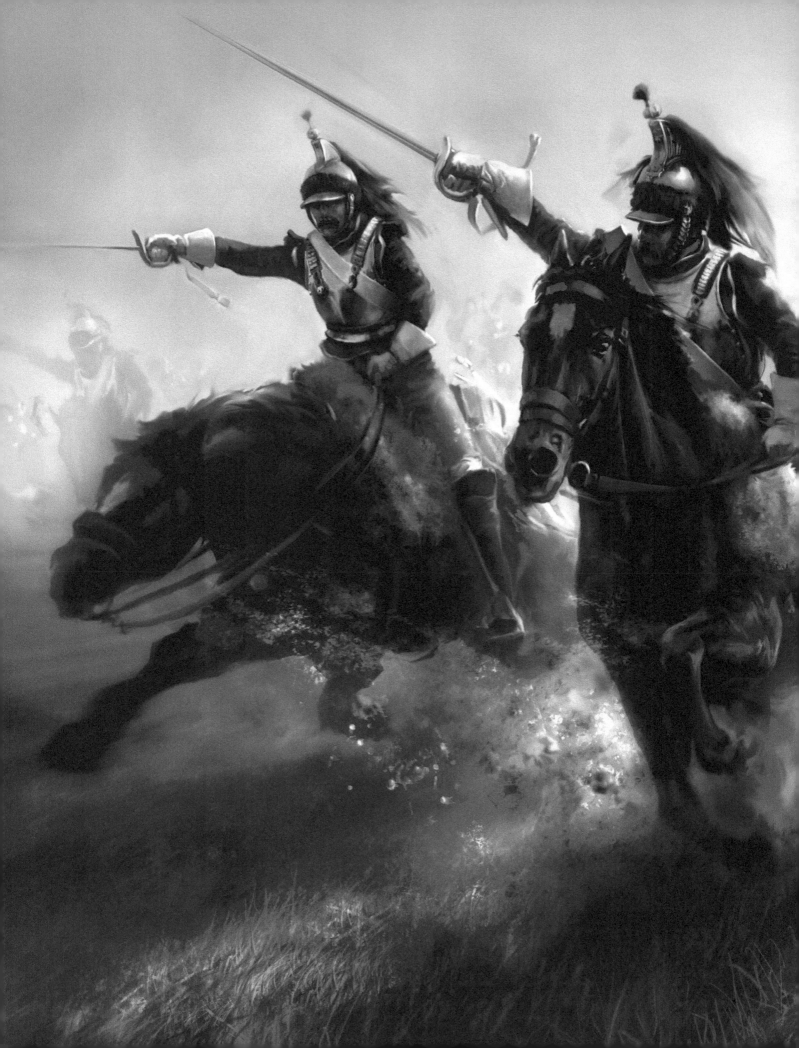

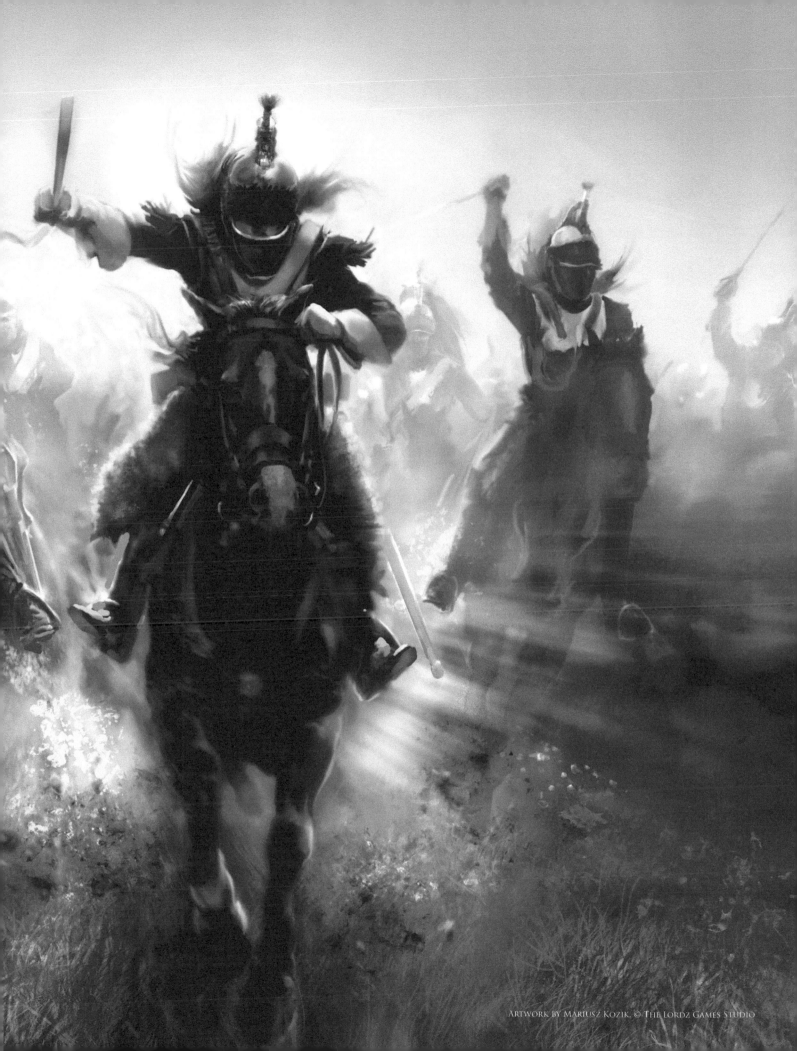

CHARGE OF THE CUIRASSIERS

BY MARIUSZ KOZIK

JOB TITLE: Concept Artist / Illustrator
SOFTWARE USED: Photoshop

USING THE SMUDGE TOOL ALMOST AS A PAINTBRUSH

After many years of working at the easel, I found it hard to switch to an electronic medium. My experience in working with physical materials certainly left its mark and set of habits. Learning digital methods was not straightforward. I am still not entirely at ease with Photoshop and for that reason I will not write much about the techniques of working with the program, but rather will focus on painting itself.

When I first took up digital art I spent quite a long time looking for a way to easily manipulate a pen on a slippery surface and discarding any "computer stiffness". I had to get used to drawing on a tablet whilst looking at a monitor, devoid of an ability to touch the canvas and feel the paint.

I found the Smudge tool (**Fig.01**) bore the closest resemblance to working with real paint. I like to start sketches with some black spots on a white background, which I then process with the Smudge tool. If, at any point, there is a need to add a different shade, I apply these as grays using the Dodge and Burn tools. I advise only using shades of gray when sketching as using

> ## CREATING BATTLE SCENES IN ART IS A HARD AND LABORIOUS TASK. I HAVE THE ADVANTAGES OF A GOOD KNOWLEDGE OF HISTORY AND EXTENSIVE KNOWLEDGE OF WEAPONS

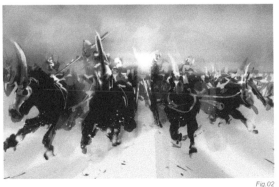

Fig.02

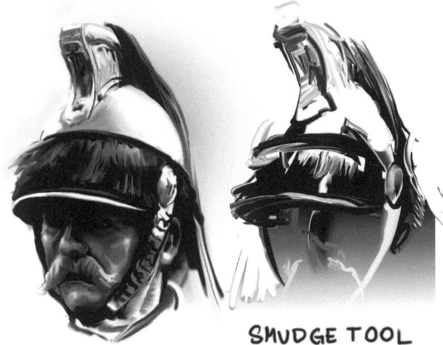

SMUDGE TOOL

Fig.01

color causes strange gradient effects. In this case it is better to use brushes that leave texture; this will save time when it comes to adding textures later. For this piece, this method helped me to quickly build the outline of the cuirassier's sheepskin saddle (a regular part of their equipment). I used the basic brushes: Linden Leaves for the Dodge Tool and Maple Leaves for the Burn Tool (see **Fig.03**).

BATTLE SCENES

Ever since I sat down at a tablet four years ago, I have been creating battle scenes. The most important issue for me is a compliance with historical accuracy. However, I create the first sketches, composition and color from my imagination. Towards the end of the sketching process I start using instructional materials and references, through which I can develop the historical details. Creating battle scenes in art is a hard and laborious task. I have the advantages of a good knowledge of history and extensive knowledge of weapons, uniforms, military tactics, etc.

CONCEPT

The Charge of the Cuirassiers during the Battle of Waterloo was fought on very wet ground. After heavy rain, the earth and grass were saturated with water. I thought that light shining through splashes caused by the horses' hooves would make a very interesting compositional element in the image. Black horses with streaks of light illuminating the drops and mud could create a very interesting rhythm in the composition. Obtaining strong contrasts would also heighten the dynamics of the frantic cavalry attack.

I wanted to use a similar effect to other artworks, as demonstrated by some of my unfinished drafts. Celtic chariots scampering through the snow was the theme of **Fig.02**. With *Charge of the Cuirassiers* I was able to realize this idea in another environment.

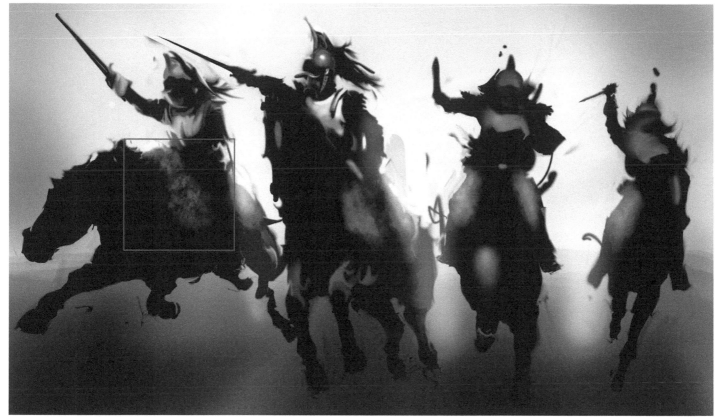

Fig.03

DYNAMISM & MOVEMENT: DIVERSITY IN UNITY; UNITY IN DIVERSITY

One very important factor in a scene of charging cavalry is dynamism. A monotonous group of uniformed cavalry in straight and smart colonne serré formation can cause a lot of problems when it comes to achieving the right perspective. It is important to remember that no two cavalrymen should be moving in the same way. Their movement needs to be aimed in different directions, preferably centrifugally as this helps to strengthen their dynamism.

FIRST VERSION

Fig.04

> ## " ARTISTS USE COLORS TO PROVIDE INFORMATION. THEY CREATE A LOGICAL WORLD ON A PLANE BASED ON INTERNAL RULES THAT SHOULD BE CLOSE TO BEING HARMONIOUS "

A convergent perspective can help a lot. When the central characters are approaching from the front, the characters at the sides need to be in a three-quarter setup (**Fig.03**). This is one of the many possible ways of energizing a composition.

In this painting I tried not to repeat the masses, the size of spots (although it seems to me that the two horses in the middle compete with each other), directions of movement, the layout or indeed the composition of light. I did this according to the principle of: diversity in unity; unity in diversity. Dynamism can also be strengthened by sharp edges, contrast and color.

COLOR: LESS IS MORE

It might seem that the use of many meretricious colors, with maximum saturation, would be a good way of achieving a highly expressive dynamic. Nothing could be further from the truth.

Getting a message across in an image is like getting a message across in everyday life. If everyone in a crowd starts to scream information, I can guarantee that you will understand nothing. The same is true with colors. Artists use colors to provide information. They create a logical world on a plane based on internal rules that should be close to being harmonious. Confidence and awareness in the use of colors is extremely important. Basic rules have to be remembered, such as the interaction between different colors and the ratio of mass to saturation. By reducing the overall

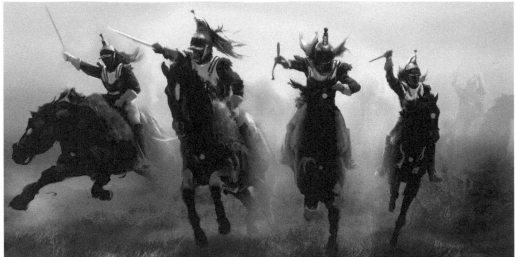

WATERLOO 2009 © ALAIN BOUFLER

Fig.05a

Fig.05b

saturation of the artwork we effectively expand the palette of colors, allowing us to emphasize the most important information contained in the image. This also creates a harmony between the colors. A color gains its true quality and value when it is next to a "calm neighbor".

Fig.04 shows how a red color next to a "calm neighbor" reveals its true power.

The French cuirassiers and their environment imposed a range of colors on the painting. The most active parts were the red elements and the details of the uniforms, completed by the blue areas on the uniforms and the gold inlay of the equipment (**Fig.05a**).

Red, blue and gold colors in the background; a delicate sky; and dirty, heavy ground with an olive hue made for a good, solid range of colors. All of this, along with the rhythm of the black horses, streaks of light and drops of water, helped to give us an interesting effect.

Why is the setting in **Fig.05b** good? Because the largest volume in this view is the background, the colors of which are unsaturated. They do not compete with or disturb the more important elements, the cuirassiers, who should be the focus of our attention. High contrasts, saturated colors, complex details and reflections of inlays ensure that these characters dominate the painting.

REFLECTIONS OF LIGHT ON THE CUIRASSES

The reflections in the cuirasses and helmets are the most important elements in this scene. All the characters are shown with the sun behind them. Although each item reflects the light from the ground and other objects, the cuirasses and helmets act as mirrors and give the whole painting a high luminosity and clearer form.

THE IMPORTANT THING IS THAT DETAIL "SHOULD NOT BE ADDED WHERE IT WOULD" BE SUPERFLUOUS: IN THE BACKGROUND, SHADOWS, ETC.

Cuirasses and helmets are not flat and so the reflections from the environment are deformed according to the spherical surfaces of these objects. In **Fig.06** it is possible to see how the surrounding objects are mirrored. The sky reflected in the metal cuirass is more saturated and darker as the cuirass reflects the darker sky behind the viewer. This is achieved using a blue color with a slightly purple hue. These mirrors introduce the luminosity of the reflected world in deep shadows.

DETAILS

It was only at the very end of the work, once I had already established a solid composition, that I developed the details. I arranged the masses, set the light and range of colors, and resolved the sense of movement (**Fig.07**).

It is often the case that there is no need for excessive detail. If all the above-mentioned elements are carried out correctly then the artwork will already convey its message well. Adding detail will only serve to highlight the most important elements. Unfortunately, in historical illustrations, descriptions of individual items such as uniforms and weapons are more important than artistic matters. This is a source of constant regret for me. The important thing is that detail should not be added where it would be superfluous:

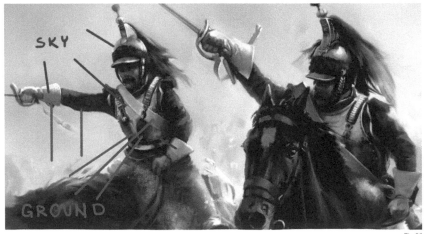

SKY

GROUND

Fig.06

in the background, shadows, etc. An excess of small details makes a painting unreadable, heavy and stuffy, especially if it is small-scale. Obviously, when working in a format such as 120 x 80cm, it is necessary to carry out work with sufficient detail. What we see on the monitor can be misleading because we do not see the complete work displayed in 1:1 scale. Well-prepared detail can jump out at the viewer when printed and once we can see the entire work in full.

CONCLUSION

After analyzing my work I came to the conclusion that it should be improved, or even started again. I feel that I devoted too much attention to the form in detail, and because of this I lost control of the whole composition. Also, at some point I stopped focusing on the lighting, which establishes the form of the painting. This work is not quite in accordance with the principles of nature. It is a well-known principle of good painting that through the manipulation of light and temperature it is possible to create good form, and therefore a good painting. Line

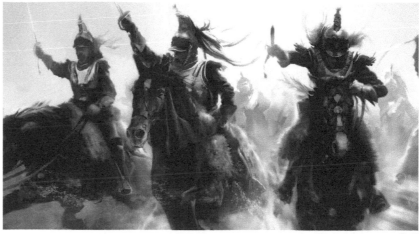

Fig.07

drawings can guide you, but ultimately should be subordinate to light and temperature. I don't feel that I fully achieved the objectives I had in mind when I started this picture. What I can say is that the best way to achieve these objectives became clearer to me as the work progressed.

I hope that these few paragraphs about my work and experience will help some of you to avoid making similar mistakes.

ARTIST PORTFOLIO

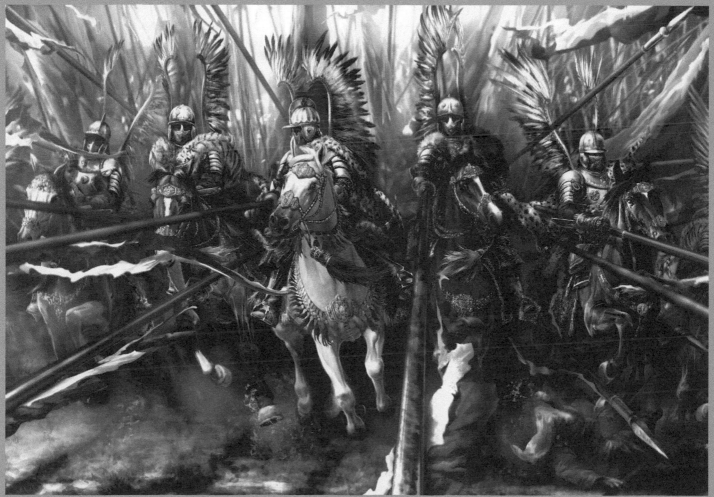

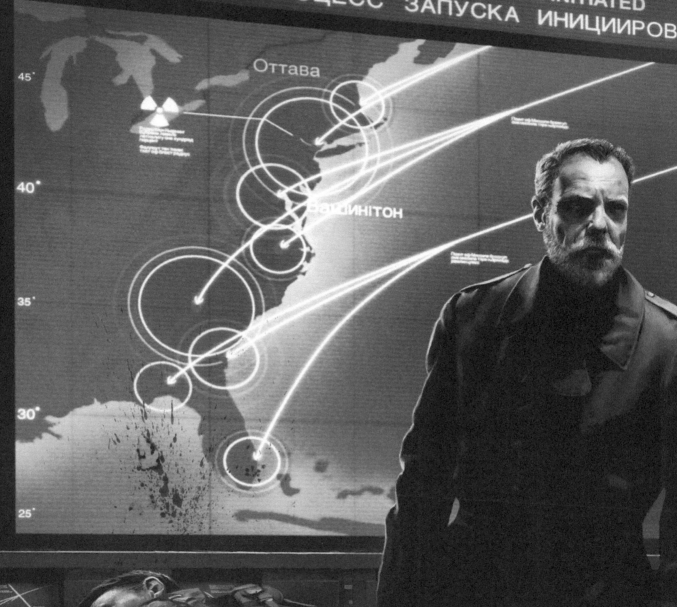

LAUNCH SEQUENCE INITIATED
ПРОЦЕСС ЗАПУСКА ИНИЦИИРОВА

80°

0:0:45

© Chase Stone

Standoff
By Chase Stone

Job Title: Concept Artist
Software Used: Photoshop

Introduction

This image was done in response to a challenge hosted by CGSociety, the theme being "Secret Agent." I had a pretty tough time coming up with an idea at first; my initial concepts just didn't feel iconic enough. Eventually I decided to go with a classic James Bond-inspired scene, complete with Soviets, suits, silencers, an evil mastermind (a rogue, ex-soviet general) and a plot to destroy the world. A little over the top, yes; but it felt right.

A lot of espionage images logically tend to focus on the agent, or even more so on the agent in a sticky situation. It's fun and engaging because the viewer has to wonder how the hero is going to save himself, or indeed *if* he can save himself at all. After roughing out this sketch (**Fig.01**), I found that it might be more fun to flip that notion around and focus on the bad guy, and to illustrate the bad guy having been defeated. I figured that if I could really nail the emotion on his face during this life-changing moment then this could end up being a special image.

Creating the Image

With this piece I basically used only one brush, called the Chalk brush (**Fig.02**). It's one of the Photoshop defaults,

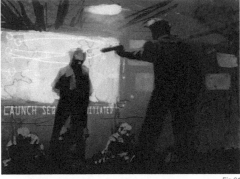

Fig.01

Fig.02

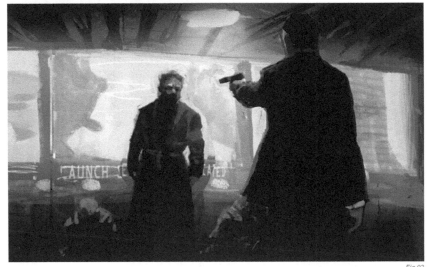

Fig.03

> ❝ I WANTED THE ROGUE GENERAL TO BE THE FOCAL POINT, SO I BROUGHT THE "CAMERA" IN AND SHIFTED IT OVER TO THE RIGHT, WHICH CENTERED HIM IN THE FRAME ❞

but in this case with Shape Dynamics disabled and Pen Pressure turned on. Usually I try to use a variety of default/custom brushes but for some reason I got stuck on this one and painted virtually everything with it.

My initial sketch was only meant to get the essence of my idea down on paper. My second sketch (**Fig.03**) was a bit more refined, and focused more on composition. I wanted the rogue general to be the focal point, so I brought the "camera" in and shifted it over to the right, which centered him in the frame. I also decided to drop a spotlight right in between the two characters that would both draw attention to the general by illuminating his face and take attention away from the agent, who would be silhouetted.

Background

Here's a quick rundown of some of the background elements. The first step was working out the perspective (**Fig.04**). When I created *Standoff* I was still learning this subject so this stage was probably the toughest part

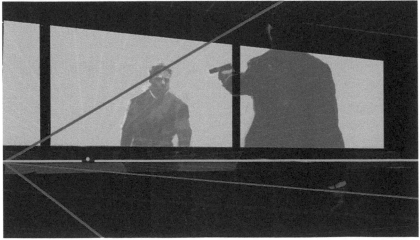

Fig.04

for me, but also the one that I learned the most from. Here you can see the horizon line (blue line), one of the vanishing points (yellow dot – the other VP is way off the canvas to the right; I just approximated their locations) and the human perspective (red lines). The faint white lines emanating from each vanishing point served as loose guides throughout the painting process.

> ## I DECIDED EARLY ON THAT HIS EXPRESSION SHOULD BE SUBTLE, SO NO ANGRY TEETH OR OVER-CONFIDENT MOUSTACHE TWIRLING

I created all the little screens for tbaring he desk monitors separately in another document, and then pasted them in and used the Transform > Skew tool to adjust their perspective. The background was feeling way too simplistic and boxy, so I decided to place the monitors at an angle to add a little variety. This meant finding another vanishing point directly above the first and having the orthogonals correspond to it (**Fig.05**).

The map (**Fig.06**) was done much the same way, created in a separate document and then skewed into the correct position.

CHARACTERS
I painted all of the characters with more or less the same basic process, so I'm just going to talk about the most important one (the general) in detail.

First and foremost, I had to decide what kind of emotion the general would be conveying; for me this was the most important part of the whole project. I decided early on that his expression should be subtle, so no angry teeth baring

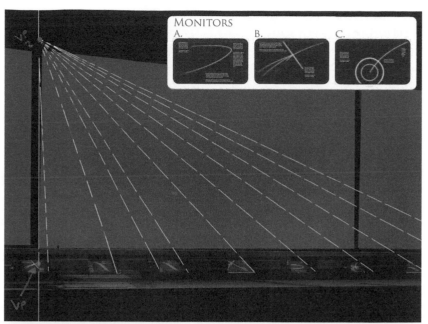

Fig.05

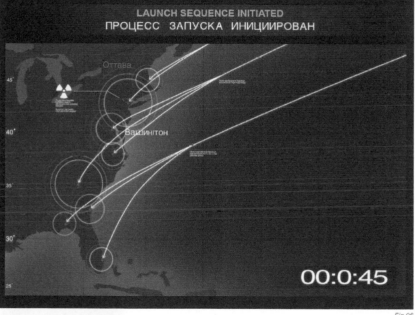

Fig.06

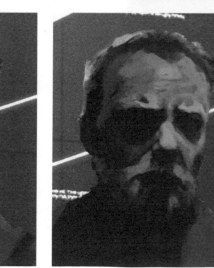

Fig.07a Fig.07b

or over-confident moustache twirling. I finally settled on cold defiance, which I felt would speak volumes about his character, given his predicament.

Using the Chalk brush at about 10-15 pixels, I started out with broad strokes, making sure the size and proportions were correct (**Fig.07a**). I may have spent the most time on this stage because even when it's rough one can still sense the type of emotion, and I had to get that defiant look right from the beginning. It took some trial and error but it finally started to come together.

During the next phase I shrank the bush to about 7 pixels, sampled a darker grey, and started refining the shadows (**Fig.07b**). I then did the same for the highlights,

taking special care to get the highlight on the left (our left) of his face just right (**Fig.07c**). I always try to apply these stages on their own layers simply because I tend to overdo things so it's helpful being able to use the Eraser tool. Once the face was really starting to come together, I zoomed in and shrank the brush down to about 2 pixels, and hatched in the details.

The color (**Fig.07d**) was the final and easiest step, because it consisted mostly of just laying in flat colors on a layer set to Multiply. One thing to keep in mind about painting on a Multiply layer is that it tends to darken your values, since the whites don't stay white but instead adopt the color you're laying down. So, after working on this layer I painted directly on top of it in a normal

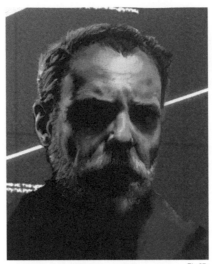
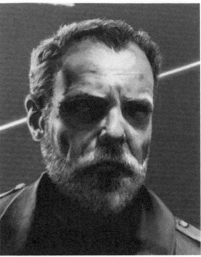

Fig.07c Fig.07d

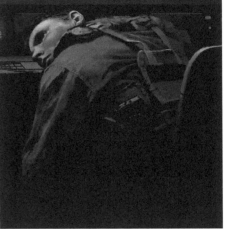

Fig.08a Fig.08b Fig.08c

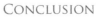

Fig.08d

layer to pump up the highlights. Because the general was supposed to be the focal point, I gave the spotlight above him a warm hue to contrast with the cool blues and greens of the rest of the image.

Fig.08a – d is another example of how I go about painting my figures, again similar to the way I painted the general's face. I start by roughing in using black and white, refining darks, lights, details, and then finally adding color. The only difference with these guys was that I actually had some direct reference material to work from with myself as the model. I didn't feel the need to invent their faces, so the two dead guys ended up almost like self-portraits.

CONCLUSION

In the end the image worked out well; I accomplished what I set out to do and everything else fell more or less into place. If I'd had more time to work on it I might have added more character and variety to the background, but other than that this image became something that I'm proud to have in my portfolio, and that's the most important thing.

Creature Design by Carlos Huante

CHARACTERS

It's a new era for computer graphics. Many traditional artists are also becoming digital artists and many digital artists are now producing stunning digital artwork that can be finally touched, thanks to the evolution of the rapid prototyping technologies.

More and more we are seeing digital and traditional artists interacting in forums and learning from each other. What was once considered a smaller art form is now being embraced and respected by many traditional artists. Artists of any media are now seeing the product of our creations and what we are able to say through the images we create; that is ultimately what really matters: the ability to convey stories.

Hardware and software are becoming more and more accessible as tools. There are many great digital artisans emerging from this new era, but just being great artisans does not automatically turn us into great artists. It's our ability to communicate feelings through our artwork that will set us apart. The simplicity of a good design should triumph over overly detailed images with no content. At the end it is our storytelling skills that will set us apart as true artists. Creation should be the focus and it's creativity that will pave the way for future generations of computer graphics or any other art form.

KRISHNAMURTI M. COSTA

kris@antropus.com
http://www.antropus.com/

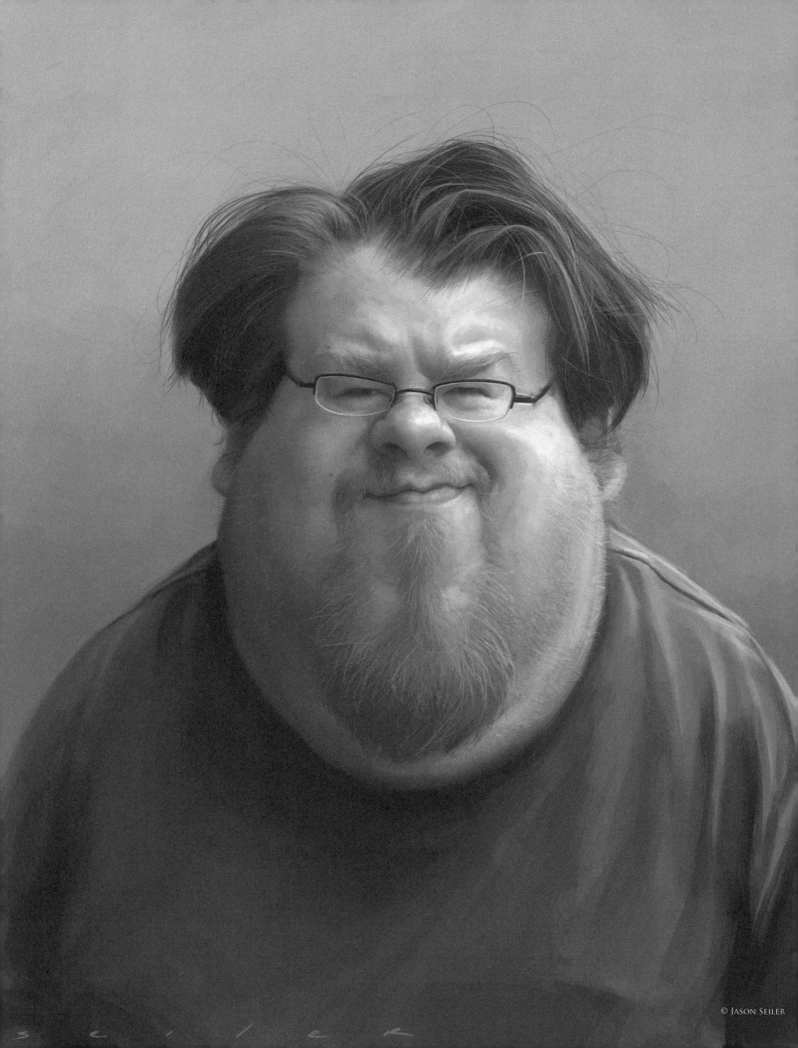

© Jason Seiler

PORTRAIT OF NATHAN
BY JASON SEILER
JOB TITLE: Illustrator
SOFTWARE USED: Photoshop

INTRODUCTION
These are the steps I took while painting *Portrait of Nathan*. The sketch was drawn with a ballpoint pen in a toned sketchbook (**Fig.01**). I used Photoshop CS and a Wacom Cintiq for the painting. The size of the painting is 8.6" wide x 10" high at 300 dpi.

THE PORTRAIT – STEP 1
After scanning in my sketch of Nathan, I chose Select All, copied that layer and pasted another copy of the Nathan sketch above the background layer, one above the other. I then switched to my background layer, used Select All again and deleted the sketch from the background layer.

Now I selected layer two, which now had the sketch on it, and set that layer to Multiply. Next I created a new layer above the Nathan Sketch layer and filled it with a flesh tone. The flesh color I chose to use in RGB Mode was R: 189, G: 127, B: 101.

> ## AS I TEND TO PAINT FROM DARK TO LIGHT, THE BACKGROUND HERE WAS USED AS A FOUNDATION TO BUILD FROM

Next, I brought the opacity level down to 58% and adjusted the levels until they felt right. I do this to soften

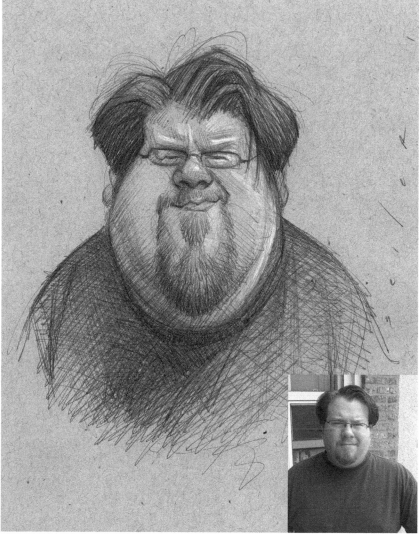

Fig.01

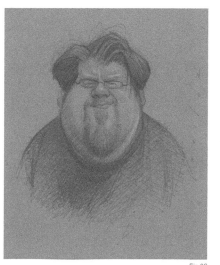

Fig.02

Fig.03

and lighten my sketch lines, which adds a nice mid-tone color and value. I don't always start with this color and, in fact, I rarely start with the same colors twice because each subject I paint presents a new mood or feeling that I want to capture. With this image, my photo references felt too cool, and I wanted a warm painting, so I chose a red flesh tone to start with. As I tend to paint from dark to light, the background here was used as a foundation to build from (**Fig.02**).

STEP 2
In **Fig.02** I set the layer with the sketch to Multiply. The reason for this was that now I could go to the background layer directly under the sketch layer and block in rough colors and values without losing my sketch lines.

The brush I started with was a 13 Round. I made sure that Other Dynamics was clicked on and that the Opacity Jitter was at 0%, Control was set to Pen Pressure, the Flow Jitter to 0% and the Control below the Flow Jitter was set to Off.

> ❝ I WANTED TO CONTROL
> MY LIGHTS, MY GOAL
> BEING TO SOFTLY BRING
> IN A LITTLE LIGHT AND
> SLOWLY BRING OUT SHAPE
> AND FORM ❞

These settings gave me the control that I prefer. I usually paint with my Opacity set to 85-90% and my Flow set to 100%, although this sometimes differs depending on the effect I'm looking to achieve. With this image I also made sure that Shape Dynamics was clicked off (**Fig.03**).

What I typically do at this stage is use my Eyedropper tool to select the color I've created for the background and then use that color to begin my blocking in. As the top layer of this image had been completely filled with a color (opacity brought down to 58%), I wasn't able to get

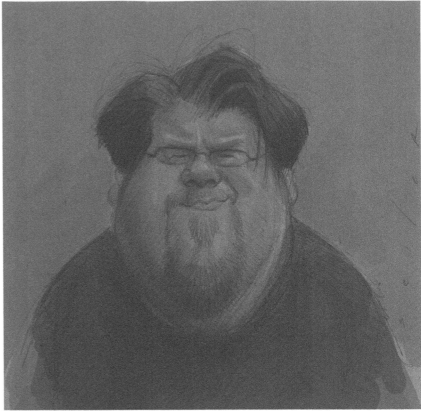
Fig.04

too dark when blocking in my painting in the background layer, because the top layer would not allow it.

I did this so that I could roughly build up my values in a controlled manner. At this stage of the painting, I was mostly concerned about painting the correct values. It was also important at this stage to not zoom in too close. I paint from a distance and use large brushes. This way I can focus on capturing shape and values, and merely suggest detail (**Fig.04**).

STEP 3

For this next step, I created a new layer that was put on top of the other layers. I then set this layer to Soft Light, chose white from my color picker and began blocking in lighter values (**Fig.05**). I wanted to control my lights, my goal being to softly bring in a little light and slowly bring out shape and form. Because my layer was set to Soft light, I couldn't get a pure white. Think of it as if you are sculpting, chipping away small pieces until the form appears. I usually save my bright highlights and whites for later on in the painting and start by establishing my darks and working lighter from there. This stage simply allowed me to create a balanced foundation for my block-in.

Steps 1-3 took 5 to 10 minutes at the most to complete (**Fig.06**).

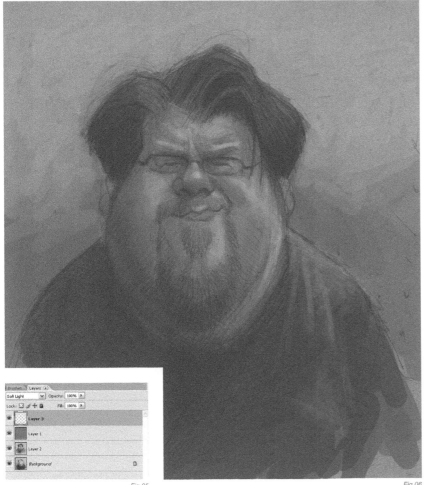
Fig.05

Fig.06

CHARACTERS

STEP 4

This is where the painting became a little more complicated. I was now ready to start blocking in my painting, but first I needed to create a color palette that was harmonious. As I said earlier, my main priority when painting is to get the values right. I know that, if I can succeed in that, I can do just about anything with the color. I usually create a variation of red, yellow and blue. With these three shades most colors can be created.

You'll notice that in this painting my colors are more earthy: reds, browns and greens. To create this palette, I made a new layer that would remain on top of all the layers from that point on. This layer was used as my "palette layer". I selected my Eyedropper tool and eye dropped a red-brown color from my background. I then clicked my color picker and chose a few more reds based on the red-brown that I'd already chosen and created a small grouping of flesh-like reds and browns.

I did this by squinting my eyes while looking at my photo reference and then choosing color according to the

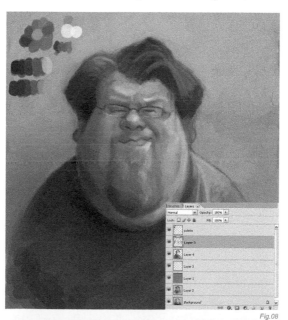
Fig.08

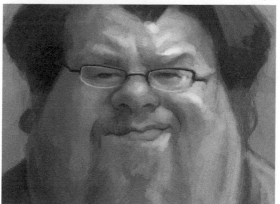
Fig.09

values I saw. When I squint at my photo reference I see oranges, greens, violets and blues. I created these colors and mixed my red-brown color into all of them to create a harmony. This technique is similar to the "pigment soup" technique that I sometimes use when painting with oils.

I now created another layer that was going to go directly under my "palette layer", but that would be on top of all the other layers. I began to paint on top of my block-in. Everything up to this point was going to serve as a guide for me to follow as I built up the layers of color (**Fig.07**).

Next, I needed to establish my darkest darks and block these in. There was no need to zoom in; I worked at a distance and continued to use a large, round brush. My technique when painting digitally is very similar to how I would paint traditionally with oils. I start with bigger brushes, block in the largest shapes of the darkest color and value and, as the painting progresses, use smaller and smaller brushes. Also, I never focus on one area for too long. Painting from a distance with larger brushes really helps you to cover more ground in less time.

STEP 5

Now this is where the painting began to come to life. I continued the same process as in Step 4. Whilst squinting my eyes, I looked for the lighter values and with a larger round brush I blocked in those values and also began to block in a bit of the background too. It's important to establish the background early on in the painting as it should complement the portrait. The colors and values of the background will affect the colors and values in your portrait, so it's important to work back and forth between the portrait and background while blocking in (**Fig.08**).

STEP 6

As the painting developed, I continued with the same approach: squinting my eyes and mixing color to match the value and temperature that I desired for the piece. Now I did

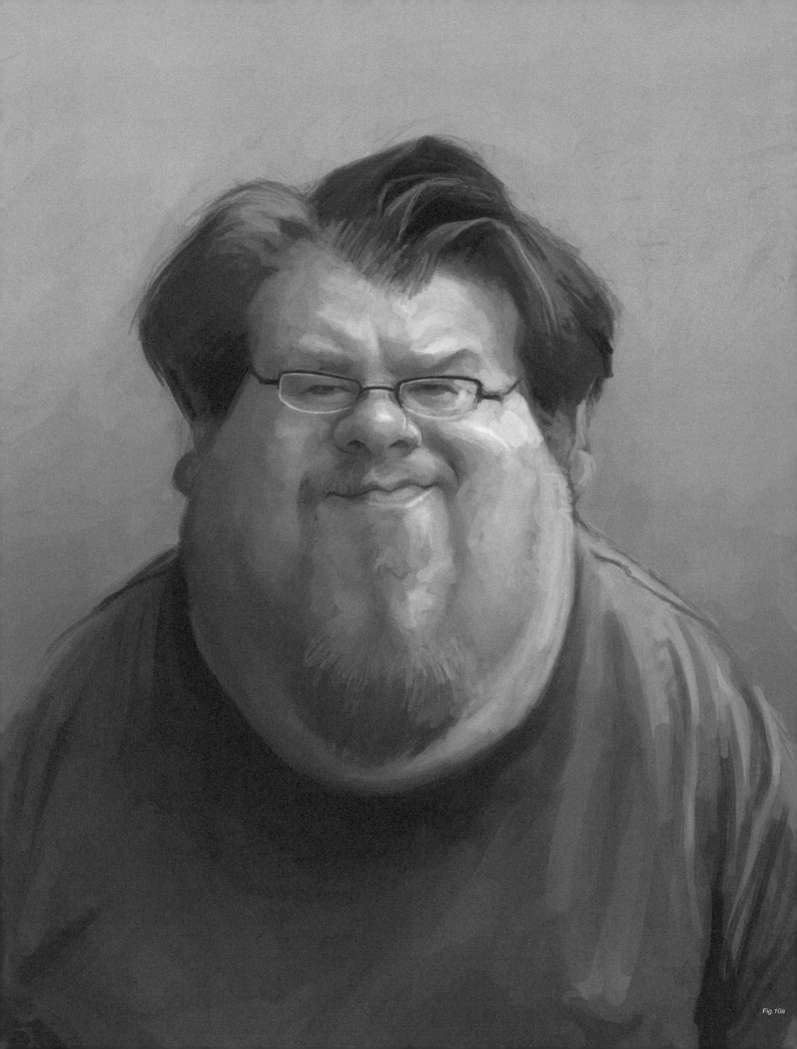

zoom in a bit and began to render in details, such as the eyes, nose and mouth. I was still using a round brush at this stage, but a much smaller brush so that I could get into the details. I continued to move around the painting, blocking in the entire piece all at once, so as to get a better feel for the painting as a whole (**Fig.09**).

Fig.10b

STEP 7
Using a round brush, I now started refining details in areas such as the mouth, eyes, nose, ears, hair and shirt. I added a bit more to the background, increasing the size for a better composition.

You can start to see a softer transition on edges between values at this point. I removed the palette because I now had enough colors in my painting to work with. If I needed to change the value or saturation of a color that I already had, I simply clicked on the color picker and mixed or adjusted my color there (**Fig.10a – b**).

> ❝ I SQUINTED MY EYES FOR VALUE AND OPENED THEM TO SEE THE COLOR ❞

STEP 8
Not much changed from Step 7 to Step 8. You can see that I added hair-like strokes to his hair as well as his beard. For hair I like to use a Soft Round brush. I clicked on Shape Dynamics so that I had a tapered point to work with, began to use my favorite Photoshop brush, #24, and followed the brush settings mentioned in Step 2. Brush #24's marks and strokes feel more like a natural

Fig.11

paint brush and I used it as such. This is also the brush I used to finish the painting, with the exception of a soft round that I used for hairs (**Fig.11**).

STEP 9
With brush #24 I continued to soften edges, adjust values and introduce additional lighter values (**Fig.12**).

STEP 10
The shirt was coming along at this point, although it was my intention to leave it a bit loose and sketchy (**Fig.13**). I continued to develop the different shapes I'd created, freely zooming in and out. I zoomed in for the details and panned back to have a look from a distance as it is important to often step back from a painting. With this painting it was not my intention to copy the color shown in the photograph, but instead to focus on values and color temperature. I squinted my eyes for value and opened them to see the color.

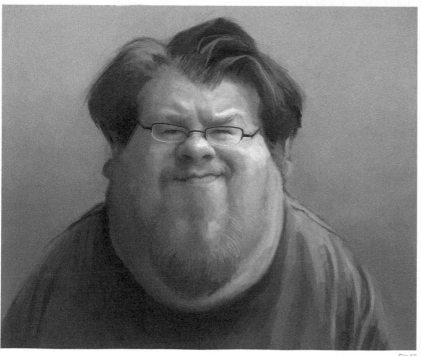

Fig.12

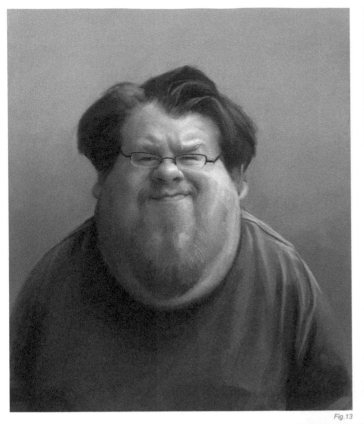

Fig.13

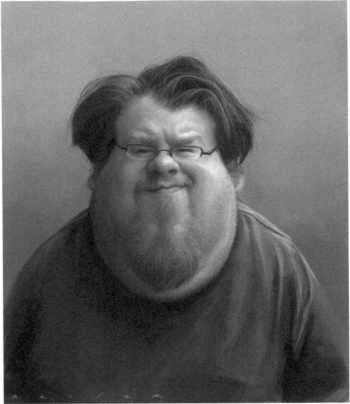

Fig.14a

STEP 11

The painting was all but finished in Step 10, with the exception of the hair. First of all I created a new layer for hair, as this way I was able to erase hairs that didn't feel right without ruining the rest of the painting.

> ## KEEP IT SIMPLE; STUDY WHAT HAIR DOES AND THEN MAKE IT MORE INTERESTING

Fig.14b

Fig.14c

Fig.14d

Fig.14e

For the hair, I painted the large mass of value and shape that I'd seen while squinting my eyes. I blocked in the basic form or design of the hair a little bit darker than it needed to be. This way, when I painted smaller hairs on top, in a lighter value, it created the illusion of depth. To add to this illusion, I also changed the size of my brush to make the widths of the hairs different, using a Soft Round brush with a tapered point to paint smaller hairs. When painting hairs it's important to keep it simple; study what hair does and then make it more interesting (**Fig.14a – e**).

Well, that's it. Remember to have fun. Sketch, draw and paint from life as much as you can. Keep it simple. If you look at the design of my portrait you can see that my shapes and forms are basic and simple. When I combine strong values and color with my basic design, the final result appears more complicated than it really is.

© JASON SEILER

Ace of Spades
By Gábor Kis-Juhász

Job Title: Character Modeler – Digic Pictures
Software Used: Maya, ZBrush, Photoshop

Introduction

I never have a clear vision in my mind when I start something. Usually I'm just doodling around in ZBrush, starting with a very simple base mesh that I've created (**Fig.01**).

After laying down some basic shapes that I like, images start to pop up in my head concerning how he/she will look. This is how this angry, old mercenary – who happened to be a fan of heavy metal – was born (**Fig.02**).

I really wanted him to have slightly stylized proportions (long thin arms, big head/hands), and to look like someone who is stuck in the 1980s. At this point I started to search for some references relating to members of old heavy metal/rock bands, and I gathered tons of pictures for his equipment. Then I decided that the image should work as game art because it's the love of my life and it's easier to handle in my free time.

> ## THE MOST IMPORTANT THING WHEN SCULPTING IS TO CONTINUOUSLY CHECK YOUR WORK FROM EVERY POSSIBLE ANGLE

Modeling & Sculpting

I usually do my sculpting in ZBrush, using about five or six brushes most of the time. The first one is, of course, the Move brush, which I use in combination with the

Fig.04

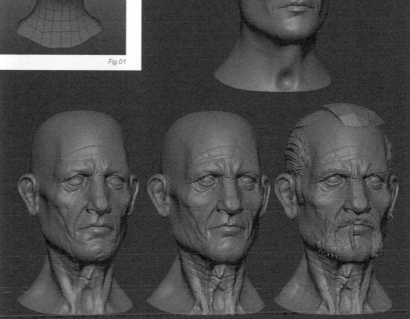

Fig.01

Fig.02

| STANDARD | SLASH 1 | MALLETFAST |

Fig.03

excellent Clay brush to get the basic proportions right. For the secondary forms I have altered the Standard brush with the mouse avg cranked up to its maximum, and with an alpha map using a large falloff (there is a built-in alpha for this in ZBrush 3.5 under ZAlphas > Falloff_Sharp-Alp.psd). This way you can create nice, crisp lines with just one stroke. For wrinkles I tend to use the Slash1 brush with a lower intensity, and for the surface noise I use the Mallet fast brush in spray mode. Sometimes I do a really subtle noise pass at the beginning of the sculpting process, because I can read the forms easier this way (**Fig.03**).

The most important thing when sculpting is to continuously check your work from every possible angle. This is especially important in digital sculpting because you will never get the correct sense of mass when viewing a monitor.

Fig.05

Fig.06

After the head was pretty much nailed down, I started to work on the torso and the arms. I have some base-meshes from way back, which I use for all of my humanoid characters. Although I knew that 90% of the torso would not be visible in the final piece, I spent a fair amount of time on it so I could model the tactical vest correctly over the top (**Fig.04**).

At this point I started to look for dozens of reference images, browsing online military shops for the weapons and the gear. It's a good idea to always try and find images where you can see the actual scale of the thing you would like to replicate (a man standing beside it or holding it).

When I was ready, I used ZBrush's Decimation Master, and optimized the sculpt to a reasonable polycount that

Maya could handle without viewport tearing (around 200-300k polygons depending on your system). Then I started to model the equipment. I used pretty standard techniques such as poly-by-poly and box modeling (**Fig.05**).

It's really important to keep an eye on the polygon count. I usually break the model into a lot of Subtools so I can divide each individual piece up into 2-4 million polygons. I don't like to go any higher because I like to see and work on the whole model at the end without slowdown or memory crashes.

Another very important thing is to decide how you want to bake the normals onto the low-poly mesh to avoid baking errors. For instance, I baked the pockets separately so that I could optimize their management later. After the equipment was done I imported it into ZBrush and start sculpting again. Usually I divide my meshes twice before exporting to ZBrush, because Maya and ZBrush smooth differently. When I felt it was ready (**Fig.06**), I used Decimation Master again, exported the whole thing to Maya and started to retopologize it using the amazing NEX plugin by digitalRaster. It works like Maya's Make Live function, but it keeps all the vertices on the desired surface regardless of the selection mode. Although I'm pretty familiar with the majority of resurface programs out there, it's a real comfort to do the retopology in the same environment as the modeling. For a nice, clean result, you should avoid angles any bigger than sixty degrees and, of course, hard edges. I use the Bevel tool when necessary and sometimes I tend to "unsnap" some vertices in the high-poly model and move then manually to get clean, soft normals through the entire low-poly mesh (**Fig.07**).

The UV mapping wasn't a big issue thanks to Roadkill – a really intuitive and fast piece of software that proves a real time saver.

BAKING & TEXTURING
Once I had the low-poly meshes UV-ready, I exported them to XNormal along with the high-poly meshes and baked them one-by-one. For the Ambient Occlusion map, I put a large plane under the high resolution mesh; this way the result looked more shaded and it served as a good starting point for the diffuse texture.

Fig.07

CHARACTERS

To get a general idea about what was going to be where in the diffuse map, I used XNormal's Photoshop filter: Normals2Cavity. With the cavity and Ambient Occlusion maps I had a really solid foundation for texturing.

The first thing I did was to block out the basic materials in the PSD file using layer groups and masks. I like to keep my layers organized so I can make changes easily without spending too much time searching for the right layer (**Fig.08**).

I avoided using too many photos other than for some details and overlay effects in Photoshop. When I'd found the perfect photo in an online texture library, I applied the High Pass filter with a one pixel radius to get rid of the color information but keep the subtle details. I tried to work on the Diffuse and Specular maps simultaneously to get a sense of the material as quickly as possible.

Fig.08

CONCLUSION

As an artist I'm never really satisfied with the end result, but being featured in this book tells me that I'm on the right track. Looking back now, I only see the mistakes and I'm eager to correct them in my next piece. I hope you will find this overview useful and, if you have any questions, feel free to drop me an email.

ARTIST PORTFOLIO

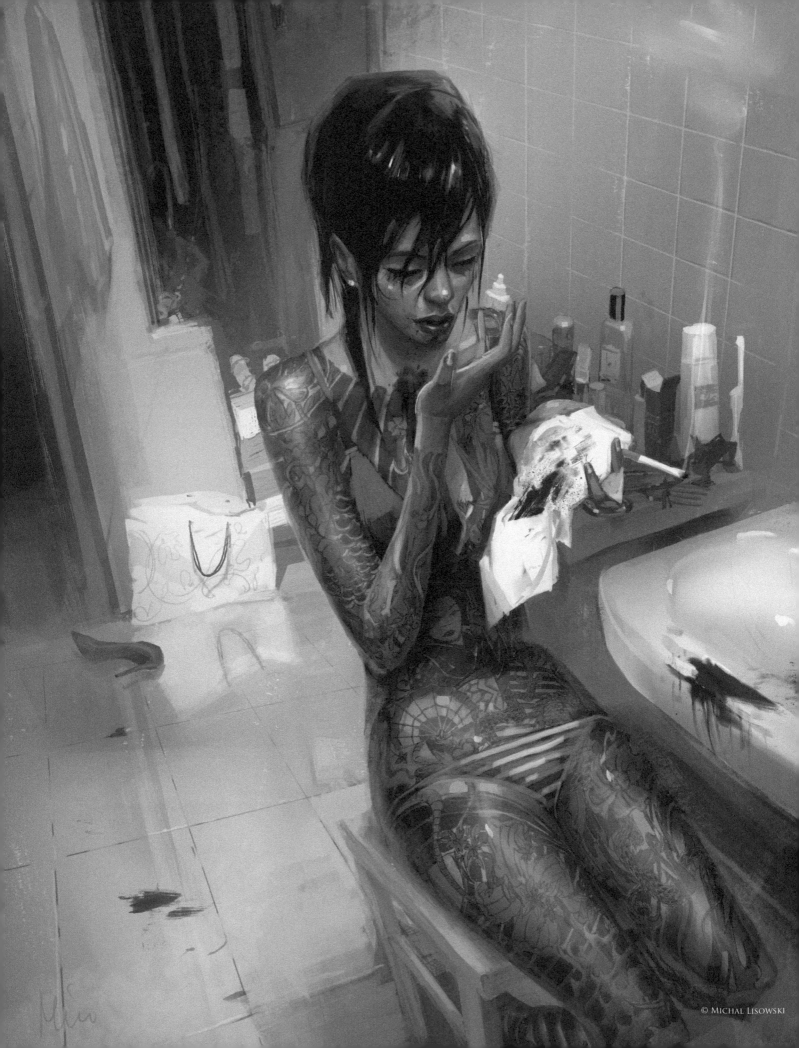

© Michal Lisowski

YAKUZA GIRL
BY MICHAL LISOWSKI

JOB TITLE: Concept Artist / Illustrator
SOFTWARE USED: Photoshop

INTRODUCTION

Interesting stories make me want to paint. In searching for a source of inspiration I surfed the internet, not necessarily looking for strictly digital-painting websites. I hit on an idea for this piece after reading some articles about the Japanese mafia. Whilst exploring this theme I found a note about Shoko Tendo, which directly inspired me to create something about a woman under pressure within the mafia organization.

My main goal was to convey a dramatic scene and create something that forcefully tells the story and evokes emotion. I didn't focus on rendering a fully realistic scene but instead tried to concentrate on showing a dramatic situation, creating a good balance between the narrative and the technical aspects. In this article I'll try to show you all of the steps behind the creation of *Yakuza Girl*, from the original concept through to the final picture, although my working process might be difficult to explain as my workflow has been messy for many years now!

SKETCH

I began the work directly after settling on the main theme and took a pencil and drew some basic sketches

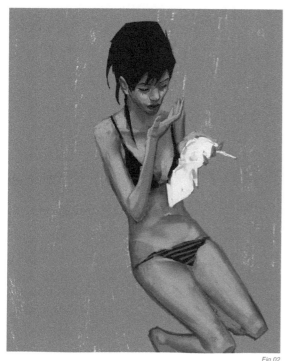

Fig.02

Fig.01

> ## MY MAIN GOAL WAS TO CONVEY A DRAMATIC SCENE AND CREATE SOMETHING THAT FORCEFULLY TELLS THE STORY AND EVOKES EMOTION

(**Fig.01**). I used some anatomy references from my library to build the body of a girl, searching for the right pose and composition. After that I took a break to get a broader view of my work and consider how I should present my idea clearly so that each viewer would understand the narrative.

PAINTING

The next stage involved scanning in selected drawings, correcting, mixing and finally starting to paint in Photoshop (**Fig.02**).

I started with a near monochrome scale, which later I intended to expand because at that stage color was not the determining factor with respect to the mood I was looking for. I would ask that you pay attention to the color palette of all of my work in progress, as at each stage I was looking for the best color combination.

I began tattooing the main character with popular Japanese motifs, typified by members of the Yakuza. This detailing was very time consuming, with the tattoos fully painted with a Round brush on a separate layer. I spent some time finding the right colors for the outline of the tattoos; it was quite black but needed some color manipulation to appear realistic (**Fig.03**).

The next step was to create an interior. I decided that the background needed to tell us something more about the girl, but I remembered that it was only a background. I wanted to focus on her and not the surrounding area. Whilst drawing the environment I wanted to convey a style akin to speed painting. I prepared some texture brushes, which helped to create a rough background. Some swift strokes here and there and it was done – my character was sitting on a chair in a bathroom (**Fig.04**).

After I had worked out the background I returned to the tattoos: spectacular body paint sparkling with color. With some extra details I arrived at the final color, which was added on a different layer to the outlines (**Fig.05**).

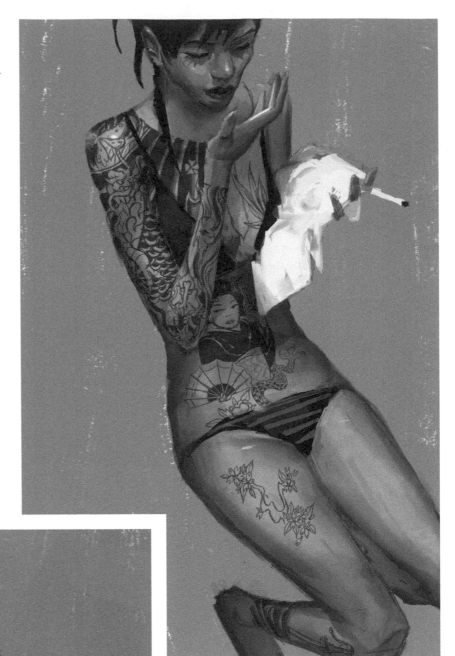

Fig.03

The work on the main content of the picture was done, and so I could start to paint in the light and enrich the color palette. Adding things such as the cosmetics on the shelf and other elements helped to enhance the narrative and create more interest. Other examples include the tiles on the wall and floor, blood spots on the sink and the paper in the girl's hand.

BUILDING LIGHT & DEPTH

I then had to build depth into the scene using the properties of light. Using a large Round brush with soft edges and a low opacity, I cut out the shape of the girl from the background. I placed this on a new layer directly behind the character. In addition to this I managed to achieve an interesting glow to the interior.

Fig.04

CHARACTERS

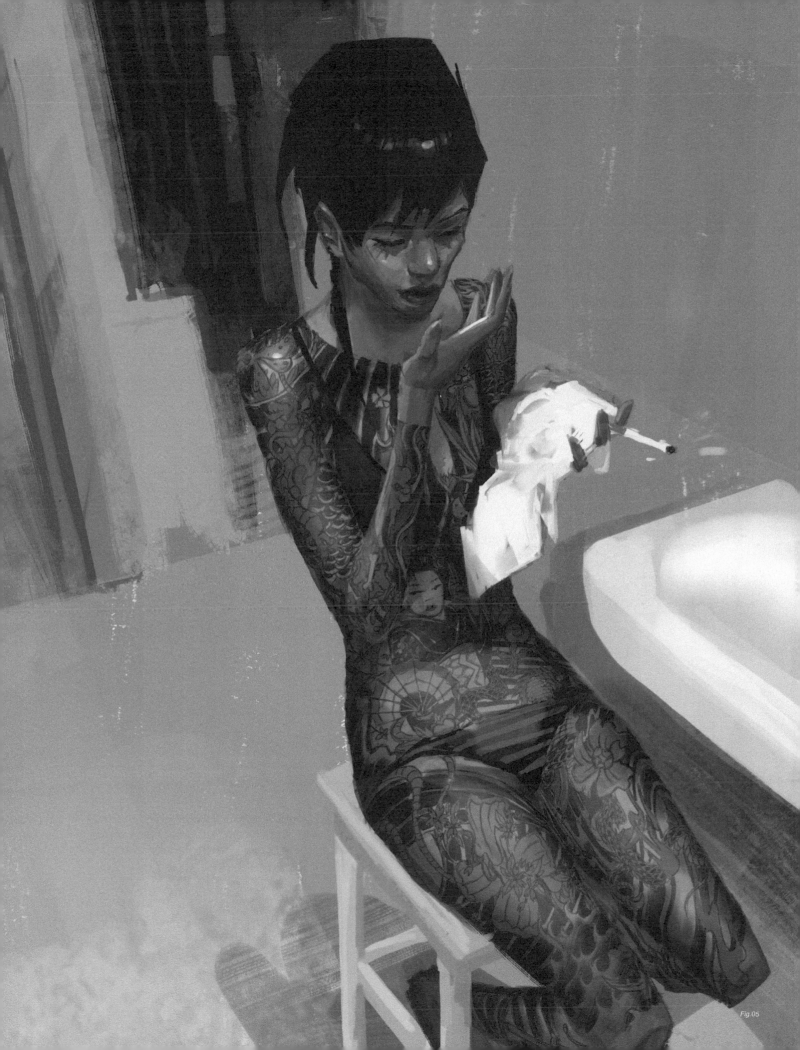

Fig.05

To create a reflection on the floor, I merged all of the layers defining the background, duplicated it and then transformed it. To alter the perspective I used the Distort tool to achieve correctly aligned reflections (**Fig.06**). I then masked this reflection layer with the Gradient tool from the bottom up to gradually diminish the strength of the reflections. The next step was to set the layer opacity to 50% and change the blending mode to Overlay.

DETAILS & CORRECTIONS

Finally I added some details such as the blue shoe and the towel to create a balance between all the areas of the composition. Furthermore, I fixed the chair to make the perspective more accurate. I also decided to wash the girl's hair as I decided it would add to the drama and increase the impact (**Fig.07**).

At this point most of the painting was complete. This was the time to add any last touches across the entire canvas, but without detracting from the picture's dynamism. Many parts of this piece still looked sketchy, but I felt this was appropriate. I took a break from my work and showed it to my friends. I wanted to hear their feedback and to know what they felt when they were looking at it. Other people often see things in a completely different way.

Fig.06

The last step consisted of making corrections and researching the best color scheme.

CONCLUSION

Whilst working on this piece my main goal was to create a palpable atmosphere and tell the story through digital brushes, as opposed to rendering it in the most accomplished way possible. The drawing was not too detailed as I thought this could have killed the piece. I did, however, obtain some new and helpful tricks and techniques along the way.

Recently for me, what I paint has become as important – if not more important – than how I paint. Your skill is only a tool, so improve your skills and push yourself forward, but don't forget to look around you, as inspiration is everywhere.

Fig.07

CHARACTERS

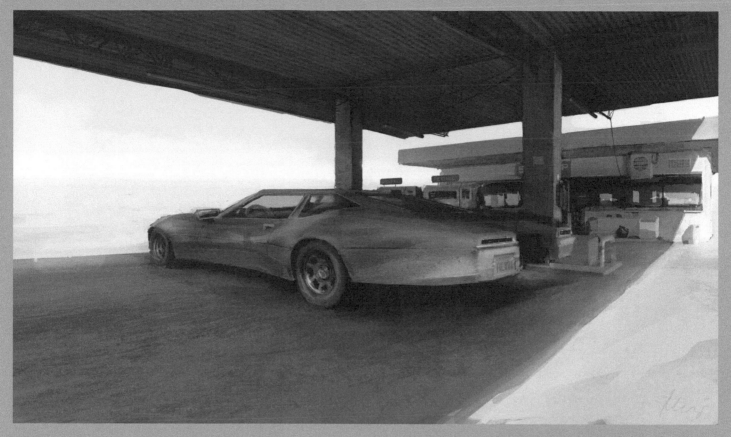

FOG (REDUX)
By Loïc e338 Zimmermann
JOB TITLE: Concept Artist / Lead Character - Luma pictures
SOFTWARE USED: Photoshop, Painter

INTRODUCTION
The first version I made of this illustration was a simple personal take on a good old photo I found during one of my crazy Google searches for inspiration. I ended up on a family ancestry webpage from some German immigrants who went to Russia in the late 18th century. I cannot take credit for the design of the damn jacket; it was all already there... What I did do was to replace the woman, add a little touch of glam and sensuality, and bring the colors in. And finally, I wanted to add an element into the image that would shift it into our time, or at least something closer to us than the 18th century – and I was done. *Fog* was born for the first time (**Fig.01**).

> ## I WANTED TO BALANCE THE MANY ELEMENTS IN THIS IMAGE BY SIMPLIFYING THE TONE

A few months later I was contacted by *Imagine FX* to write an article about gothic illustration and they wanted

Fig.01

Fig.02

Fog on the cover; to be more precise, they wanted a cropped version of Fog, which definitely made sense. Anyway, it freaked me out because I knew the resolution wasn't enough to extract a full size torso and face and it would also make her face (which I didn't like that much) the central focus. Something had to be done!

A few more months passed; I reorganized the rubbish on my hard drive and I found these two versions and suddenly wanted to combine the best of each into a new vision and finish this story once and for all. And here are the things I had to think about...

Fig.03

COLORS

The first version was mostly green and orange with a very pale skin, whilst the latest version is almost monochromatic in a sense, with a strong dominance of warm colors. I wanted to balance the many elements in this image by simplifying the tone. The initial color shift was a necessity for the *Imagine FX* cover. It had to be punchier and the jacket needed to be purple. The final version is a little less saturated, with the jacket and background fairly close this time. The jacket is not the subject of this illustration although it's a very strong and rich element. I wanted the skin to emerge from the surrounding area, which is why it's also the brightest element in the picture (**Fig.02**).

CROP

The *Imagine FX* version was a real close up on the chest/ face area. The original one almost showed the entire

Fig.04

Fig.05

character, although a large proportion of the bottom of the image was in darkness. For the final version I wanted something between the two, including the table since it had to be back in the frame for the sake of the subject (**Fig.03**).

I think the composition is way better with a stronger diagonal, which always brings a little bit of groove into a composition and drives us to the origins of the image title. You can see that the upper right side is bright and the lower left dark, both of which help create a dynamic in the composition (**Fig.04**).

A Story about Love and a Hat

I really wanted to put some more work into the ornament she had on her head, but in the meantime I wanted it to be almost abstract, not fully rendered and very graphical. I knew the jacket was a strong element and the image needed something a little lighter to balance this. And so a cloud of lace crashed onto her head.

To make this happen I used some broad strokes using a rake brush, then overlaid some lace texture. Finally I defined some of them more clearly to make it easier to read and added this bright curve at the center to make it "pop" a little (**Fig.05**).

Doll's Face

The two versions have this one thing in common: a certain sadness in the face. I had to keep that for the cover version, although in the final one she definitely looks less sad. The mouth is slightly open and the lips are very sensual, but she's looking at us as though

Fig.06

Fig.08

she doesn't really care about our presence. She's not trying to seduce us, but still... well, that is what I intended her to say. Do you feel like that or not? I'm not sure at all (**Fig.06**)!

The Necklace

The necklace was done in the same way as the hat, starting from abstract texture overlays. From this chaos I then extracted some shapes; spirals and stuff are not very original, but they do mimic the ones on the tiny table at the bottom of the image. Let's face it; it's an easy move (**Fig.07**).

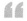

> # I didn't want to display it as a dominant element, but in the meantime the composition was leading to it

The Bong and the Piercing

I'm sure she's hiding some tattoos and must listen to some weird music too! The purpose of the bong is simply to say that the image is still current. Now, I do recognize the controversial nature of such a statement; bongs have existed for centuries, but let's pretend it's from the 1960s! And what about the piercing? Well, the same thing actually. Wow, my whole theory has been ruined as I tried to make my point clear...

However, it still works! No portrait from this period (the 18th century) would display a chick like this, her jacket open and exposed, with a bellybutton piercing and a bong nearby. No way! I still think she remains classy and, believe it or not, some people completely overlooked the bong and didn't realize it was there for some time, which I find pretty amusing and satisfying. I didn't want to display it as a dominant element, but in the meantime the composition was leading to it. I suddenly realized that some people would be simply drawn into a loop (eyes, mouth, boob, mouth, boob...).

I rendered the bong in the same manner as the vase behind, which contributes to the confusion (**Fig.08**).

WALLPAPER!

The very simple background evokes a wall with the fragment of a column on the left. I wanted to add a little extra interest by using a gothic wallpaper pattern derived from a bison's skull (**Fig.09**), and consequently anchor my character firmly in the present through this final touch (hopefully). It also adds a nice rhythm to the image, something that I'm increasingly using in a more radical way, simply for the sake of it. When you juxtapose big shapes with lots of tiny ones, something just happens (**Fig.10**).

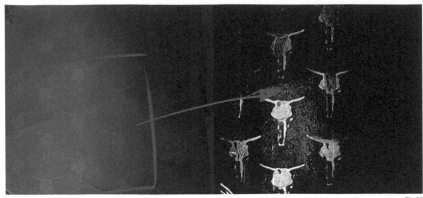
Fig.09

> " YOU WANT TO DRIVE THE AUDIENCE INTO YOUR IMAGE, CREATING SOME SORT OF PATH, BUT IN THE MEANTIME YOU DON'T WANT TO CONSTRAIN PEOPLE "

CONCLUSION

In my work I try to be restrained regarding the accessories and everything else, as I like my characters to remain simple. On the other hand, working on this image involved a lot of elements that needed to be balanced. It's about the way you deal with these

elements; how you treat each of them and consider which are really important. You want to drive the audience into your image, creating some sort of path, but in the meantime you don't want to constrain people. Having a succession of interesting elements for the eye to travel through is better than having it constrained to a single focal point. The good old rules always work even when you want to have some freedom, so learn them first before having a play with them.

In this image, or at least its final version, one of my biggest challenges was the monochromatic aspect I wanted so much. Would it be easy to read? Could something be both sober and saturated?

I guess it's OK. What I'm actually proud of is how I was finally able to come back to some older work I felt I wasn't done with yet and improve it, whereas in the past I'd have just turned the page. I've been doing this for a while now and feel capable of leaving an image alone for a (long) period when I'm stuck before coming back and finishing it. It's a very good thing to be able to do, since you have a fresh eye and no real worries about destroying what you've done before. Time does that for you.

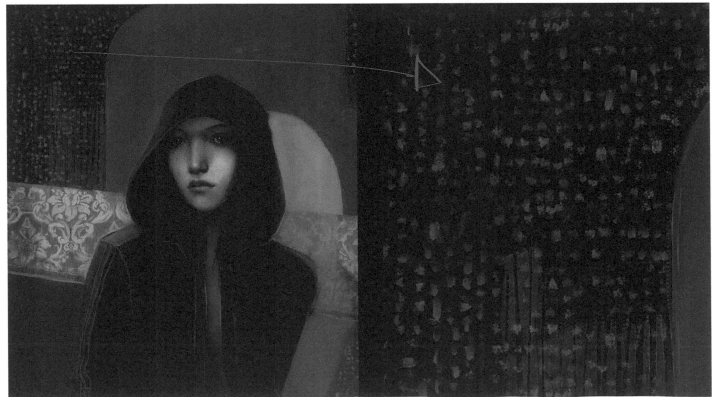
Fig.10

CHARACTERS

© Pascal Ackermann

FLOWER OF SOUNDS
BY PASCAL ACKERMANN

JOB TITLE: Lead Artist 3D - ACTIPLAY

SOFTWARE USED: 3ds Max, ZBrush, After Effects, Photoshop

INTRODUCTION

I'd just finished creating a series of Wolverine images and so for this illustration I wanted to make a sweet girl instead. I had seen a magnificent piece of concept art by a fantastic artist, Stanley Lau, named *Pepper Robot II*. After seeing his work I wanted to achieve something similar but with a pinup quality and a touch of R'n'B.

So I created my own concept art, but as usual the concept evolved during production. This is a definite bonus of doing a personal project – it allows for more flexibility (**Fig.01**).

MODELING

I have my own modeling process, which is a fast and efficient workflow between Max and ZBrush.

I started by making a fast low-poly model of the character, with neat UVs and respecting the constraints of ZBrush. I then exported this mesh into ZBrush and subdivided it, as I wanted to use Transpose to quickly pose the character (**Fig.02**). Finally I just exported the subdivided (level 2) ZBrush model into Max with a displacement map (level 2) and normal map for the high details (level 4 in this case) (**Fig.03**).

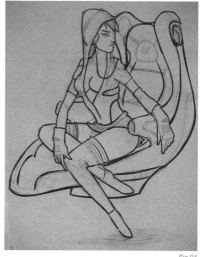
Fig.01

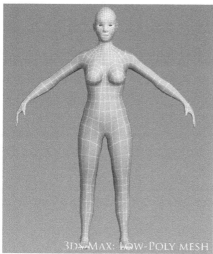
3DS MAX: LOW-POLY MESH
Fig.02

> ## THE MAIN ADVANTAGE OF THIS METHOD IS THAT YOU DO NOT NEED TO RETOPOLOGIZE THE MODEL FOR THE RENDER; IN FACT, YOU USE THE BASE MODEL THROUGHOUT THE PROCESS

The main advantage of this method is that you do not need to retopologize the model for the render; in fact, you use the base model throughout the process. The only thing left to do was relax the UVs to avoid the map stretching if the model was modified in ZBrush.

After the main character was placed into the scene, I created the accessories originating from the character mesh, such as the skirt and top. The spherical chair was very simple

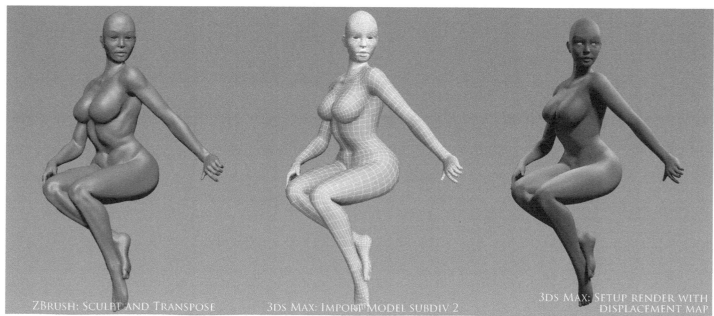
ZBRUSH: SCULPT AND TRANSPOSE 3DS MAX: IMPORT MODEL SUBDIV 2 3DS MAX: SETUP RENDER WITH DISPLACEMENT MAP
Fig.03

to create with the only difficult part being to match it to the character, although Transpose proved very helpful in this case (**Fig.04**).

SHADERS & TEXTURES

I spent a lot of time on the shader settings and so will try to provide some tips! **Fig.05** shows the relationships between the shaders.

The advantage of 3ds Max 2010 is the compositing input, which allows you to color correct your map and add layers in a fashion similar to After Effects. As a result, I used only one skin texture for the unscattered, epidermal and subdermal colors! The addition of layers is useful when adding fine details on either the skin color map or bump map. You can also add a texture with different mapping coordinates (box mapping with a tileable bump map) or a procedural map (for bump or color variations).

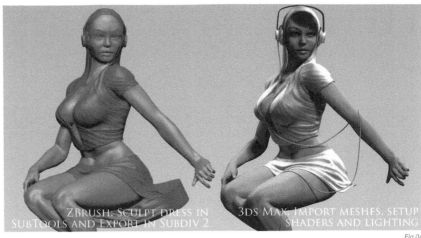

ZBRUSH: SCULPT DRESS IN SUBTOOLS AND EXPORT IN SUBDIV 2

3DS MAX: IMPORT MESHES, SETUP SHADERS AND LIGHTING

Fig.04

To texture the character, I used ZBrush and Polypaint for the first pass to roughly block in the color. The details were made later as separate layers in Photoshop. You can use the normal map (in high level) and XNormal filter to transform the normal map and then add this layer to see the model detail.

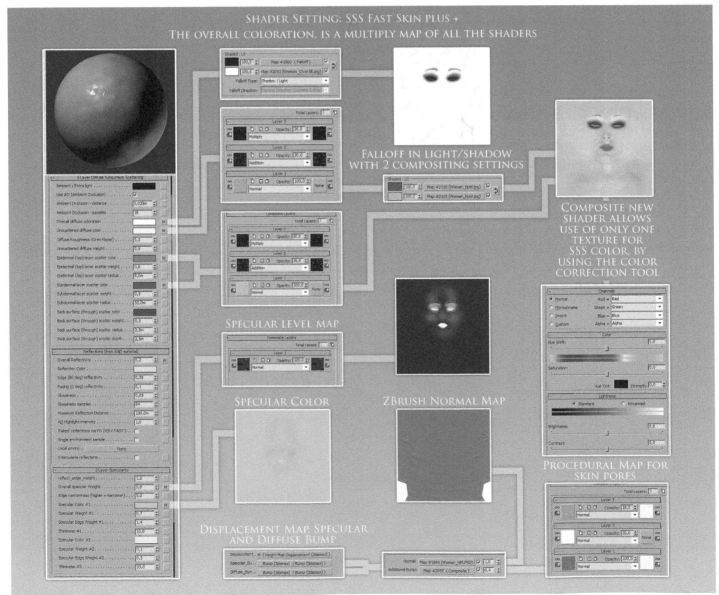

Fig.05

Tip: The layer must be in Color Burn blending mode (or other) and you must add an adjustment layer above it to desaturate the result.

HAIR & FUR

When the character was satisfactory, I created the hair system. I would recommend stopping working on the proportions and pose at this stage, as it will imply further changes to the overall model. I created a mesh for the hair and eyebrows, which were not renderable. Usually, I render parts of the scene separately because of the time it takes to render the shadows cast by the hair. In this case, the low amount of hair permitted me to render everything at the same time.

LIGHTING & RENDERING

The lighting was simple; a Key and Fill light, two backlights for the rim effect along with a MR Omni Light set to cast ray traced shadows. I

> " CREATING THIS IMAGE RESULTED
> IN A LOT OF STRESS AND FUN,
> AND THERE WERE A LOT OF
> CHANGES BETWEEN THE CONCEPT
> AND THE FINAL RESULT, WITH THE
> CHARACTER EVOLVING DURING
> THE PRODUCTION "

placed a red light behind the character to add some contrast to the scene and a Skylight to help blend the black shadows with the red tint.

POST-PRODUCTION

At this stage I used After Effects because you can update a layer easily; keep important information such as color correction, position etc.; and also see a quicker result. The process used a few render passes, including a beauty render, hair and fur, and a ZDepth pass used to simulate the depth of field.

CONCLUSION

As is my usual practice, creating this image resulted in a lot of stress and fun, and there were a lot of changes between the concept and the final result, with the character evolving during the production.

I believe that simplicity is a good path to elegance in 3D! In the beginning the character was very close to the original concept art, but sometimes 2D concepts do not translate perfectly into 3D and so I moved away from the original concept to create my final design.

In the end the mix between old-school (pinup style and pose) and a more modern style proved very inspirational; something that always helps you to finish a project!

ARTIST PORTFOLIO

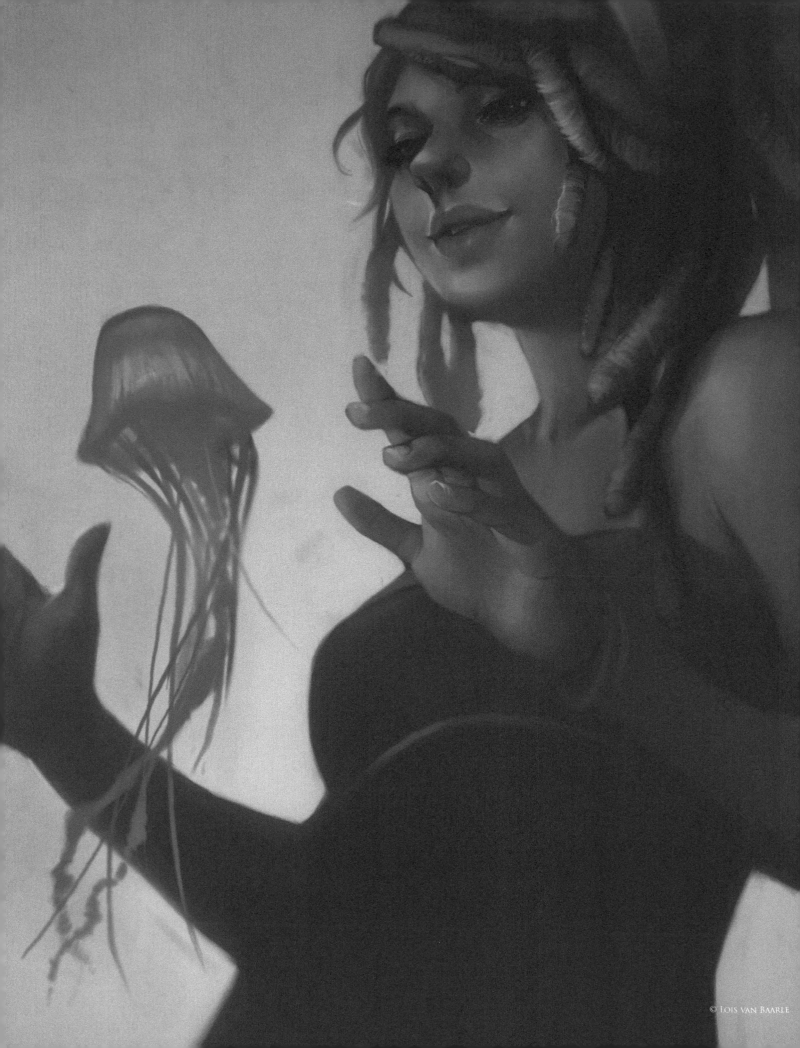

Evening Glow
By Lois van Baarle

Job Title: Animator / Illustrator

Software Used: Photoshop

Introduction

I've been drawing characters with digital media for years, ever since I began messing around with the Smudge tool in Photoshop Elements when I was 14. I started out very cartoony but developed a fondness for digital painting a few years ago, realizing that this could give my characters much more depth and mass, making them more real and believable somehow. Around the time that I drew this image, I wanted to push myself a little further and create more of a realistic feel than I had done in my previous images by adding more detail (especially in the hands and face), and working with a more

> ❝ Composition, pose and other aspects are all subject to change throughout the drawing process, to suit the feeling I have in mind ❞

Fig.02

Fig.01

atmospheric light source – that of a sunset. I was inspired by occasions of experiencing sunsets on the beach during the summer and the serene, timeless feeling this evoked.

Process

My work always starts very rough because I never have a specific image in mind when I start drawing. I usually just have a certain atmosphere or feeling in my head that I want to get down. Composition, pose and other aspects are all subject to change throughout the drawing process, to suit the feeling I have in mind (**Fig.01**). Basically, the early phases of the drawing – the sketch, rough colors, and so on – are phases in which I just slap colors on the image and play around with different approaches until I like what I see and can go into more detail.

By this point (**Fig.02**), I was happy with the lighting (especially the glow coming from behind her head), the color scheme (deep blues and purples against a sunset sky), and the overall composition of the image. This is where I merged the sketch lines with the coloring layer for the character, and just started painting freely, letting go of the lines

drawn in the sketch and basically sculpting the forms with the colors I had chosen. I generally work with very few layers and for this image I used just three from this point on – one for the sky, one for the character, and one for the jellyfish. In the case of this drawing, I just used the Standard Round Photoshop brush, using a varying flow based on how soft or hard I wanted the brushstrokes to be.

Here (**Fig.03**) I was working quite roughly and trying to introduce more detail into the picture. This part of the process was particularly challenging for me. I had a hard time painting realistic features onto the face (**Fig.04**) without losing the perspective from the original sketch. Many aspects of the drawing gradually changed during this phase, especially the composition. Although I lost some of the feeling in the original sketch, I intuitively moved towards a new composition in which more space was created in the centre of the image for the jellyfish and the expression of the character changed.

At this point (**Fig.05**), I had to stop myself from focusing on the details too much. I made some changes to the background (a simpler gradient), reduced the number of jellyfish to just one and added a soft texture to the character. This not only helped to give the image a more organic feel, but also had an effect on the colors, which become deeper and more reddish as a result. By making these changes, I had a better notion of how the final image was going look, allowing me to get a good idea of what needed to change before the image was complete.

One thing I was not happy with at this point was the hand. Using my own hand as a reference, I started painting a more realistic hand that stood out a little more, creating more depth and catching some of the orange light (**Fig.06**). As with the face, it was hard for me to

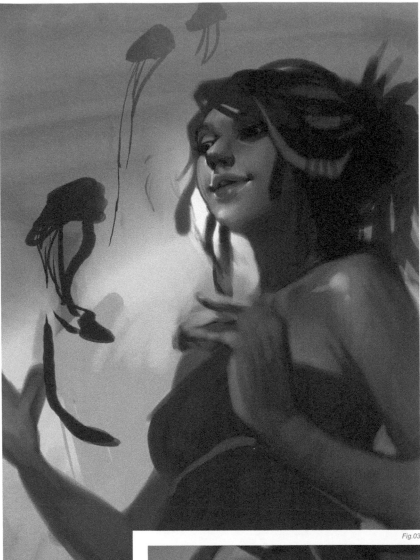
Fig.03

Fig.04

approach the hand realistically without having it seem out of place compared to the rest of the drawing. Making it work was a question of keeping at it and stopping every now and then to zoom out and check for consistency over the whole image. This part of the drawing process was the part in which I pushed myself further than I usually would have in terms of detail (**Fig.07**). However, some parts of the drawing, such as the body and the background, were left quite simple in order to make the detail on other parts stand out more.

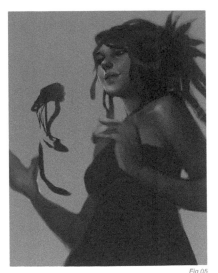
Fig.05

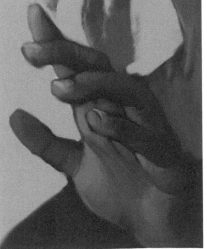
Fig.06

CHARACTERS

Fig.07

Fig.08

By this point (**Fig.08**), I was adding the finishing touches and moving towards the final image. This involved painting the final details (the jellyfish, bracelets, etc.) and shifting the composition around a bit. The image needed to start coming together and forming a finished whole.

By the final phase, I'd added a texture onto the background, edited the colors a little bit using the Color Balance tool, and added a subtle backlight effect. Finally I stopped working on the picture and just called it finished, mostly because I was satisfied with it, but also because I had to force myself to just let it go and move on!

CONCLUSION

In the end, the drawing didn't turn out exactly how I had planned it (I wanted something with more movement and life), but I was nevertheless happy with the result. I just let it evolve naturally, focusing mainly on achieving the right atmosphere and letting the rest follow, and this worked out pretty well in the end. Although adding more detail and using references was partially an experiment, I realized that this can give an image a lot of added value. I definitely see this image as a big step forward in the evolution of my digital painting skills.

ARTIST PORTFOLIO

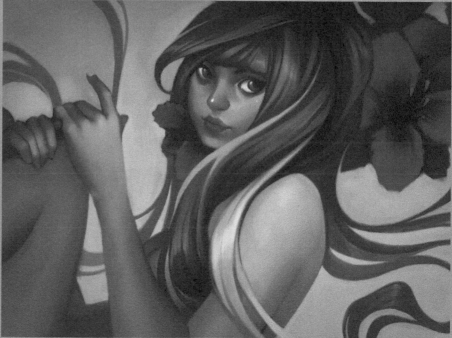

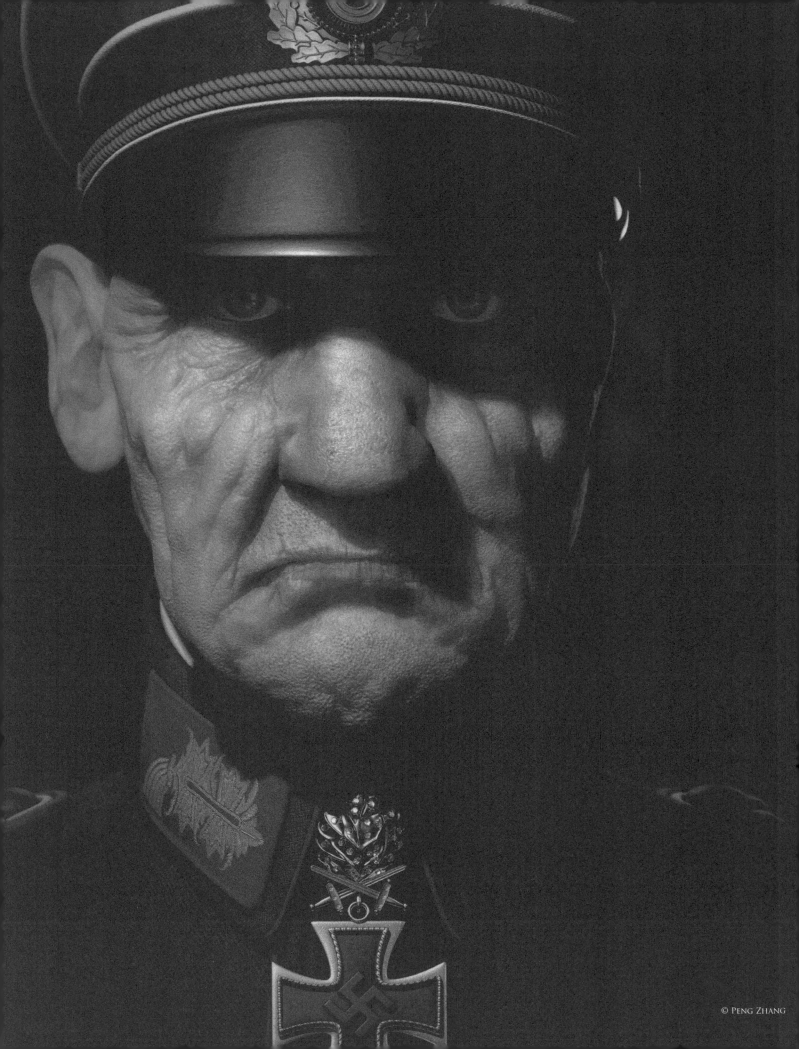

CROSS OF IRON
BY ERIC ZHANG

JOB TITLE: Texture Artist - MPC Vancouver
SOFTWARE USED: Maya, ZBrush, Photoshop

INTRODUCTION

I am a big fan of military topics. Since I had already done a soldier, this time I wanted to try a World War II German general.

REFERENCE

Because this character was based on a real world look and feel, I didn't draw any concepts for it. Therefore, I needed a ton of references instead. I found an old man reference from http://www.3d.sk that I decided to use for my character; the reason was simply that it was a perfect reference to practice my ZBrush sculpting skills with and would also fit my character pretty well (**Fig.01**).

> ❝ MODELING IS ONLY THE FIRST STEP OF THE PRODUCTION PROCESS; THERE IS A LOT OF WORK AFTER THAT, SUCH AS UNWRAPPING, RIGGING, ANIMATION, ETC. ❞

MODELING

I created a plane in ZBrush with the reference image as the texture. Then I started to model the head from a sphere. It's much easier to get the right proportion if you have an image plane (**Fig.02**).

After I'd roughly finished the sculpting, I exported a high-poly OBJ file to Maya and started to retopologize it. This is a very important step if you want your model to be

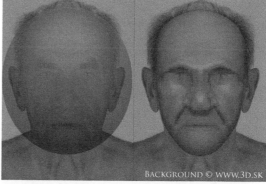

Fig.01

Fig.02

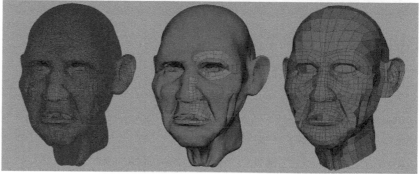

Fig.03

used for real production. Modeling is only the first step of the production process; there is a lot of work after that, such as unwrapping, rigging, animation, etc. If you can keep your wireframe clean and appropriate, it will make everyone's lives much easier. I used a Maya plugin called NEX, which is a very nice tool for retopology. Using this plugin will keep your polygons in quads and evenly spaced (**Fig.03**).

After completing the retopology, I exported another OBJ file and went back to ZBrush. With clean edge-loops, I was able to finalize work on the details. There's one thing to make a note of here: each area of the face has a particular skin texture so don't use the same texture everywhere (**Fig.04**).

Fig.04

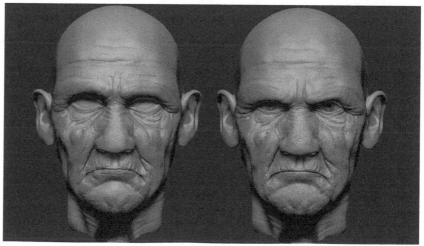

Fig.05

It was now time to give the general an expression. I wanted the general to have a cruel feeling, but his expression also needed to be natural, not artificial. This meant that making only some very subtle changes should be sufficient (**Fig.05**).

I don't have much to say about the uniform; I just carefully referred to my references and made sure that, after I put every single piece back together, he still looked and felt like a German general (**Fig.06**).

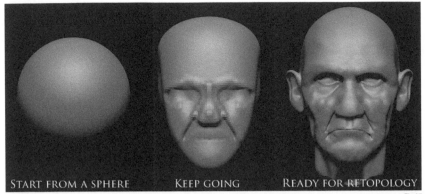

START FROM A SPHERE KEEP GOING READY FOR RETOPOLOGY

Fig.07

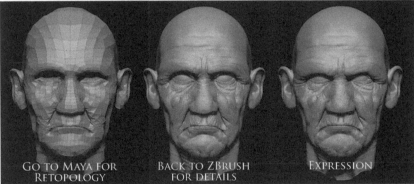

GO TO MAYA FOR RETOPOLOGY BACK TO ZBRUSH FOR DETAILS EXPRESSION

Fig.08

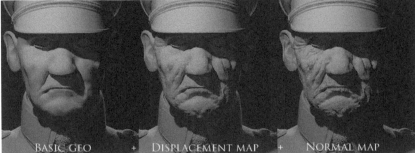

BASIC GEO + DISPLACEMENT MAP + NORMAL MAP

Fig.09

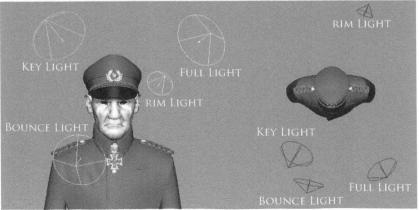

Fig.10

Fig.06

That brings me to the end of the modeling part, so I'm just going to summarize my workflow so far (**Fig.07 – 09**):

1. Start from a simple mesh
2. Deform this mesh to match the reference
3. After getting the correct proportion, retopologize the mesh to create a nice, clean wireframe
4. Sculpt every detail until you get the result you want
5. Create a facial expression.

Next I exported a low-poly OBJ, a displacement map and a normal map from ZBrush to Maya. With these three elements, I was able to exhibit a very highly detailed model with just low-poly geometry. The low-poly mesh provides a clean and simple wireframe that can be rigged and animated easily. The displacement map gives further detail to the low-poly version and the normal maps adds the final, super-fine detailed base (**Fig.09**).

LIGHTING

The light setting was fairly simple. I used four lights – a key light, a rim light and two bounce lights – which gave me the illumination I needed. I made the rim light a blue color to add some variation and make the lighting more interesting. The eyes shining under the shadow gave a creepy feeling (**Fig.10**).

TEXTURING

I used Zapplink to paint the color map – it's a free plugin for ZBrush and is a perfect tool for painting organic

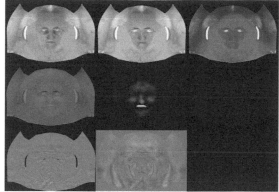

Fig.11

models. I painted all the other five maps based on this color map (**Fig.11**).

SHADING

I used MiSSS Fast Skin Shader with six maps for the skin, giving the epidermal a light blue color and the subdermal layer an orange tint. I put the real skin color on the overall color (**Fig.12**).

COMPOSITING

After rendering, I was at the final stage of the creation process. Compositing is a very important step towards achieving the final result and here I tried to give the image an aged, photographic feel, similar to the picture on an old TV (**Fig.13**).

CONCLUSION

I am very satisfied with this portrait and feel I achieved my original goal, which was to practice my ZBrush sculpting and Maya rendering skills. Compared with the previous portrait I made, this one demonstrates more realistic detail and a much better skin shader and render. I know it is not perfect and there are still a number of improvements that could be made, but I will keep challenging myself to achieve this objective.

Fig.12

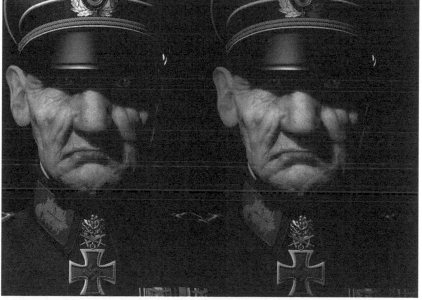

Fig.13

ARTIST PORTFOLIO

© PENG ZHANG

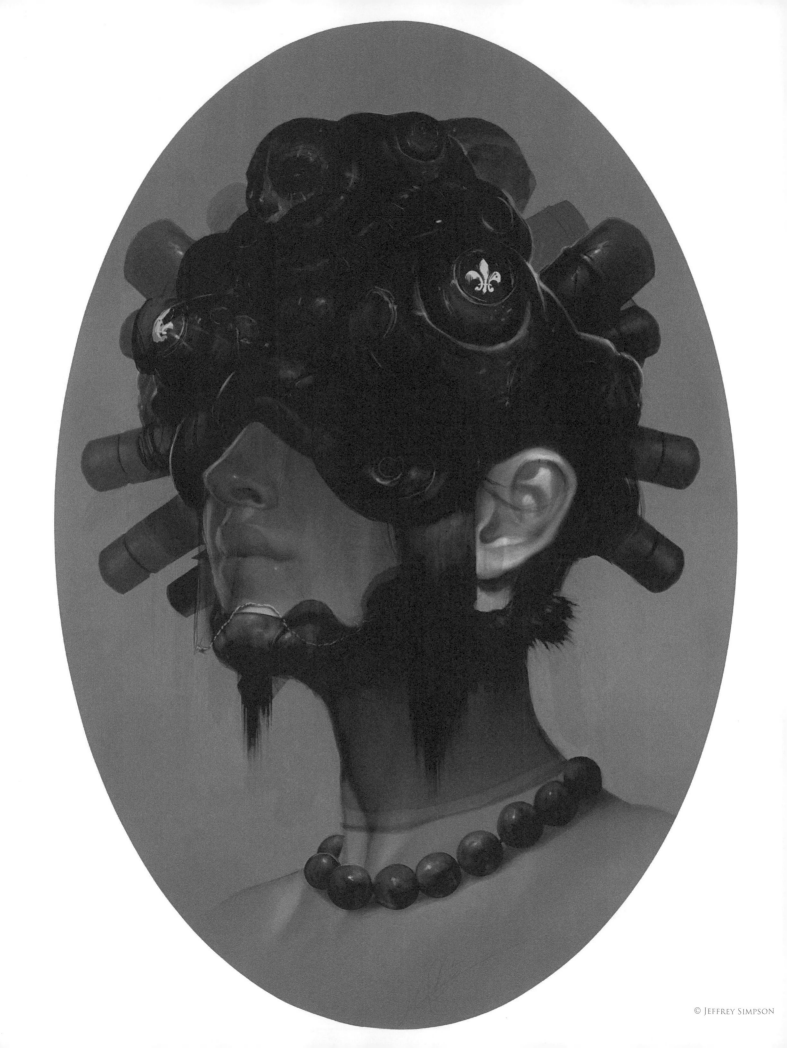

Mothma
By Jeffrey Simpson

Job Title: Concept Artist / Illustrator – Ubisoft
Software Used: Photoshop

Concept
This piece was originally done for a gallery show with the theme of "steampunk". Normally I try to avoid sci-fi/fantasy clichés or overly fantastical elements in my work in favor of a more serious and simplistic look. This is especially true when I am to put the work up on display. I want to make it look like it fits in a gallery and not in a game studio as a piece of concept art (although having it feel right in both is a bonus!). This made it difficult for me to conceptualize something relating to the theme, since I normally envision steam punk as being very fantastical and overly extravagant. It's not often that the initial idea I have for a piece ends up being crystallized in the final work, and this is no exception. I

> " I AM OBSESSED WITH RENDERING AND WILL OFTEN GO AHEAD AND START PAINTING BEFORE I HAVE FULLY PLANNED THE IMAGE "

Fig.01

was initially playing around with a lighter, less mechanical look. I had intended to give her feathers and fabric, as if she were some kind of dancer or entertainer (**Fig.01**).

Workflow
I am obsessed with rendering and will often go ahead and start painting before I have fully planned the image, maintaining a naïve assurance that it will all work out perfectly in the end. Since this piece was done mostly for fun and without a "client", there was no real pressure on me to get things right straight away. I rendered the girl's skin in a almost grayscale fashion, with the intention of adding color later or using color adjustments, gradients, overlays or more painting (**Fig.02**). Naturally, at this point I became stuck because I had not really planned specifically what I wanted to do with the hair/headdress.

Fig.02

I tried several goggle and helmet designs. I eventually came up with the idea of a helmet that looked like a snake's head, leaving only the bottom half of her face exposed through the snake's mouth. I'm not sure how well this idea turned out in the final image though! In retrospect I probably should have made it more obvious (perhaps through added teeth, more prominent eyes, etc.) (**Fig.03**).

In addition to making the helmet I was also trying to figure out what to do with her neck/torso. While I wanted to focus mainly on the head, I was worried it would look too simple and boring so I began designing clothing for her: strange punkish belts and leather chokers … Eventually I decided it was turning into too much of a piece about character design and less of an art piece that people would (theoretically) want to put on their wall in a frame.

> " NOT LOOKING AT A PIECE FOR A FEW DAYS CAN REALLY CHANGE YOUR PERSPECTIVE OF IT AND YOU SEE ALL THE FLAWS AND ALL THE STRENGTHS MUCH MORE CLEARLY "

After spending too much time deliberating on how to complete the image, I lost interest and started something new. This happens a lot; it is difficult for me to work on an image for a long period of time if I'm not required to.

Fig.03

Fig.04

The deadline for the show had passed and I eventually came back to the piece with the intention of finishing it. Not looking at a piece for a few days can really change your perspective on it and you see all the flaws and all the strengths much more clearly (mostly the flaws). I was unhappy with the composition and silhouette, although I can only blame myself since I had not given much time or thought to either! I eventually formed her helmet into a shape I was happy with, making the image feel more balanced and interesting, having a contrast between the dark metal and her porcelain face.

Having been able to look at it with fresh eyes, it did not take long for me to finish the work; I drew some inspiration from recent games like *Gears of War* to add to the helmet. For every piece I create there will always be at least one happy accident that will come along; in this case it was the veil. I was experimenting with tattoos on her face when one of them seemed to look like a veil, so I enhanced it and kept it in. It's things like this that make it difficult for me to stick strictly to every predetermined detail; the randomness of mistakes can help make a work go from good to great (**Fig.04**).

By this point I was less strict with myself on creating a work that looked "fine-art-ish" and was just having fun. As usual, if I am having fun with an image it will turn out more interesting and I think this piece is a good example of that. As I've said before there are still many things I would have done differently with it, which is the attitude I have towards all of my paintings. However, seeing flaws and imperfections in my works always makes me strive to create something better for the next piece.

FRANKENSTEIN'S MONSTER
BY ANTO JURICIC TONI

JOB TITLE: Character / Environment Designer – Primetime
SOFTWARE USED: Maya, ZBrush, Silo

INTRODUCTION
The saying, "A picture is worth a thousand words", was my primary guideline on this project, and I hope this image can say a few words. It was a big challenge for me at the time to overcome the technical challenges because this was one of my first Maya projects, but even more challenging than that was creating something that would "touch" the spectator.

I have always wanted to model Frankenstein's monster because he's a classic character with such a strong story, and so this was a great opportunity. Many great artists have created versions of this subject and produced

> ## WITH EACH AND EVERY PERSONAL PROJECT I TRY TO LEARN SOMETHING NEW RATHER THAN JUST USE THE SAME WORKFLOW OVER AGAIN

Fig.01

great work, which made my job that much more difficult. I thought that the best way to reach the spectator was through the facial expression, through his eyes, which would tell the story of a sad, lonely monster.

With that in mind, I planned out how to go about achieving my goal. The first job was to split the work into different tasks such as sculpting a base mesh, retopology, making a high definition sculpt with new clean topology, making clothes, posing, unwrapping, texturing, hair, lighting, rendering and finally compositing.

MODELING
With each and every personal project I try to learn something new rather than just use the same workflow over again. This time I decided to take a more artistic approach and use digital sculpting as much as possible. The quickest way for me was to make a simple ZSphere bust in ZBrush (**Fig.01**) and make a generic bust sculpt with a few features that would reflect my final model, such as a long head and the facial expression.

My next step was to retopologize my base mesh because clean topology and evenly distributed polygons always

Fig.02

Fig.02

Fig.04

pay off later in the process. For this task I used ZBrush's retopology tools and Silo for editing the new topology. With this new mesh complete it was time to create the proportions and the Move brush was a perfect choice for the task. After nearly an hour of tweaking and exploring different forms in ZBrush, I finally arrived at **Fig.02**.

Now came the fun part that I enjoy most – sculpting.

I have learned over time that the overall form of the model is more important than details such as skin pores and fine wrinkles. These are the kind of details that will come at the end so the best advice I can give about sculpting is not to rush to the detail work. It is easy to get carried away with all those brushes and the possibilities that ZBrush or other sculpting software can offer. Keep yourself contained and don't divide your model too soon into higher poly counts. After you have used every possible polygon to describe form, step up the level and continue the process.

Fig.05

After a few hours of having fun in ZBrush and exploring different poses and expressions, I was happy with the results and I re-used some clothing from earlier projects to complete the full scene (**Fig.03**).

TEXTURING

Before creating any color information, the model needs to have a clean UV map. The right choice for this task was some great software called UV Layout, which enables you to unwrap the model in a matter of minutes. Since ZBrush was my main tool for this piece, I decided to continue to use it for the texturing too. I decided to make the monster look kind of fleshy and more alive-looking rather than the pale version seen in many illustrations and the movie.

To achieve this kind of look I planned to use Mental Ray for rendering as it's a great, fast skin shader. Fast skin shaders come with many slots for textures that need to be added in order to achieve real-looking skin, but I decided to use only the main ones such as overall color, front and back scatter, specular and bump. In my opinion the best way to make human skin is to use actual photos because skin color is really complex and composed of many different shades of red, yellow, blue, white and many other shades that are hard to recreate by hand.

I found the easiest way was to project photos directly onto the mesh using Zapp link and combine a few different projections in Photoshop. I then edited the original textures further to make a few more; from left to right – front, overall and subsurface color (**Fig.04**).

If you desaturate the base texture and apply the High Pass filter then you can generate a great bump map.

HAIR

I have tried a few different solutions for hair, but the one that works best for me is the Shave and Haircut plugin for Maya. If you are working in 3ds Max then this plugin is already implemented as the hair and fur system. Basically, the workflow was simple: I made scalp geometry, which I then populated with hairs, the modeling of which was really fun, using the many brushes integrated in this tool.

CHARACTERS

Rendering the hair was a bit difficult and after much trial and error I decided to render it with the Maya software renderer. This is quite fast at rendering hairs and blending them together with Ambient Occlusion, which I also rendered in Mental Ray (**Fig.05**).

LIGHTING & RENDERING

Lighting a portrait is very important. Good lighting can add much to a scene and bad lighting can ruin it. Basically, I imagine lighting as painting the image with light so that every light in the scene has some color and purpose. I was guided by the three-point lighting theory even though I may have eventually used more than three lights. Most of the lights in this scene were Area lights because they produce very accurate shadows and a softer feel. Also, Area lights react with the specular components of fast skin materials, so the bigger the light the wider the specular reflection, which can give you great control over the final look of your skin. Since I did not use any Global Illumination, I added a few more lights with only diffuse aspects in order to emulate some ambient light.

After rendering the beauty pass I rendered out an Ambient Occlusion pass (**Fig.06**) and composited everything together in Photoshop.

CONCLUSION

This project was a great experience for me and I learned that exploring new ways of producing art and different workflows can pay off and be very rewarding.

Making art and having fun at the same time is fuel that keeps me going and I hope you have enjoyed reading this article as much as I did writing it.

Fig.06

ARTIST PORTFOLIO

ALL IMAGES © ANTO JURICIC TONI

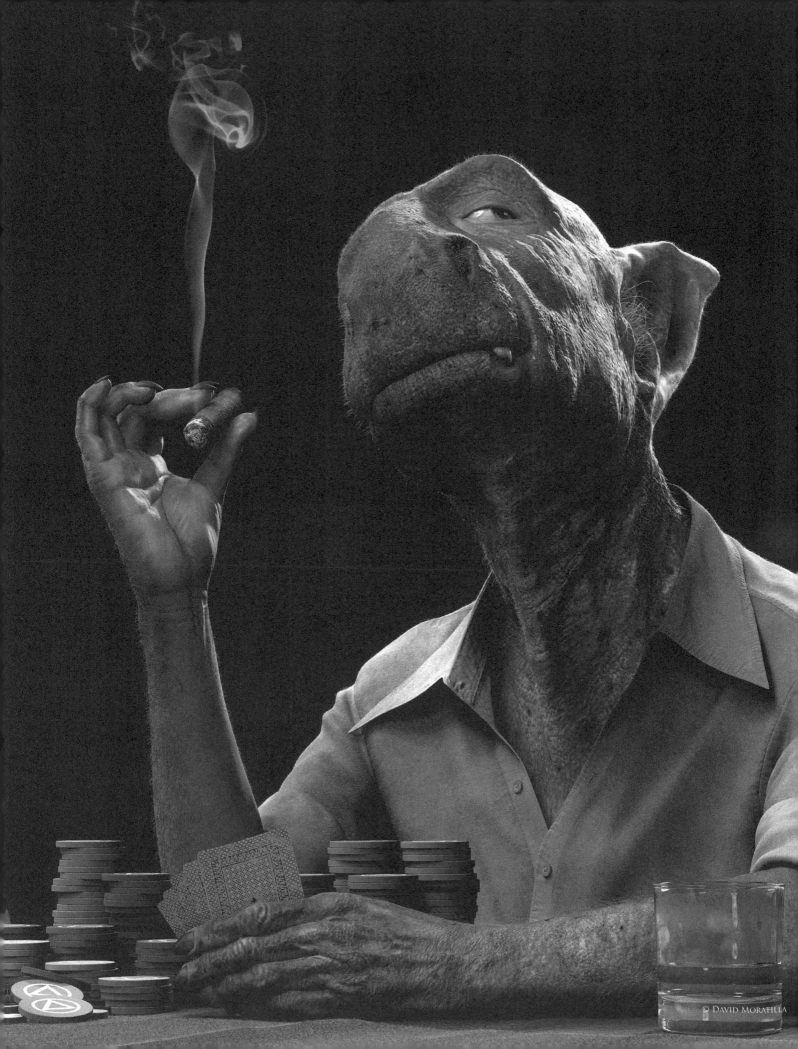

POKER MASTER
BY DAVID MORATILLA AMAGO

JOB TITLE: Lead artist – Indra Simulation
SOFTWARE USED: ZBrush, Maya, Photoshop, BodyPaint, Mental Ray

INTRODUCTION

I made this image as a way of applying all that I had learned over the past few years. I wanted to create a highly detailed character and give him some personality to make the image as believable as I could. I also wanted to learn the "new generation" tools such as ZBrush, and this project gave me the opportunity for exactly that.

A big part of the inspiration came from reading *Blacksad* comics and watching old poker films such as *The Sting* to gather some reference material.

I will try to explain the techniques that I used to create this image, but will focus mainly upon the creation of the character.

MODELING

I made a basic model in Maya, taking care to ensure that all of the polygons were four-sided before exporting it into ZBrush (**Fig.01**).

I could have generated the UVs here as this would have been a good opportunity for projection mapping; however, I decided I would use the UV layout later With this software, the character pose doesn't matter and so I decided to wait until I had a more detailed mesh from ZBrush.

I imported the OBJs into a ZBrush file using SubTools before creating some reference objects such as the table and cigar to help position the character using Transpose Master (**Fig.02**).

Fig.01

TRANSPOSE MASTER

Fig.02

Fig.03

Using the Standard and Move brushes, I then began the process of adding detail and refining the meshes. I continued this until I had something similar to the geometry that I wanted, but still with a low number of polygons (**Fig.03**).

I deleted the polygons that were not going to be visible, such as the torso and the interior of the shirt. I then had three different meshes: head, arms and shirt. I exported

Fig.04

SOME ALPHAS GENERATED FROM PHOTOS

ALPHAS USED TO START ADDING
DETAIL USING THE DRAGRECT TOOL

Fig.05

these meshes to OBJ format to create the UVs with a UV
layout. In the UV layout, I made some UV shells for the
sake of a better distribution and less distortion. I tried to
place the seams away from the camera view (**Fig.04**).

SKIN: DETAILING & TEXTURING

Once I had the OBJs with the correct UVs, I imported the
mesh back into ZBrush and started to subdivide and add
detail. At this point, it became a joint process between
ZBrush, Photoshop and BodyPaint. I used different
methods to add detail, such as using alphas with the
DragRect tool in ZBrush (**Fig.05**). Also in Photoshop, I

HIGH DETAIL MESH CAVITY MASK

TEXTURE GENERATED FROM CAVITY MASK

Fig.08

Fig.06

ORIGINAL ORIGINAL + TEXTURE

INTENSITY MASKING RESULT

Fig.07

added some texture layers from photographs (**Fig.06**), and then modified the geometry
in ZBrush based on the textures with a method of masking by intensity (**Fig.07**).

Sometimes I started by generating the displacement map in ZBrush and then used that
information to modify the texture, using cavity maps. In Photoshop I used the cavity
map for masking (**Fig.08**). I also used ZBrush's poly painting feature and BodyPaint to
remove the seams, add detail and project photos. Finally, I created a normal map to
apply to the shader in Maya. **Fig.09** shows the final result of the geometry in ZBrush.

CHARACTERS

Fig.09

LIGHTING

Back in Maya, I assigned a neutral white shader to start off the lighting tests. I used three lights, as follows (**Fig.10**):

- One light above his head acting as the main light (light 1)
- One bluish backlight that accentuates the volume of the head (light 2)
- One bluish fill light coming from the left of the image to reduce the dark areas of the character (light 3).

You can see the effects of this lighting setup in **Fig.11**.

At this point, I decided to add an HDR sphere to give more variation to the lighting. In Photoshop, I merged different HDRs and placed the light sources of those HDRs so that they matched the lighting that I had previously created in Maya. I also duplicated some light sources from the HDR and changed the hue and intensity (**Fig.12**). I then mapped the HDR to an invisible sphere.

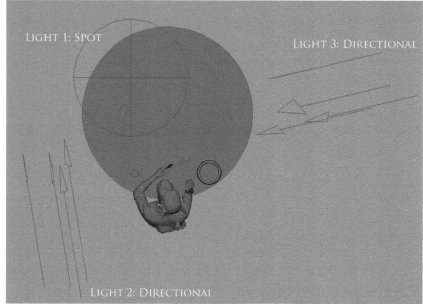

Fig.10

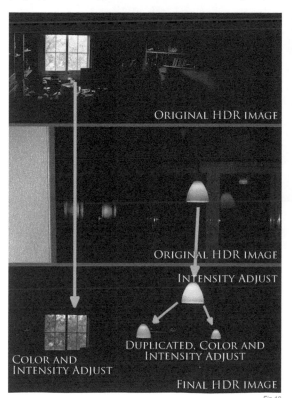

ORIGINAL HDR IMAGE

ORIGINAL HDR IMAGE

INTENSITY ADJUST

DUPLICATED, COLOR AND
INTENSITY ADJUST

COLOR AND
INTENSITY ADJUST

FINAL HDR IMAGE

Fig.12

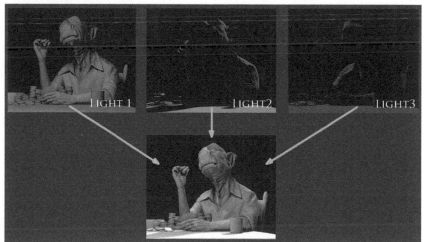

Fig.11

As this FG lighting would be added to the previously created lighting, I reduced the intensity of the initial Maya lights in order to obtain a similar light intensity with the FG sphere I'd just added (**Fig.13**).

SHADING

For the skin, I used the Mental Ray shader, "MiSSS fast skin". With the color base assigned, I adjusted the colors and the weight/radius values. Instead of using a solid color for all those color boxes, I duplicated the base texture and made some adjustments in Photoshop to match the color that I had previously chosen. This resulted in adding more variety to the shader (**Fig.14**).

The base color texture was 4096 x 4096 pixels, with the other textures being 2048 x 2048 pixels to reduce texture memory.

For the other elements in the scene, I mainly used my own photographs to make the textures (**Fig.15**).

Once I had created the color textures from the photos, I made variations to generate the specular, bump and other maps required for each shader.

EYES

The eyes are one of the most important things in a character and the first thing that most people are going to look at, and I wanted them to be realistic.

I modeled these in three separate parts: the eyeball, iris and pupil. For the texture maps I used photographs of my own eyes. The Iris has a Lambert shader with the color texture also applied to the bump and the pupil has a black Lambert.

RENDER

For the render, I separated the scene into different elements and made a render for each one: head, shirt, hands, cigar, table, chair and poker chips. I prepared a different file for each render layer, adjusting the render attributes to show only the parts that I wanted to see.

Fig.13

Fig.14

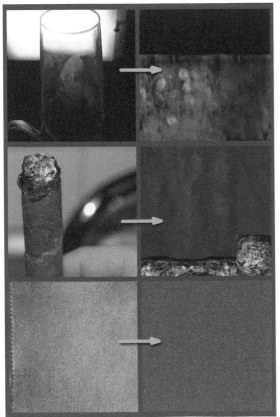

Fig.15

This helped me to reduce the render time. It would have been impossible to render everything at once. Eventually I merged all the layers in Photoshop (**Fig.16**).

FUR

In this image I decided to add fur to increase the sense of realism. I made a different render layer for each type of fur. This gave me the possibility to control all of them individually in post-production. I configured the render to show only the fur, with the rest of the image remaining black.

CHARACTERS

For the ear and nose fur, I painted the baldness map with Maya's Paint Fur Attributes tool to control the placement. For the small facial hairs I assigned the fur all over the face and then in Photoshop I masked the parts where it was not required, such as the eyelid and lips. Because this was intended as a still image, it meant I had this option.

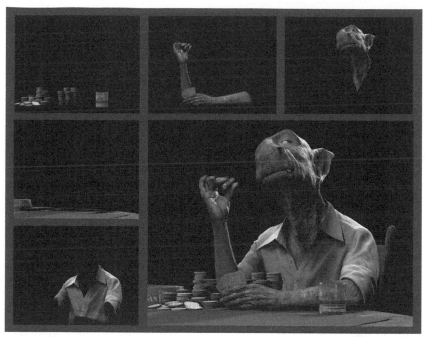

Fig.17

Fig.16

I used the Screen blending mode to composite the fur layers in Photoshop (**Fig.17**).

FINAL COMPOSITION

Finally, I added the smoke of the cigar and the background in Photoshop. Both are from photos that I took for this very purpose. The result is the final image.

CONCLUSION

With this image I managed to achieve what I wanted to create. There are perhaps some things that I could have made better (I would change some things), but in general I'm happy with the final result. And of course, I had to stop working on it at some point. I invested years of 3D knowledge into this image and from it I learned a great many things that I hope to take with me into my future projects.

ARTIST PORTFOLIO

THE MOUNTAIN PATROL
BY MICHAL SUCHÁNEK

JOB TITLE: Art Director
SOFTWARE USED: 3ds Max, ZBrush, Photoshop

INTRODUCTION

The Mountain Patrol is something completely different from my previous creations. After finishing several pictures themed around pinup girls, I wanted to relax a bit and create a classic fantasy artwork. One of the most important things that I have in mind when creating something new is the story behind the picture. Without this, it is just a model showcase.

STORY

Gorek knew this was coming. That is what their purpose was, anyway. To guard the eastern border and the mountain pass. But at that moment he realized how unprepared they were. He looked at Gumar, who just happened to be trying to pick something awful out of his nose. He was doing it with the enthusiasm and concentration only a little child could afford. A little child and Gumar, Gorek thought. He tapped his giant friend on the ankle and Gumar lifted him up, allowing him to sit on the vast landscape that represented Gumar's shoulders.

"Gumar, we have to run."

Gorek's bottom vibrated with Gumar's voice.

"Why run? We guard."

Gorek glanced at the dust cloud growing at the base of the mountain pass. This army was not just a few hundred filthy men with swords and bows. They

Fig.01

were hundreds of thousands strong. And they had catapults, magicians and battle machines of a weird design. They were organized, moving fast and eager to fight. This was not an army that was scared. This army came to win the war.

"We are not guarding the border anymore, Gumar. We are going to travel the world and see the Jibah waterfalls, remember?"

The giant looked confusedly at the dark shape closing in through the mountain pass.

"We kill enemy. Then we go Jibah."

Gorek sighed. Gumar was obviously ready to take on the whole army if no one else joined him. Even though Gorek was quite sure Gumar would be able to kill several hundred, this was far beyond a suicide mission. This would be plain stupid.

"I didn't tell you, Gumar, but we have a secret mission. We... uh... we need to deliver the news of the invasion to Paleachi."

"Paleachi near Jibah. We do mission and then we go Jibah."

Gorek's face reorganized the wrinkles into a satisfied grin.

"Good thinking, Gumar. So let's run."

Later that day, when Urghan the Bloodthirsty drew his last breath, overseeing the bloodied and crippled remains of his once powerful army, he could only whisper one word.

"How?"

How could his army be taken by surprise? Only one living soul in the world knows and he is just watching his best friend splashing about under the Jibah waterfalls. Screw war.

GOREK & GUMAR

Creating an orc or goblin character might seem quite easy at first as there are tons of pictures of them on the internet, but many of them feel pretty much the same – soulless and emotionless. Consequently, I tried to give them real character and a story to tell so that they would feel alive and believable. The idea was that the big guy (inspired by

Fig.02

the sculpture of Miles Teves) was all muscle with little intelligence, whilst the short one stays out of trouble and does all the thinking. With this in mind, I started the preliminary sketches and composition setup (**Fig.01**).

A GOOD SILHOUETTE ❝ AND CONVINCING SHAPE ❞ WERE IMPORTANT FOR A NATURAL LOOK FOR BOTH CHARACTERS

MODELING

For modeling I used the "box modeling" technique, which gives me the best control over the mesh topology and provides a solid base for later exportation into other sculpting software (**Fig.02**).

A good silhouette and convincing shape were important for a natural look for both characters. Their color scheme and expression was also important for the overall feel of the picture. After completing the modeling I UVW-unwrapped the models and imported them to ZBrush (**Fig.03**).

Fig.03

Fig.04

Fig.05

After years of modeling and rigging characters in Max, I prefer to pose models inside ZBrush, especially if it is for a static image. I find it much faster than creating bones and rigging the whole mesh.

After finding the correct poses and shapes, it was time to add more detail to both models (**Fig.04 – 05**). Wrinkles, skin pores and imperfections are all aspects of realistic and believable characters.

HAIR & FUR

One of the other realistic elements I wanted to include for both friends was hair and fur (**Fig.06**). I used the 3ds Max Hair and Fur modifier, but, to be honest, I was a little worried as I have less experience with this tool than I would like. I always model the

Fig.06

CHARACTERS

hair in a separate Max file and render it using the default Scanline renderer. The rendered hair is then ready for final post-production in Photoshop.

LIGHTING

I used a Free Rectangle light with raytraced shadows for the main light. There are two additional lights with less intensity. I like to use colored boards to help light the scene with the appropriate color. In this scene there are two boards, the blue one on the right side and the brown one on the ground (**Fig.07**).

CONCLUSION

After rendering the whole image, I was quite satisfied with the way it looked, even though I could still find tons of things to improve. This was the first time I had used the Mental Ray renderer, and throughout the entire time I was not sure whether I had succeeded in integrating everything I wanted. However, after an exhausting struggle, I made it to the end of the path and here is the result.

Fig.07

ARTIST PORTFOLIO

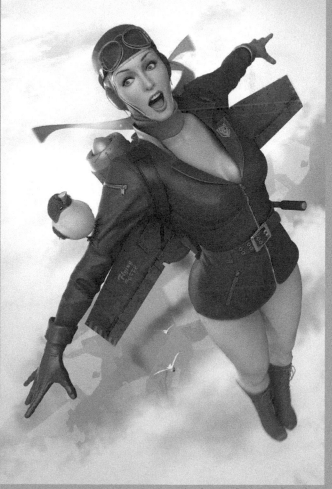

ALL IMAGES © MICHAL SUCHÁNEK

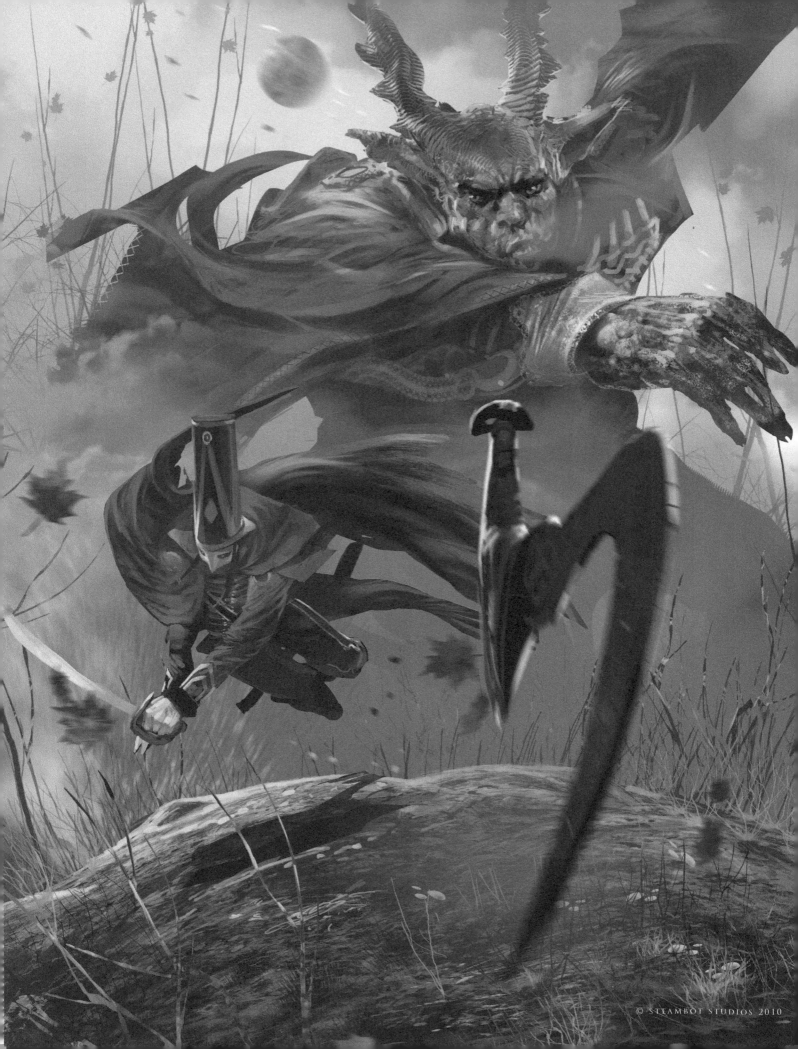
© STEAMBOT STUDIOS 2010

FANTASY

The best fantasy universes are based on the most realistic dramas and settings. Having worked in the movie and videogame industry for fifteen years, I have seen a very wide array of artists, designs and creations travelling from the beginning to a finished product, using that rule of thumb. What you will see in the next few pages will always fascinate me, almost like a magic trick. All artists have different visions, techniques and subtleties; witnessing the step by step process is almost like peaking over their shoulders and being part of that magic for an instant. Sharing those techniques also proves a level of confidence, which is what makes our industry move forward. Enjoy!

DAVID LEVY

vylewind@yahoo.com
http://www.vyle-art.com/

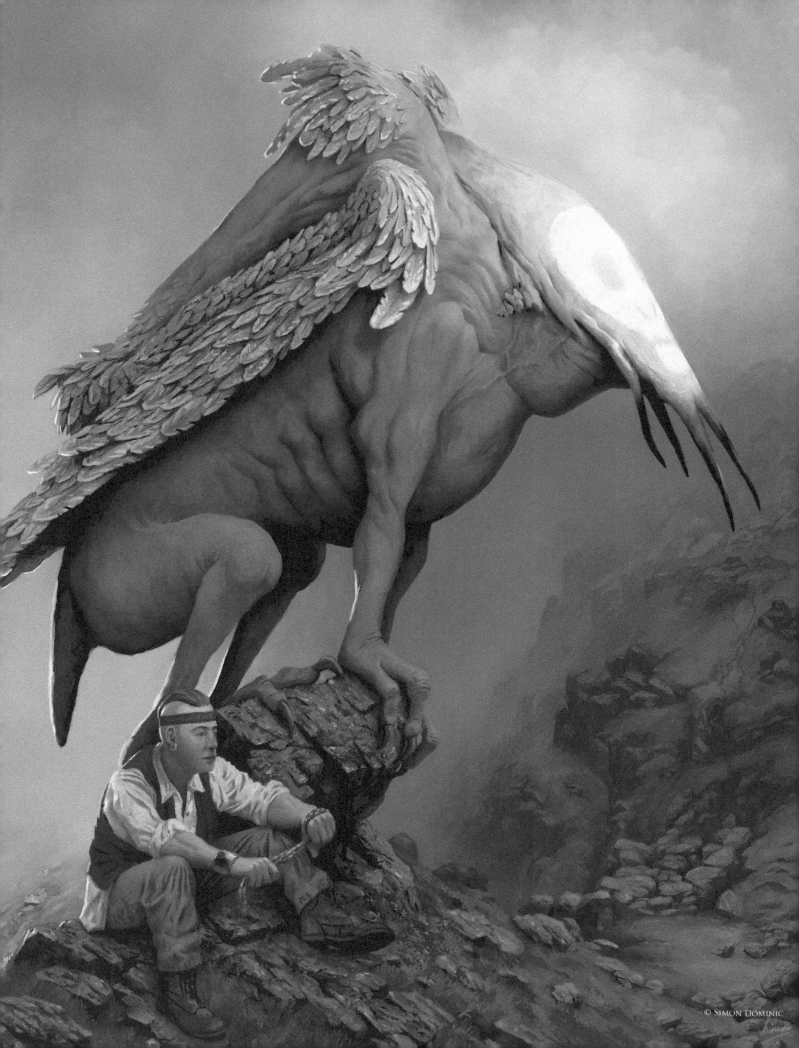

© Simon Dominic

BIG BLUE
BY SIMON DOMINIC

JOB TITLE: Illustrator
SOFTWARE USED: ArtRage, Painter

INTRODUCTION

Whilst I enjoy the challenge of tight specifications, it's good every once in a while to let one's mind go wandering. With this personal piece, *Big Blue*, I injected this very attitude into the image itself. I had an idea about two travelers – one human, one creature – taking a break from their long journey just to sit and ponder their futures, each lost in their own thoughts.

To better convey the mood of the piece, I tried to stay away from clichés, so partially-clothed babes, greased warriors and fire-breathing dragons were immediately ruled out. I designed the male character to be somewhat nondescript, with an unremarkable appearance, so as not to overpower the general mood. With this in mind, I referenced a photo of myself – although I must stress that I don't own a red waistcoat. Honest (**Fig.01**).

I made the creature mysterious, its origin and purpose unknown and entirely dependent on the whim of the viewer. The wings give the impression of a mythical beast and the skull pattern on its head suggests a certain danger or hidden power. I contrasted this with its calm, contemplative stance to give the impression of intelligence behind that foreboding exterior.

Fig.02

Fig.01

> ## IF SOMETHING DOESN'T SEEM RIGHT, CHANGE IT AS EARLY AS POSSIBLE BECAUSE THE LATER YOU LEAVE IT THE MORE DIFFICULT AND TIME-CONSUMING THE CORRECTIONS BECOME

PREPARATION

Sometimes I'll create several thumbnail concepts before I start, and also collect numerous references to work from. In this instance, however, the composition and atmosphere of the piece were clear in my mind and therefore I decided to skip the concept stage and move straight to the initial sketch.

In terms of references, I only used a couple of photos of myself. The creature and the environment are entirely products of my peculiar mind.

THE INITIAL SKETCH

I started on a small canvas in ArtRage and created a sketch of the guy and the creature. In my initial sketch I wasn't keen on the pose of the male character, so I referenced another photo and changed it. If something doesn't seem right, change it as early as possible because the later you leave it the more difficult and time-consuming the corrections become.

SHADING AND VALUES

Next I shaded the characters to produce a value study. Basically this indicates how the light will behave in the finished piece and how the different areas of the image will contrast with each other (**Fig.02**).

COLOR WASH

Using a brush with plenty of thinners, I painted over the entire piece, ensuring that the sketch was still visible through the paint. I wasn't too bothered about the landscape at this stage so I used a broad brush to apply earthy colors to the ground and brighter hues to the sky (**Fig.03**).

ROUGH DETAIL

I suspect "rough detail" is an oxymoron, but what I did here was to start applying a thick layer of paint over the entire piece. Some of the detail applied during these stages would be refined later, but some would make it through to the final image and for this reason I resized the canvas upwards to its final print size before I began.

I started out painting the creature's body. Although I predominantly used shades of blue, I varied the color hues regularly. If I hadn't done this then the blue color of the creature's skin could have become overpowering. The paint values (how light or dark it is), however, remained consistent with the value study sketch-work (**Fig.04**).

BACKLIGHTING

Whilst painting the rocks and the male character, I had the idea that a strong backlight would make the characters stand out, or "pop". Therefore, I imagined a light source situated in the lower left somewhere, shining onto the guy's back, the jutting rock and also the back legs of the creature. Where does the light source come from? Nobody knows ... (**Fig.05**).

Fig.03

Fig.04

Fig.05

Fig.06

SCRUFFY FEATHERS

I wanted the creature to have huge, powerful wings, so I was careful not to obscure its form with too many feathers. Therefore, I left the upper wing mostly free of feathers and ensured the others lay relatively flat against the wing arm. I ruffled the feathers too (so to speak), as imperfections can be used to enhance the realism of a piece.

At the same time, I painted some detail into the background landscape. Because I wasn't working from a reference I could create exactly the look I wanted, which in this case was misty and unobtrusive yet still interesting to look at (**Fig.06**).

FINISH THE LANDSCAPE

I completed the landscape whilst still in ArtRage because, although the brush engine isn't ideal for all types of small detail, it does an excellent job on organic detail such as rock, grass and wood.

FANTASY

I was careful not to put much background detail in the area around the creature's head so as not to muddle the focus. Keeping the regions around the creature relatively free of detail helped the character to stand out more (**Fig.07**).

FINAL BLENDING

For the final stage I exported the image into Painter so as I could make use of Painter's great blending brushes. I didn't want to blend the entire final image by any means, but the character's skin and especially the sky needed to be made much softer.

I used two brushes to do the blending. The first one blended at a low pen pressure only, and when more pressure was applied it acted like an acrylic brush, laying down paint. This is so that the small, fiddly areas can be blended and enhanced as required. The second brush was a pure blending brush with the resaturation set to zero so that it didn't lay down any paint. I used this brush mostly for large areas – the sky and the main bulk of the creature.

Fig.07

Fig.08

When blending it's often tempting to go too far and start blending everything. This should really be avoided. Boundaries and intentionally sharp value and hue transitions should be left unblended so that the image doesn't become undefined and too "digital-looking". This applies equally to the type of painting brush you use because excessive usage of soft-edged brushes tends to produce fuzzy results.

After finishing the blending I went over the entire image at a high zoom looking for any little bits I could tidy up. When that was done I saved the final file, went to bed and dreamed of blue feathers (**Fig.08**).

ARTIST PORTFOLIO

© Wei-Che. Jason. Juan

THE LAST
BY WEI-CHE (JASON) JUAN

JOB TITLE: Character Artist
SOFTWARE USED: Photoshop

INTRODUCTION

All living things that move create a rhythm and flow of curves that lead us to believe they are alive. As human beings we are all born as similar people, sharing the same basic emotions and visual experiences. We tend to see color more than black and white, and notice moving things more than still objects. We also enjoy change because it keeps us fresh and attracts us for longer periods. In paintings, we try to create a flowing motion between color variation and contrast,

> **ACCIDENTS ARE A GOOD WORD TO DESCRIBE WHY I LIKE DIGITAL PAINTING, AND IN FACT THIS PAINTING EVOLVED FROM SUCH AN OCCURRENCE**

Fig.01

Fig.02

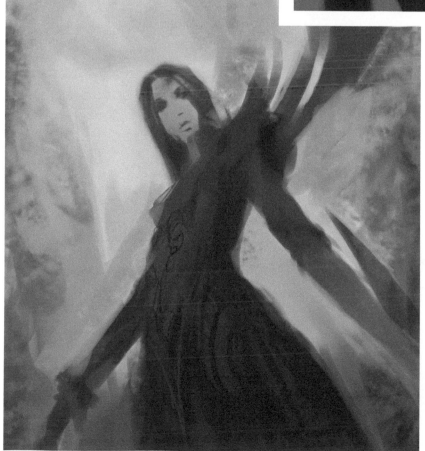

Fig.03

and between geometric shapes and curves. In the real world we also use facial motion or expression to convey emotion. These are also some of the techniques used to make a painting stand out from others, even if they share a similar concept and content.

Sketch tools that can be carried anywhere are important for me. That doesn't mean that I am constantly drawing, but I do need to have some tools to hand when an idea comes to me or I just suddenly feel inspired to create something. For example, I have a 12" tablet PC from Craiglists and a four-year-old Acer VGA screen PDA. I carry them with me and use them to sketch out ideas. A PDA or a tablet PC is not a perfect tool for serious painting since the pen devices are not particularly sensitive and spending hours on these kinds of devices may harm your wrist. However, for a quick sketch in under an hour, a portable device proves sufficient and that is how this painting started.

WORKFLOW

In this painting, there were several objectives I wished to achieve. The first was a flow or rhythm that created a feeling of movement, even if the object in the painting was not actually moving. The second was using the

full range of color and values. The third was the facial expression and the last one was the composition. Above and beyond all of this, I tried to build up a story behind the painting.

Accidents are a good word to describe why I like digital painting, and in fact this painting evolved from such an occurrence. In the first sketch I designed an assassin holding a sword and gun, living in a modern world (**Fig.01**).

I did not find this interesting at all; the composition was okay, but the painting as a whole had very few interesting elements. All of the elements in the first sketch were linear and straight, so I decided to change the camera angle and create a diagonal line. Most of the lines were still straight and so I changed the large weapon in her left hand to break up the straight lines, resulting in **Fig.02**.

At this stage, most of the elements in this painting were set and the next thing I needed to do was add more

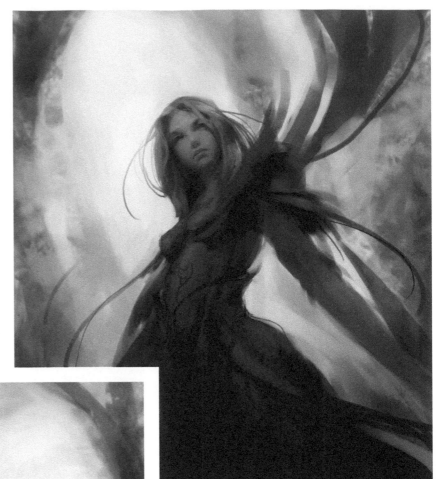

Fig.04

definition to make them clearer. At the same time, while looking at the image, I started to feel that she looked somewhat determined and was clad in a kind of fancy dress, so I changed my mind and made her into a fantasy warrior.

The next two images show a very important process. These stages were key to what happened beyond this point with regard to the rendering and lighting.

As you can see in **Fig.03**, there were some suggested lines to describe the design of the clothes, a more defined face and some value changes to suggest the larger shape. But something was still not resolved – the rhythm. The canvas itself was rectangular and had four sharp corners, which is something that can easily kill a painting. The easiest way to avoid this is to either darken or lighten the corners to emphasize the central area, but that may not always be the best solution. I like to paint in some more elements to create this feeling, such as a landscape in the background, plants, or even some

Fig.05

FANTASY

clouds. The purpose of doing so is that I want people to keep looking around the canvas and keep their eyes moving inside the painting.

Each painting uses different ways to solve this problem but, in this painting, the whole body was a big curve from one joint to another. Making the curves feel right was rather like constructing a house. I observed the painting carefully, even slowly, and decided where to put the strokes. Then, when I put down the strokes, I did it fast and with confidence.

John Singer Sargent is the 19th century painter who is famous for his wonderful strokes of careful proportion and color. His paintings are the perfect reference to learn this technique from.

In **Fig.04** you can see that the image is close to the final result. The rest of the actual painting was very time-consuming and seemed to last forever, even though it mainly consisted of rendering and filling in the blanks.

In **Fig.05** I defined some of the more secondary elements and color throughout the painting in general.

In **Fig.06** I further established the lighting, making sure to use a full range of color, painted in the finer details and smoothed out the rough sketch strokes.

I decided to name this painting *The Last*.

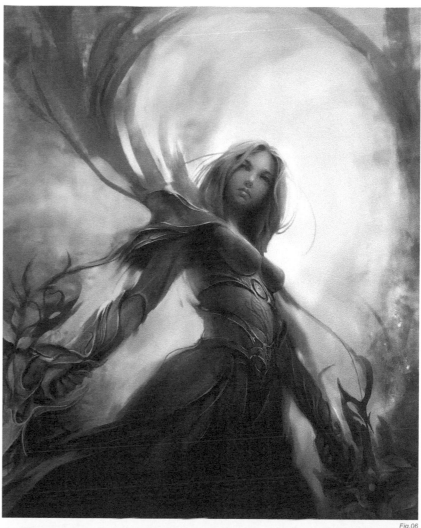

Fig.06

ARTIST PORTFOLIO

All Images © Wei-Che. Jason. Juan

FANTASY

NIZARI
BY IRVIN RODRIGUEZ

JOB TITLE: Student

SOFTWARE USED: Photoshop

INTRODUCTION

Hello, I'm Irvin Rodriguez. I am currently studying at the Grand Central Academy of Art in New York City while working as a freelance illustrator. In this article I will explain the process and working methods used in the making of *Nizari*. The Nizari were a group of assassins who were a part of the Ismā'īlī Shia Muslims during the middle ages and who sought out targets based on political and religious reasons. The idea of assassination dates all the way back to the Middle Ages and I wanted to explore the world of the Nizari with a painting that would best illustrate who they were.

> ❝ I WOULD LIKE TO THINK OF THE DRAWING AS THE ❞ SKELETON THAT HOLDS UP THE STRUCTURE. IT IS THE FOUNDATION TO ANY FINISHED PAINTING

THE DRAWING

I would like to think of the drawing as the skeleton that holds up the structure. It is the foundation to any finished painting. I probably spend more than 30 percent of my time in the drawing phase (**Fig.01**). It is so important for me to resolve any problems with the work, whether it is a compositional or anatomical issue or a slight perspective problem. I do not want to be figuring things out as I go as I'm definitely not an artist who paints on a blank canvas. I need to put down some kind of information first.

With the drawing here, I blocked in the two figures and later added the armor and accessories. I wanted to put

Fig.01

emphasis on the armor and make it seem like it was attached to or almost hugging his body. I also gave the dagger a similar design to maintain a consistent style throughout the equipment.

THE GRISAILLE: ESTABLISHING THE VALUES

I usually try to maintain a minimal number of layers when working in Photoshop. The first application of "paint" or pixels is the black and white value study (**Fig.02**).

I am lost without first establishing the values; it is the first transition from the line drawing to something dimensional. Here is where I set a key for the darkest shadows, brightest highlights and all the values in between. I tried to keep the brush variation to a minimum while working out the values, trying not to get fancy and staying focused on shaping the forms.

GLAZING

Once I was satisfied with the amount of information I had put into the tonal study, I began to introduce some color.

Fig.02

Fig.03

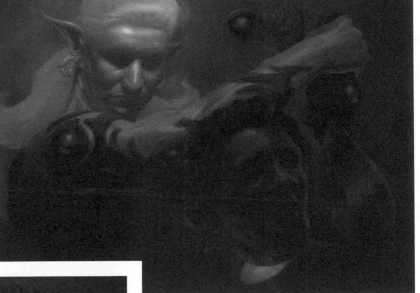

Fig.04

> ❝ I TRIED TO SEPARATE THE FIGURES FROM THE BACKGROUND, ARMOR, HAIR AND ANY METALLIC OBJECTS ❞

By doing so I created a Selective Color adjustment layer in Photoshop over the value study (**Fig.03**).

I kept the adjustment layers separate from the value study layer so that I could maintain maximum flexibility. Following the adjustment layer, I created a new layer and activated the Overlay blend mode. From here I used a standard circular brush and begin glazing subtle color into the painting. I tried to separate the figures from the background, armor, hair and any metallic objects (**Fig.04**).

Fig.05

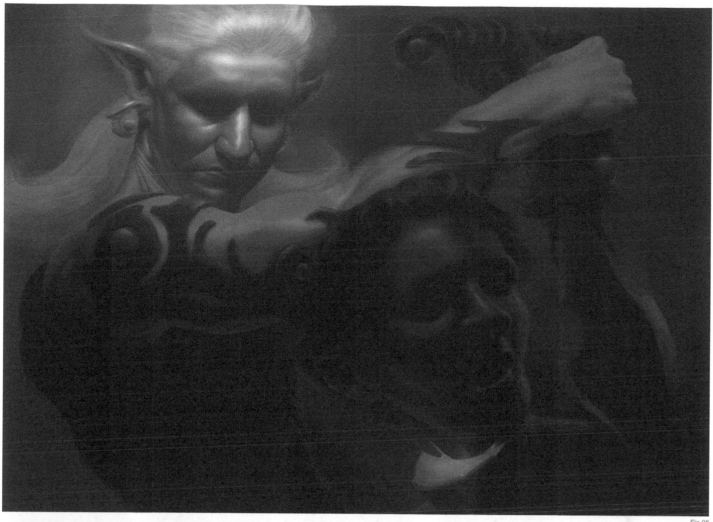

Fig.06

Fig.07a

Fig.07b

Fig.07c

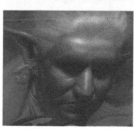

Fig.07d

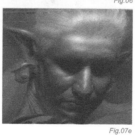

Fig.07e

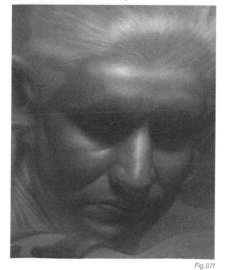

Fig.07f

Fig.07g

REFINING THE SURFACE

Here is where I began painting in full opaque color, which, to some extent, is like using thick oil paint with no medium. I tackled all the subforms and begin stressing the surface texture. By tightening the transitions in the gradations across the forms (some more than others), the painting started to come together (**Fig.05 – 06**).

The focus of this image happened to be the face of the elf, so I treated this area of the painting with the most delicacy. I sampled colors that I'd painted in during the previous glazing phase and used those colors in a thicker opacity to paint over and refine the previous layers. Any stray brush strokes that were not adding to the overall look of the painting were eliminated, although I tried to

leave some parts rougher to keep a balance between very tight and loose strokes throughout. If there was any time during the course of the painting that required the use of custom brushes, it was now. The hair required the most attention from the custom brushes, as seen in **Fig.07a – g**.

> " I FEEL LIKE THE BEST DIGITAL ART IS A MARRIAGE OF BOTH TRADITIONAL AND DIGITAL MEDIA "

FINISHING TOUCHES

Whenever I am approaching the end of a painting, I sit and stare at the piece for a long time. I will add a few strokes, hit Undo quite a bit and try again until I'm happy. I also use a combination of adjustment layers and try rearranging the order in which they sit to see what effects I can achieve.

Fig.09

Fig.08

For this painting I scanned some India ink patterns that I'd painted on bond paper. Afterwards I replaced the color of the black ink in Photoshop and placed the ink work into the painting (**Fig.08 – 09**). I try to make use of some types of traditional media and fuse them with my digital work. I feel like the best digital art is a marriage of both traditional and digital media (**Fig.10**).

CONCLUSION

This painting was an excellent experience for me. I learned a great deal from it, especially how to work faster with each painting I do. I was also able to make use of the classical training I am obtaining from my studies at the academy and was very satisfied with the results of this painting. I hope that you can find some use from this walkthrough of *Nizari* and would like to thank everyone at 3DTotal for making this possible.

Fig.10

FANTASY

© Min Yum

BABA YAGA
By Min Yum

JOB TITLE: Concept Artist / Illustrator
SOFTWARE USED: Photoshop

INTRODUCTION

Baba Yaga was created for a Character of the Week activity at conceptart.org. I didn't know about Slavic folklore at that time and so spent a bit of time reading up on the background history of the tale. It's a rather dark tale about an old witch (hag) who flies around in a giant mortar preying on small children! I was instantly drawn to the story and wanted to create a really sinister witch. A quick search online turned up a large collection of previously created Baba Yaga interpretations by other artists, which worked as a huge inspiration for me, and I hastily started drawing up my initial designs of the old hag. Throughout this account, I will try and summarize my working methods and share my thoughts during the process.

> **"** COMPOSITION IS SOMETHING WE OFTEN OVERLOOK, MAYBE BECAUSE THERE'S NO BLACK AND WHITE ANSWER, BUT IT HAS THE POWER TO MAKE THE PICTURE WORK OR TO TURN IT INTO A VERY BORING IMAGE **"**

Fig.01

SKETCH & TELLING A STORY

My first approach was to simply design the witch and interpret how she would look. **Fig.01** shows my initial sketch of her (it's a cleaned-up version). But with Baba Yaga being a folk story, I felt compelled to tell a story instead of just designing an old witch. I remembered reading about Vasilisa, who seems to appear in different versions of the folklore as a heroine. Maybe I got greedy, but I wanted to show more than just the witch by incorporating both characters into a scene and showing the interaction between the two.

With that in mind, the composition was going to play a crucial role in describing this scene. Composition is something we often overlook, maybe because there's no black and white answer, but it has the power to make the picture work or to turn it into a very boring image. That led me to picture a scene with the witch overpowering the girl, hunching over and breathing down onto her. I wanted the witch to be almost creature-like in appearance and show gestures that portrayed a predator, fondly playing with its prey before the inevitable.

Fig.02 shows the initial rough sketch with the witch overpowering the helpless girl within a cramped corner of

Fig.02

the frame. The girl's supporting role was to compliment the witch in both the composition and in the story. The background trees were included to break up the overall flow of the witch and to add more interest.

A cleaned-up version of the sketch can be seen in **Fig.03**.

BLOCKING-IN

This step is where I define the overall mood of the painting. I am rather fond of playing with direct lighting, but thought it was also good to go for a more dynamic setup to compliment the composition in this image. I created a layer underneath the cleaned-up sketch and started with a simple color scheme. Some texture brushes were used with Color Dynamics enabled to help break up the colors. I've mostly used red and green to roughly block in the overall mood. This is also where I defined the local colors for each area of the painting (**Fig.04**).

> " **THIS PART OF THE PAINTING IS ALWAYS DAUNTING AND TIME-CONSUMING, YET AT THE SAME TIME IT'S ALSO THE PART I LOOK FORWARD TO THE MOST** "

I also went ahead and adjusted the image to add stronger contrasts. More attention needed to be focused on Baba

Fig.04

Fig.03

Yaga, so I made her skin paler and darkened the background with cooler blue tones. The shadows and highlights were done with different brush blending modes: Multiply and Overlay, respectively (**Fig.05**).

RENDERING

This part of the painting is always daunting and time-consuming, yet at the same time it's also the part I look forward to the most.

Digital painting has the advantage of allowing you to zoom into an area to add details and provide greater control. The disadvantage of such control is that we can often overlook the bigger picture and add too much unnecessary detail. I sometimes find myself over-rendering unnecessary details that aren't going to show up in the final image, which can also eat up a lot of time. The easiest way I've found to overcome this is by opening a duplicate window of the same painting, but at a smaller scale, similar to how Navigator works in Photoshop but with a bigger window. By doing this I am always reminded of the bigger picture rather than smaller insignificant details. It can be found under Window > Arrange > New Window for

FANTASY

Fig.05

Either way, I enjoy the rendering stage despite the grief it gives me. It's a simple process of following the blocked-in colors and of defining/redefining details. I usually start with a good, strong drawing and try not to use references most of the time, unless I am dealing with an unfamiliar subject, in which case I tend to do studies prior to starting an image rather than during. This seems to help avoid the issue of copying too much and also helps me to remember better for future references. **Fig.06** shows a close-up view; almost done!

> " IT'S TOUGH BEING A GOOD CRITIC AFTER STARING AT THE IMAGE FOR SO LONG, AND OFTEN YOU FIND YOURSELF GETTING ATTACHED TO A CERTAIN PART OF THE IMAGE THAT DOESN'T ALWAYS WORK WITHIN THE BIGGER PICTURE "

Fig.06

Fig.07

FINISHING UP

I always find the last five to ten percent of the painting the hardest; tying up all the loose ends and making sure there's consistency with the brush strokes and details, without losing the original idea. It's tough being a good critic after staring at the image for so long, and often you find yourself getting attached to a certain part of the image that doesn't always work within the bigger picture. I try and flip my image horizontally every now and then and even work on it flipped before flipping it back. It seems as though our eyes and brain sometimes like to trick our judgment and it's often hard to tell whether something is misplaced/wrong unless it's presented in a different form. This proves to be a great technique in picking out anything unusual! It's also a good idea to ask for criticism from your peers to see if you've missed anything, just as I did in this case.

Fig.07 shows another close-up.

CONCLUSION

If I were to do it again I think the girl could have been designed to look more unique as she perhaps feels a little too generic at the moment. Maybe I would have given the characters a softer appearance and painted them in a more classically realistic style. Ultimately, it was fun and I am rather pleased with the end result. Working on this image has also led me to think and ask more questions about composition, which I may have neglected in the past. It definitely deserves more credit and exploration in my book!

We Found The Gate To Hell
By Christer Wibert

Job Title: Concept Artist
Software Used: Photoshop

The Prologue

I have always been deeply fascinated by the concept of hell and its inhabitants. Trying to depict how the most evil place in the universe may look is a challenge that I never tire of and, when I'm at home painting for my own pleasure, I often end up with some kind of demonic world or character.

This image began life as a quick sketch I made some years ago. I found it while browsing through my many folders of abandoned concepts – something that I tend to do when inspiration fails me. I was itching to try to merge matte painting with concept drawing in a bigger way than I had ever done before, and the concept proved to be a perfect fit for such a project. I had recently painted a similar snow-covered mountain without using textures, and, although rewarding in its own right, I wanted to find out how I could use photographic textures to speed up the process and maybe come up with a new workflow (**Fig.01**).

> ❝ I LIKE TO BEGIN MY
> SKETCHES BY DRAWING
> REALLY LOOSE SHAPES,
> BUILDING THE IMAGE UP
> SLOWLY WHILE KEEPING
> MY MIND OPEN TO
> POSSIBLE CHANGES IN THE
> COMPOSITION ❞

Fig.01

Fig.02

The Sketch

Like many other artists, I like to begin my sketches by drawing really loose shapes, building the image up slowly while keeping my mind open to possible changes in the composition. I always start out working in grayscale values, adding colors as I go along. This helps to keep my mind focused on the shapes and overall composition. This is how I work nowadays at least, but the sketch is a couple of years old, so I'm certain that I had no real workflow when I made it.

The Detail

With a rough sketch ready and inspiration coming along in hefty doses, I started out by finding a good rock texture and placing it in the image (**Fig.02**).

Fig.03

Fig.04

Fig.05

I then created a new layer, set the blending mode to Color, and created a Clipping Mask (Alt + left mouse button in between the layers). I then colored the texture blue to match the painting (**Fig.03**).

One technique I used was to mask the layer with a threshold, which enabled me to quickly paint only the highlights of the rock. This technique proved quite useful and it was done by adjusting the sliders under Blend If, found in the Blending Options of the layer (**Fig.04**).

I continued working in this manner by adding textures and painting them so that they merged until I had all the rocks textured. During this process I tried to keep the level of detail even throughout the painting. This is something that can be tricky when working with different quality textures and I frequently used the Curves adjustment tool to correct colors, constantly adjusting the curves for each of the color channels (**Fig.05**).

As the painting progressed it started to feel cramped and claustrophobic, so I removed the cave-like ceiling to give it some air (**Fig.06**).

The mountains in the background also received some extra attention. One mistake I made here was to use unnecessarily strong black and white values too early in the process. I find it's almost always best to wait until the very end of the process before working with the brightest highlights and the darkest shadows, since doing so will give you greater control of the overall contrast of your painting.

By now I was also spending too much time navigating layers, so I decided to flatten the image. I find that too many layers can hamper creativity and flow while painting, and, as long as I'm not working for a client who may require changes late in the process, I tend to work with as few layers as possible.

I duplicated the flattened layer and reduced the saturation a bit, using the Hue/Saturation adjustment tool, since the strong blue tones were bothering me. I often duplicate my image layer, alter the value or hue, and then erase the areas where I want the hues and values of the underlying layer to show. The same effect could just as easily be created by painting in the mask of an adjustment layer (**Fig.07**).

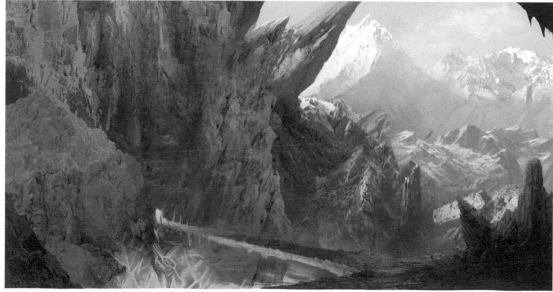

Fig.06

Fig.07

FANTASY

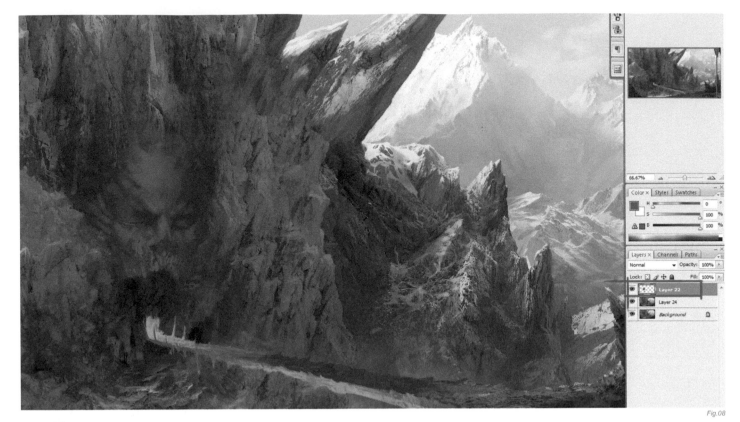

Fig.08

THE THEME

By now I had the beginnings of a very pretty
mountainside, but the idea of this being an ancient
gateway to hell was not coming across at all. The bridge
was there, and so too was the gateway itself, but without
any distinguishing features it could really have been
a gate to anything. So, after a long session of intense
brainstorming, I decided to go with a human face carved
out of the rock, weathered over the years in the harsh
environment.

I wanted the face to be that of a demon, and since
God created man in his image, I figured the Devil and
his demons would also look similar to us. A tortured
man would serve as a warning to anyone who found

Fig.09

> ## IT'S A RELAXING EXPERIENCE TO WATCH THE ROCKS TAKE SHAPE AND MERGE WITH EACH OTHER AS YOU ADJUST THE CURVES AND PAINT IN THE CRACKS

themselves at the entrance, and the second jaw could represent the twisted horror that
awaits anyone who dares to enter.

Having decided upon this idea, I added it to the painting by creating a new layer and
painting the head in, matching colors on top of the mountainside (**Fig.08**). Using a
small brush, I carved out the edges of the face and added small details to integrate it as
seamlessly as possible with the rest of image.

Once satisfied with the gate, I drew the two ignorant adventurers preparing to venture
inside the mountain to face its horrors, also providing a sense of scale that had been
sorely lacking up to this point (**Fig.09**).

THE LAST WORDS

All in all this has been one of the most rewarding paintings I've ever created. Working
with photographic textures really helped to speed up the workflow, and, although
painting everything from scratch is wonderful and rewarding in its own right, the time
saved using this technique will prove invaluable in a stressful production environment.

Working with rocky landscapes and mountains is a lot of fun. The chaotic patterns
and shapes lend themselves really well to creative experimentation, and it's a relaxing
experience to watch the rocks take shape and merge with each other as you adjust the
curves and paint in the cracks. In between cityscapes and science fiction interiors, I
always come back to the great open vistas of snowy hilltops and jagged mountains. And
below some of them, ancient terrors might very well be lurking …

FANTASY

FANTASY

© István Vastag

THE WAY I FEEL
BY ISTVÁN VASTAG

JOB TITLE: 3D Artist

SOFTWARE USED: 3ds Max, ZBrush, Photoshop, V-Ray

INTRODUCTION

The story behind this image started one late summer morning. After awakening I looked at the foggy sunrise and it was then that I decided I would like to see this back on my screen. I started thinking about what kind of environment would be most fitting. A lot of different concepts came to mind (a city view, a house near the lake, etc.) but the winner was a fantasy-like canyon with small shelters and Zeppelins. With the concept in my head, I started modeling. It was not long before I faced many obstacles, as it is very hard to create an image based upon a feeling, and especially one that will convey my original feelings to the viewer.

> " I USUALLY START MODELING FROM A PRIMITIVE AS OPPOSED TO USING DIFFERENT MODIFIERS "

Fig.02

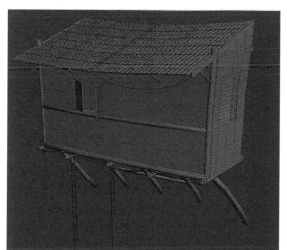

Fig.03

Fig.01

MODELING

Modeling was done in 3ds Max using Editable Poly techniques (**Fig.01**). I think this is the most common and accessible method used in the industry. I usually start modeling from a primitive as opposed to using different modifiers such as FFD (free-form deformation), Bend, Symmetry, Taper, Shell, Noise, etc. I find that Editable Poly tools which include Extrude, Bevel, Inset, Connect, Bridge, and Extrude along Spline, etc., can be used to achieve the desired forms. I then proceeded to starting to adding the details.

The houses, Zeppelins and some environmental elements were made using the techniques mentioned above (**Fig.02 – 03**).

The rocks were done in ZBrush using just a few brushes. The main tools were the Standard, Move, Rake and Stitch brushes with custom-made alphas (**Fig.04 – 05**).

For the larger cracks the tools were used in both Drag Reject and Spray mode to mould the surface details. The flow of modeling was the same: working from large towards smaller details. For the falling leaves I used Particle Flow, which is a very powerful tool that can be used for many things. Obviously the Emitter was the tree and the leaves went into Shape Instance and were affected by the wind force.

TEXTURING & SHADERS

With regard to mapping I consider there to be two main parts: the UV-mapped elements (such as the rocks) and the unwrapped parts (the houses and Zeppelin). I try to avoid unwrapping as much as possible because I find it time-consuming and extremely boring.

Fig.04

Fig.05

> **" I USED V-RAY FOR MY RENDERING. WHILE IT'S MOSTLY USED FOR ARCHITECTURAL VISUALIZATION, IN MY OPINION IT WORKS PERFECTLY WELL IN OTHER CASES TOO "**

COLOR

Fig.06

I used Photoshop for the texturing and in most cases I baked an Ambient Occlusion pass for the unwrapped elements, which I then used to create a mostly photo-based texture over the top. Many very good texture sites can be found on the internet; for example, http://www.cgtextures.com and http://www.grungetextures.com. Once the diffuse texture was ready, I used it to create the Specular (reflection) and Bump maps, both of which I was able to adjust later in the Material Editor (**Fig.06 – 08**).

Since I usually use V-Ray for rendering, the main shader for this image was VRayMtl. For the important details I used a lower blur on diffuse bitmaps (0.1 – 0.2 instead of the preset 1). This way, I was able to achieve a sharper look. I also used tiny Fresnel reflections with strong glossiness to bring the colors together and lend a more natural look. Since the geometry of the falling leaves had no thickness I had to assign a VRay2Sided material to simulate Subsurface scattering.

LIGHTING & RENDERING

Due to the open space, the lighting for this scene was considerably easy. For the main illumination I used a V-Ray Plane light and then a Target Direct light was used to simulate sunshine. I used VrayShadow as the shadow type with the option of an Area Shadow.

As mentioned earlier, I used V-Ray for my rendering. While it's mostly used for architectural visualization, in my opinion it works perfectly well in other cases too. The render setup for the image was quite basic. I usually use Adaptive DMC for the image sampler with a minimum value of 1 and a maximum value of 32 with the AA filter disabled and Global Illumination active. The primary bounce was done with an irradiance map with a low preset of 40 Hsph subdivisions and an interpolate sample

BUMP

Fig.07

REFLECT

Fig.08

of forty. For secondary bounce I used Light Cache with a subdivision of 400. Motion blur was turned on, which increased the rendering time but at the same time made the falling leaves much more realistic. Color mapping was exponential with sub-pixel mapping turned on.

The final render was set to 3400 pixels and took about one and a half hours using my home desktop Core2Quad computer with 8GB of RAM. I found the rendering time considerable but acceptable. Using many different render elements such as Vray ZDepth, Vray Mtlid and Vray_Global Illumination proved to be very helpful during post-production.

POST-PRODUCTION

Getting into post-production, I could have started by concentrating on what initially started the whole process: that need to create a certain feeling. But, as you can see from the raw render, the image was far from complete (**Fig.09**). First the rocks were separated and in some places were replaced with matte painted elements. The fog was achieved by a pre-rendered ZDepth pass (**Fig.10**).

Photo-filter colors were added to the layer and later the layer's blending mode was set to Screen and the opacity adjusted. The next step was to correctly implement the lens flare. To achieve this I used the Knoll Light Factory plugin by Digital Anarchy. Using the ZDepth map and color range tools, the background and foreground were separated to begin the color correction, which involved adjusting the Hue/Saturation and Color Balance.

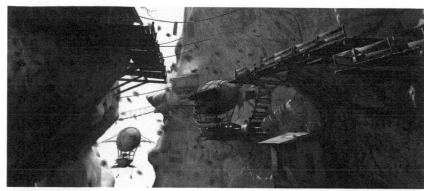
Fig.09

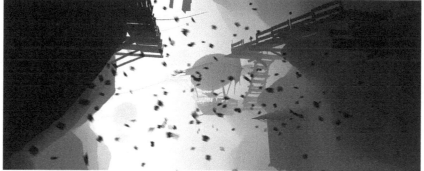
Fig.10

The foreground was given a bluish-green tint to emphasize the atmosphere of a narrow canyon, with the background being given a brighter yellow hue. After these corrections, I added some effects such as lens vignetting and Chromatic aberration, which were made using the Tiffen Dfx filter.

FINAL WORDS

I really enjoyed the process of creating this piece and have learned many things. By reading through this article you will gain an insight into my workflow, which I believe doesn't contain anything particularly technical. The greatest challenge for me was to convey the desired feeling and concept, in which end I hope I have succeeded.

ARTIST PORTFOLIO

© JUSTIN YUN

MAGICAL FOREST
BY JUSTIN YUN

JOB TITLE: Concept Artist
SOFTWARE USED: Photoshop

CONCEPT

The idea for this personal piece derived from my fascination with rocks and trees. Ever since I was in college I've been drawn to organic lines and shapes, so I often find myself sketching trees and figures. With this piece I wanted to create an organic environment that the viewer could imagine themselves getting lost in.

PROCESS

I start most paintings by blocking in shapes with a Chalk Square brush and build up from there. When I began to block out the shapes for this piece I initially had a "lava rock" structure in mind (**Fig.01**).

> " THE UNPREDICTABLE ASPECT IS EXCITING AND, ONCE YOU GET THE SHAPES YOU WANT, EVERYTHING BEGINS TO FLOW NICELY "

The beginning is always fun because you have an idea of what you want to do, but you really don't know

Fig.01

how it's going to turn out. The unpredictable aspect is exciting and, once you get the shapes you want, everything begins to flow nicely. At this point I still wasn't sure what it was going to be but I liked the shapes and the composition. My goal was to keep viewers' eyes interested, moving around the whole environment and not wandering off the painting. To achieve that I made the shapes converge towards the middle of the page. After that I started playing with a Hue and Saturation layer and tried to see whether a different color would work better. As soon as I saw the green tones I knew exactly what I wanted to paint (**Fig.02**).

Magical Forest was born and from there I started to paint in the trunks of the trees and pathways for the figures

Fig.02

to walk through. Adding the pathways gave depth to the painting and provided a story for the audience to follow. At this point I began introducing textures into the painting and started detailing some areas (**Fig.03**).

The Chalk Square brush is good for blocking in big shapes, but not as efficient at creating hard edges. In order to create tighter and more detailed lines, I use the Hard Round brush. In addition to the Chalk Square brush and the Hard Round brush, I often use a Soft Round brush and a custom texture brush as my main tools (**Fig.04**).

Going back to the painting, I created some more pathways in the background so that I could get more depth into the painting and also bring in some interesting repetition. I also introduced the main light source, which

Fig.03

Fig.04

Fig.06

Fig.05

comes in from the top left, by adding some highlights to the trees. They started to take their form, but something was off. The two tree trunks on the left were the same width, so in order to separate them I had to push one back by making it lighter and bring the other forward by making it thicker (**Fig.05**).

This is also when I started adding atmospheric perspective by adding fog and pushing the objects in the middle ground and background further back; this helped to define the space better.

I was happy with the direction this painting was going in, but something was missing … it wasn't "magical" enough. It was turning into a good-looking piece but it was still

empty. I didn't feel the magic and the fantastic nature I was aiming for. I was stuck. I wasn't sure what it needed and that's when I took a step back and walked away from it. When I'm stuck on a painting it always helps me to work on something completely different in order to free my mind from it. This was the hardest part to overcome. After I cleared my head I came back to the painting and realized that the trees were interesting but it felt dead. I didn't want to add branches or change the composition because I knew that would just make it overly complex. So I decided to play with light. I created a Color Dodge layer and began to bring light within the trees themselves (**Fig.06**).

It felt as if I had given it a heart. That was the magic I had been looking for. The forest was alive! For the finishing touches I added figures to the environment to give it a sense of scale (**Fig.07**). I also added more texture in the foreground and painted in some more pathways. After some more detailing, I was ready to call it finished.

CONCLUSION

My goal was to create a magical environment and have fun doing it. This was the most fun I have had painting and I hope it shows. It's always rewarding to know that you have achieved what you set out to do with a painting. Problem solving is a challenging and yet fun part of painting. Working on this piece helped to remind me to be patient and to walk away when I need to, knowing that eventually I'll figure it out. I hope that when people look at this piece they will be drawn into the environment and be excited by the story I'm trying to tell.

Fig.07

ARTIST PORTFOLIO

© JUSTIN YUN

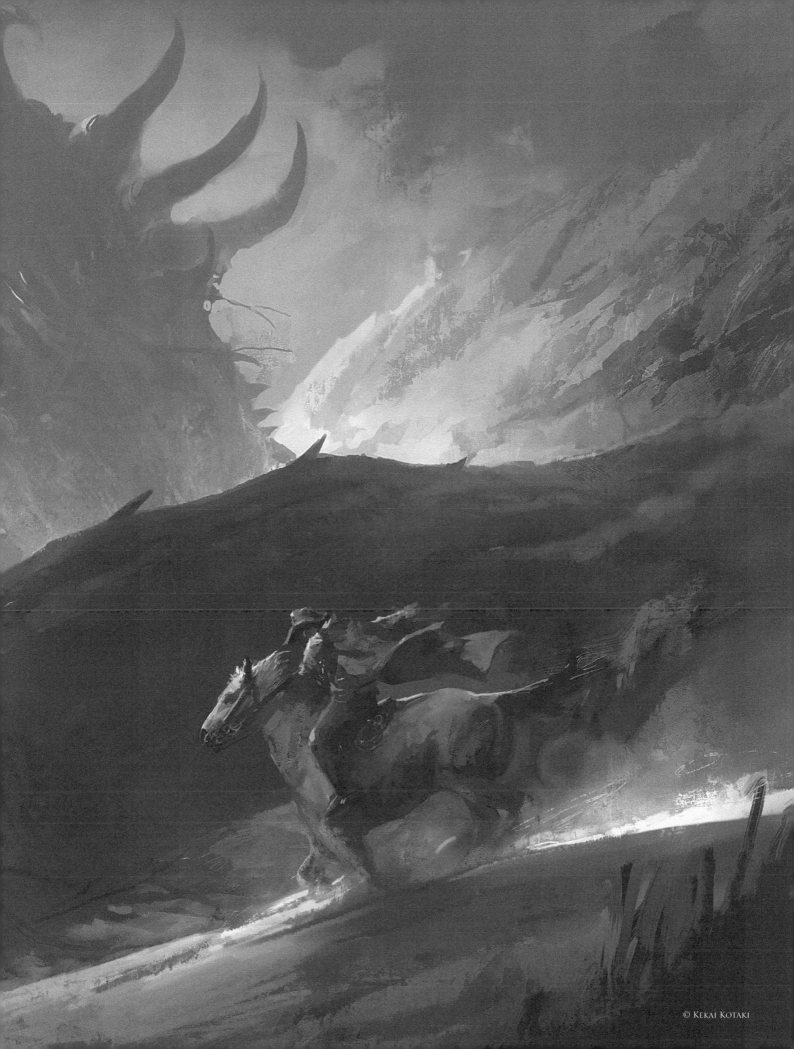

COWBOY VS. SANDWORMS

BY KEKAI KOTAKI

JOB TITLE: Concept Art Lead – ArenaNet
SOFTWARE USED: Photoshop

INTRODUCTION

I like to give myself little side projects when my schedule is open. This gives me the chance to do things that I enjoy and at the same time get some practice in too. Also, being able to update my blog is always a plus. The piece *Cowboy Vs. Sandworms* started out as a little speed paint that I liked to call *Cowboy Vs. Sandworm*; get it? – there's only one. (**Fig.01**).

Lame joke, I know, but that is the last one … maybe. Anyway, after looking at it I really wanted to push it further and actually get a good piece out of this concept. Something I could put in my portfolio and submit to publications. Cowboys are awesome and everyone loves sandworms. Slamming the two together seemed like the next logical step.

> " HAVING A STRONG DIRECTION TO FOLLOW RIGHT AT THE START SOLVES MANY OF THE PROBLEMS THAT MAY APPEAR TOWARDS THE END OF A PIECE "

Fig.01

Fig.02

Fig.03

STARTING OUT

When starting a piece I like to work in black and white. Grays naturally begin to occur too. I like to get the composition started as soon as possible. Having a strong direction to follow right at the start solves many of the problems that may appear towards the end of a piece (**Fig.02**).

To help me out I like to add in texture layers. These are things I paint that can be placed anywhere and which I like to keep because I can use them again (**Fig.03**). I generally like to set these layers to Soft Light.

SIDE THOUGHT

One of the reasons I like sandworms is because they are simple shapes. They help me to practice getting

movement into my compositions because at their core that's what they are: big shapes swooping across the page.

SANDWORM

Here, I have already settled on where the sandworms are positioned (**Fig.04**).

Although still rough, I was pleased with their general placement. I now tried to figure out what kind of details they would have. I knew that the sandworm's mouth was going to be the one place where I could really design something. Should I go for the standard "Dune" or something a little different? I went with a spiky-headed sandworm. I chose to use a smudge brush during this time as it allowed me to get a broad "arty" stroke really quickly.

DETAILS

Fig.05 shows the stage at which I was rendering and putting in additional details. At the same time I tried to

Fig.04

Fig.05

Fig.06

make the heads appear consistent so that they looked like they were the same species. I was basically trying to draw the same sandworm head from different angles.

Fig.06 shows where I have used the same trick touched upon earlier, using an old painting that is layered over the top to create some textural detail.

> ❝ THE CLOSER THE ELEMENT IS TO THE CAMERA, THE MORE DETAIL IT RECEIVES. ❞ IT IS JUST ONE OF MANY TRICKS AND NOT A HARD RULE TO FOLLOW

Fig.07

Fig.07 shows a close up of the main sandworm. It shows the level of detail, or lack thereof, that I go for in my images. The closer the element is to the camera, the more detail it receives. It is just one of many tricks and not a hard rule to follow.

COWBOY

When I reached this point I realized that I needed a stage for my cowboy to be able to run with the sandworms. Looking back on my original sketch (see **Fig.01**), I did not feel quite satisfied with the big black shape in the foreground (see **Fig.05**).

This is when I started to add a slope to the piece (**Fig.08**).

I also added some more lighting to the scene at this point. Getting a cool bounce light off the ground really added some drama to a piece and it also gave me a chance to use a hot spot on the ground, which could be further used to highlight the cowboy. I also started to add color to the piece during this phase, using layers set to Soft Light and Lighten, which are favorites of mine. I also used Color Balance to shift the entire piece into color and out of the gray zone it had been in until now.

Fig.06

Side note: If you haven't already noticed, I knew where I wanted to put the cowboy. This may seem kind of weird, in that I like to block out things beforehand. However, because I was using that first sketch as a starting point, I knew where I wanted to go with it. At this stage I could basically see the cowboy in the piece. It was one more element just waiting to appear. Up until this point I'd just been setting everything up just right.

> ## DRAWING AND PAINTING A HORSE IS HARD ENOUGH, BUT INCLUDING A RIDER JUST ADDS TO THE PAIN

COWBOY 2

The cowboy finally arrived at this point (**Fig.09**).

I started rough and just kept on going until something looked right. Having reference pictures of people riding horses to hand helps a ton. Drawing and painting a horse is hard enough, but including a rider just adds to the pain. Also, I hadn't really painted the final lighting into the scene yet. I was just using generic lighting at this point, trying to get things to look right. The dynamic lighting

Fig.09

came later, when I was comfortable with what I had. You can see the different brush strokes and the roughness in the close up shown in **Fig.10**. Even though it was rough I tried to make sure each stroke counted so that I wasn't just making a mess.

FINAL

Here I added the final touches. At the end I like to tweak certain things such as the color and contrast. I try to make sure things stand out and "pop" in the final piece. I also dropped the main sandworm back so that it rested firmly on its own in the space in the piece. Having the dusty clouds in there sort of blended the two together, taking away some of the scale of the sandworm. Adding a shadow to the cowboy helped emphasize the highlights around him. The final thing I did was to smudge some tall grass into the foreground to add some interest there (**Fig.11**).

Fig.10

CONCLUSION, ENDING, ETC. ...

This was an exercise in trying to create an exciting composition. Using and being aware of the components involved with the piece helped immensely. By understanding the elements I wanted to play with I was able to get a sense of movement and direction. I was also able to establish lighting that helped convey depth and scale and, in the end, I was able to draw a cowboy riding with some sandworms.

Fig.11

FANTASY

FANTASY

GuildWars 2: Mole Mine
By Richard Anderson

JOB TITLE: Concept Artist – ArenaNet / NCsoft
SOFTWARE USED: Photoshop

INTRODUCTION

This concept was done for *Guild Wars 2*. The assignment I was given was to create an underground mine. I was given a description of the monsters and races that would populate the mine and would likely meet underground.

The thing with this first concept was that I wanted to keep that kind of traditional, dirty old mine feel, but give it something new and mysterious. I started looking at a lot of references, everything from old mines to random heavy structures under construction. In fact, what I typed into http://www.flickr.com was "massive structure construction".

So, after gathering and looking at a lot of references, I started my concept. The first thing I started to do was just lay down some rock texture and play with the layer modes to get what I thought would be the best look. I do that a lot; just scroll through the layer modes and see what happens and a lot of the time you will notice something you didn't see beforehand that looks really good. I find it keeps a lot of variation in the colors and ideas open.

So, after playing with that for a bit and getting a feel for what I thought I would want, I started blocking in my perspective. I figured that as this was a mine there would be little paths everywhere and I thought this would be the best place to start since it's what you would mostly end up seeing (**Fig.01**).

> " I DO THAT A LOT; JUST SCROLL THROUGH THE LAYER MODES AND SEE WHAT HAPPENS AND A LOT OF THE TIME YOU WILL NOTICE SOMETHING YOU DIDN'T SEE BEFOREHAND THAT LOOKS REALLY GOOD. "

So now that I had a texture to play with, I started to once again experiment with the sharpness and Color Balance, and as you can see I actually flipped the images and laid down a rock surface for the floor as well (**Fig.02**). Still not sure exactly where I was headed, I played around for a little bit to arrive at what I thought would be the best solution. I cooled the colors down and started to focus more on the actual look of the path.

MAKING OF

I now had something I really wanted to proceed with and so started to think about the surface of the floor, its supports and whether it should be rock or mud. Maybe it was a giant hole with a hanging walkway? I decided it was better to situate it on the ground for the sake of the game, as solid ground was necessary for gameplay

Fig.01

Fig.02

> ## ONE THING I REALLY LIKED ABOUT THE SUPPORT BEAMS WAS THE HORIZONTAL LAYERING OF THE BOARDS, WHICH HELPS WITH THE DIRECTION OF THE PIECE

reasons. One thing that I really liked was the yellow lighting, which I thought had a good vibe. Something I wasn't sure about was the look of the green cold stone, so I decided to change it.

You can see in **Fig.03** that I have warmed up the image using the Color Balance tool and flipped it once again. This simply came down to what I thought looked best for the piece. I also liked how the roof of the mine couldn't really be seen so I started to play with the silhouette of the cave walls. When doing this I used the Lasso tool, making a random selection of the other rocks, copying and pasting them in and then erasing away until I found a good silhouette. I also found a great photo of a support beam from some ongoing construction. I pasted in the photo and played with the Transform tool a bit, also overlaying some color to match it with the painting I had already started. One thing I really liked about the support beams was the horizontal layering of the boards, which helps with the direction of the piece. Since I had a mainly vertical composition it helped to create a certain kind of rhythm to the piece. Another bonus is that the lighting in the photo was appropriate and really matched well with what I already had in the painting. In my mind I already knew that I was going to add a few more along the path (**Fig.04**).

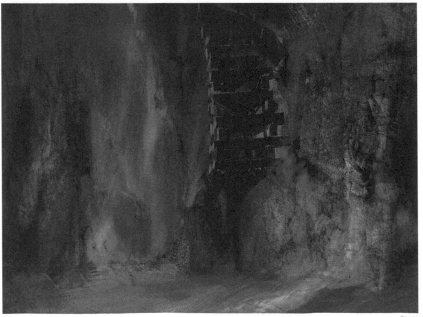
Fig.03

FANTASY

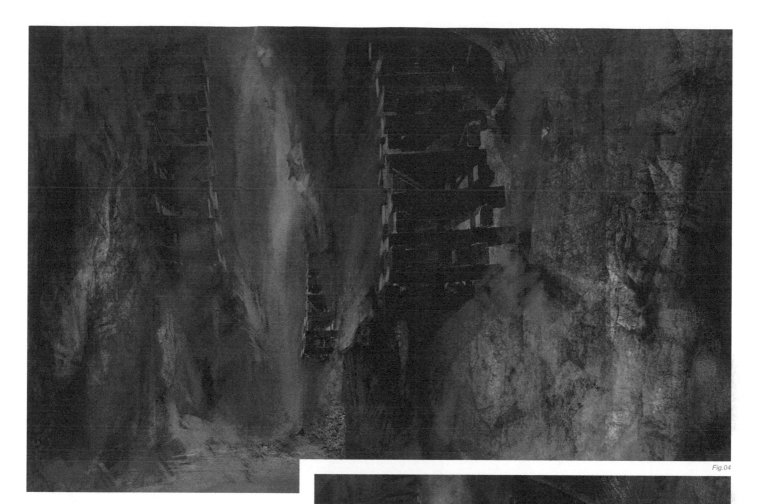

Fig.04

You can quickly see that I've just copied and pasted the pillars, using the Transform tool to scale them down and correcting their perspective. This really started to bring the picture together and my coworkers weren't so confused about what I was trying to do!

In **Fig.05** I started to really draw in the shadows and play with the Levels on some of the layers to bring out more contrast. I also made a layer set to Multiply in order to

Fig.06

Fig.05

draw out some of the pillar shadows. Once I had established my light source I thought about how strong I wanted it to be and how reflective the surfaces would be.

Now in **Fig.06** it was time to draw out my path. At the beginning of this piece I was looking at tons of reference photos and I came across one that was great. It was of a small mine or type of hole using boards as walkways, creating a platform over the mud, which I thought would look great in my mine. So I painted in some boards in a way that drew the eye through the mine. You can also see that I drew some ropes or cords hanging from pillar to pillar.

Fig.07

As I got closer to completion, I decided to get rid of the ropes for the time being and concentrate on the detail and lighting of the boards that guide the viewer through the mine (**Fig.07**). I wanted to push the contrast even more using Image > Adjustments > Levels, and add a few more shadows. Further down the tunnel I wanted to have a softer contrast to show more depth and keep a stronger contrast nearer to the viewer.

I felt at this point that the piece was very close to what I had in mind, with the improvement of a few happy mistakes along the way.

In **Fig.08** I decided to add some ropes once again to help draw the viewer further down the path. In the actual game I thought it would also give the cavern a more mysterious look, especially if you could see the ceiling of the cave with the ropes acting as a barrier.

Now complete (**Fig.09**), I was happy with the look and feel of the piece, and so played with the Levels a bit, adding a few "darker darks and brighter brights" – sounds like a detergent commercial!

Fig.09

I used Color Balance really quickly to brighten up the yellows in the highlights and bring some more red out in the shadows. Finally, just before calling it a day, I tried to add a more painterly feel and create some hard edges using the Smart Sharpen filter to enhance the sharpness of the image.

CONCLUSION

You know when you have a few pieces that you really learn from…? This was one of them. With this painting I was really trying to force myself to work quickly and use my resources to meet the art director's criteria. I realized that simply adding those cross pillars and boards as a compositional device really brought the piece alive. I was really thinking about how others would view this and how I could help them and that's why I added these elements. I guess I learned not to get so wrapped up in my own thoughts and try to consider the viewer a bit more.

Things I would change for sure in this piece are a few of the foreground elements. When looking at it now, I feel it could be a bit more intense in the foreground with maybe a bit of bubbling mud under the boards or some larger rock slabs at the base of the pillars.

All in all I'm happy with the outcome of the piece and I hope whoever looks at it or plays through these levels in *Guild Wars 2* will enjoy themselves too.

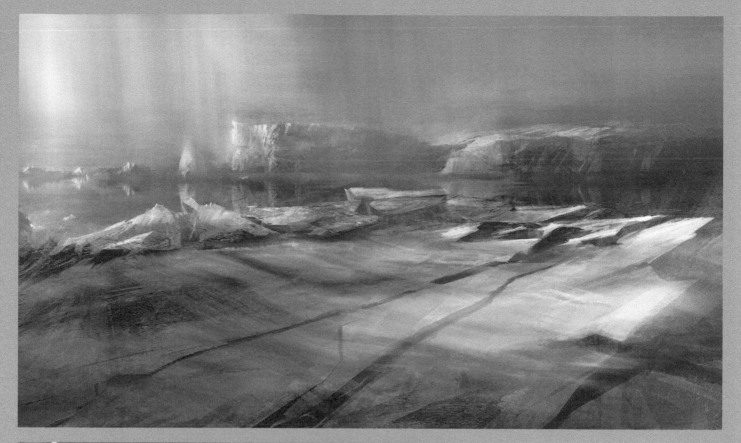

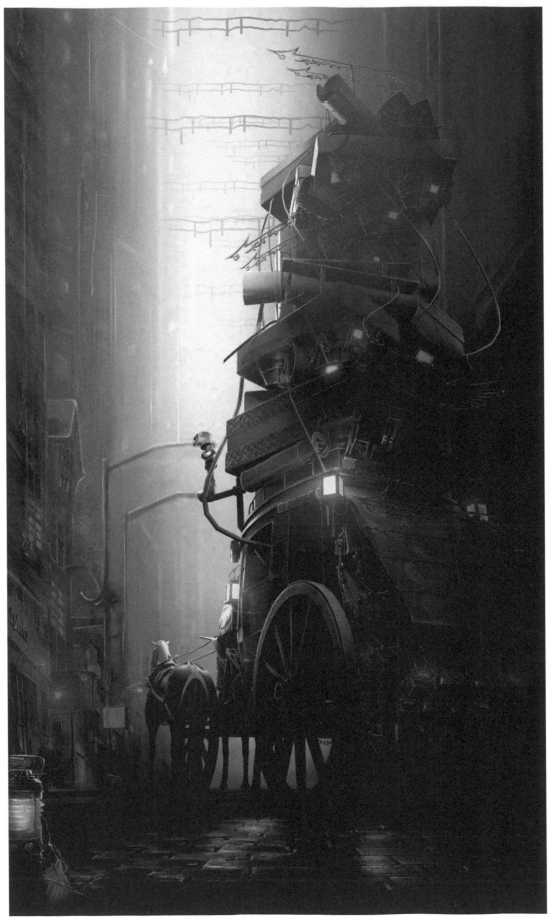

© JIEMA

CHRISTMAS EVE
BY JIEMA
JOB TITLE: Matte Painter – Pixomondo Visual Effects
SOFTWARE USED: 3ds Max, Photoshop

INTRODUCTION

Hi everyone, I'm Jiema from China and I work as a matte painter. It's a great honor to be introduced in *Digital Art Masters: Volume 5* and I'm happy to share my production knowledge of *Christmas Eve*, which I hope you will find helpful.

WORKFLOW

This work was finished on the last day of 2007. I was alone on Christmas Day that year and had many worries about study, work and family at the time. On Christmas Eve I thought about what I should do to remember that year, and then this subject came to mind. I didn't know how the picture would eventually look. Later, I came across a small work I had done when I was learning 3ds Max and felt it was an interesting picture and that it would

Fig.01 Fig.02

be a shame not to finish it. Unfortunately I couldn't find the 3ds Max file, but then it occurred to me to finish it by way of matte painting.

I guess you may be curious about Christmas Day in China. In fact, the atmosphere downtown is like other countries: lively and full of people. But when you go back to your housing estate, it is quiet and normal; you almost can't feel a festival atmosphere. Christmas Day is not strictly a festival for the family in China, but is instead like a kind of social recreational activity for people. It's difficult to avoid a sense of loss when people come back after their reveling, feeling the contrast between the lively downtown area and their dreary housing block.

I therefore had the idea of using Christmas Eve to express the sense of loss that was reflective of my mental state in 2007.

I will now address the production process.

Fig.01 shows the original 3ds Max work. As you see the image has no real detail; it is just an unfinished scene created as an educational exercise. I just put some interesting models together without really knowing what I was doing. I was not proficient in 3ds Max at the time and so rendered it out without textures and little light. I planned to add the color and light within Photoshop in the next phase of production. The 3D picture was just the rough draft in this process.

I started by gathering some reference images. Next, I spent time building up an environment, during which time my train of thought became clearer (**Fig.02 – 03**).

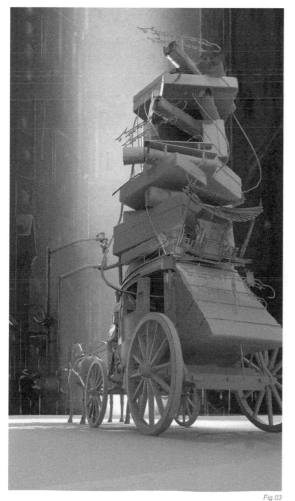

Fig.03

Fig.04

Fig.05

I continued to enrich the scene, using the pictures I'd found to make up a new house. During this process I did not feel any need to rush into depicting the main objects because I wanted to present a rich scene around my focal object (**Fig.04 – 05**).

EMPHASIZING PARTIAL DETAILS EXCESSIVELY WILL MAKE THE PICTURE DISJOINTED

Once satisfied with the environment, I started to work on the main objects, which was an interesting process. It is great to see a beautiful thing emerge gradually before your own eyes and to be able to improvise along the way. My approach was to establish the color, add details and patterns, portray light and generally accentuate the environment (**Fig.06**).

The property of the Softlight brush in Photoshop can easily imitate the effect of a glowing lantern. I set the brush strength at about 10% and then drew the light effect I needed lightly in the center of the luminosity (**Fig.07**).

Fig.06

Fig.07

Fig.08

When working on the main objects in a scene, it's important to pay attention to the environment. Emphasizing partial details excessively will make the picture disjointed. I added some new elements into the picture at this point, several of them being mechanical objects to make it more like a steampunk image. I like things with that feeling! After that, I returned to the background and continued to work on it.

FANTASY

Fig.09

Lighting is used several times in this work. When I added the lights, I always reminded myself not to make them too disordered and to show the difference between near and far lights through changes in the brightness. Different lights were used to emphasize the sound perspective of the scene. I also used a hard brush to highlight the rim lights on the borders of the main objects and give them cool and warm colors. This gave the image plenty of details (**Fig.08**).

Because the color and shadows of some objects had changed, I had to return to the ground. I found a texture picture of ground from a free texture website, but it's unfortunate that the original type was lost.

I drew the color and brightness reflected onto the ground strongly on purpose because the ground was looking too dreary. I drew them in the same way that I'd done the lighting earlier (**Fig.09**).

Finally, I adjusted the brightness and contrast, which completed the work (**Fig.10**).

CONCLUSION

As you see, it wasn't too difficult. I hope this article was enlightening and gave you a good look at the creation process behind this image. If you have any questions, you can send an email to me.

Fig.10

ARTIST PORTFOLIO

© JIEMA

TITANOMACHY: FALL OF THE HYPERION

BY MARCIN JAKUBOWSKI

JOB TITLE: Freelance Concept Artist

SOFTWARE USED: Photoshop

INTRODUCTION

The image was painted for the CG Challenge "Steampunk: Myths and Legends" run by CGSociety. My goal was to create a dramatic scene in a spectacular location with iconic elements connected to steampunk. I love painting huge metal structures so I dreamt up the concept very quickly.

PREPARATIONS

I started by seeking the reference materials and ideas for the railway station, locomotive, people and typography. The old photos of the demolished Pennsylvania Station in New York proved very inspiring. I made some concept sketches of the main objects such as the locomotive, gigantic robot and elements of the hall construction (**Fig.01**).

Sketching is one of my favorite stages of working because it's very creative and there's yet to be a need to make any crucial decisions. I already had a conception of the scene in my mind, but I wanted to see how some other variations would work. I drew a few quick thumbnails that only confirmed my choice (**Fig.02**).

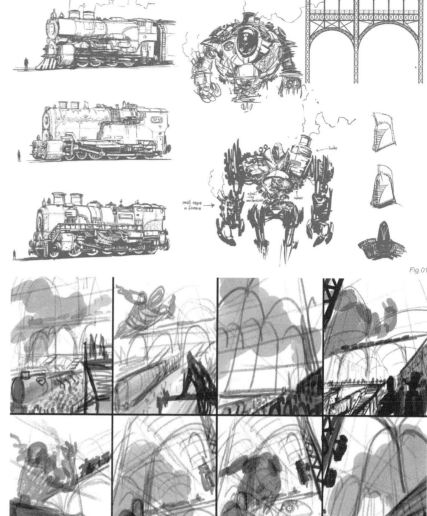

Fig.01

Fig.02

> ## I PLACED THE MAIN ACTION IN THE CENTRE OF THE IMAGE, TO WHICH THE EYE IS LEAD THROUGH THE RHYTHM OF THE STRUCTURES

COMPOSITION

My vision of the scene was monumental and the atmosphere tense. The crowd remain unaware of the situation; the falling structure is still in the air. I wanted to depict the feeling of a moment in time just before the disaster. I decided that the best angle was as if the observer was part of the crowd, staring dumbstruck at the collapsing structure. I placed the main action in the centre of the image, to which the eye is lead through the rhythm of the structures. An additional way in which I tried to direct the attention was through a continuation of the arch and dense details such as debris, human figures and the clock.

PERSPECTIVE

Before I was ready to move on to the painting I had to plot the perspective accurately. I was afraid that if I made a mistake at this point it would be impossible to correct such a

Fig.03

complicated environment later. Having the simple sketch in the background, I established the horizon line and drew a grid on a new layer. I copied it several times so that I could reuse it.

First I wanted to use one of these copies to establish the upper vanishing point. I transformed the perspective (Ctrl+T and then right click the mouse, choosing Perspective from the menu), tapering the top and therefore creating the upper vanishing point. I chose it arbitrarily, trying to preserve the balance between a natural look and the distortion of a wide camera lens (**Fig.03**).

The second grid was then transformed (Ctrl+T) by dragging the corners with the Ctrl key held down. The left and right sides were aligned with the previous grid and the bottom with the horizon. The upper side matched the side of the train (**Fig.04**).

I could then stretch the grid across the whole image by moving the points in the middle of each side. Scaling a grid by simply dragging the corners should be avoided

Fig.04

Fig.05

Fig.06

because by doing this the perspective is lost. The last grid was transformed the same way, but only matched the front of the train and the background constructions (**Fig.05**). By using the transformed grid, I avoided painting the vanishing point, which is often beyond the canvas. I tried to preserve an accurate consistency across the grid as it helped me to keep the structures in proportion later on.

CONSTRUCTING
When the perspective grid was ready I could draw the side of the train and transform two circles, creating the shape of the steam boilers. It was important to make it neither too wide nor too narrow (**Fig.06**). I had to trust my grid and intuition because to construct it using geometrical rules is rather complicated.

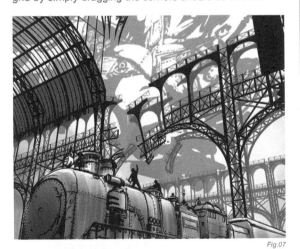

Fig.07

After this I was ready to build the metal construction behind the train. I picked up the previously designed elements consisting of the arcs and the columns and transformed them to align with the grid. This had to be done with every part of the station, including the background. I kept them on separate layers and locked the transparency (/ key) to make the painting easier. This was the most time-consuming and frustrating part of my work and during this phase I tried to continually bear in mind the rhythm, scale and proportions. When the hall was done I was able to move to the coloring stage with a feeling of relief (**Fig.07**).

PAINTING
In apprehension of the scene developing into a mess, I decided to use calm and clear colors without any bright light. I laid down the first layer of plain colors with a big brush (**Fig.08**).

Fig.08

FANTASY

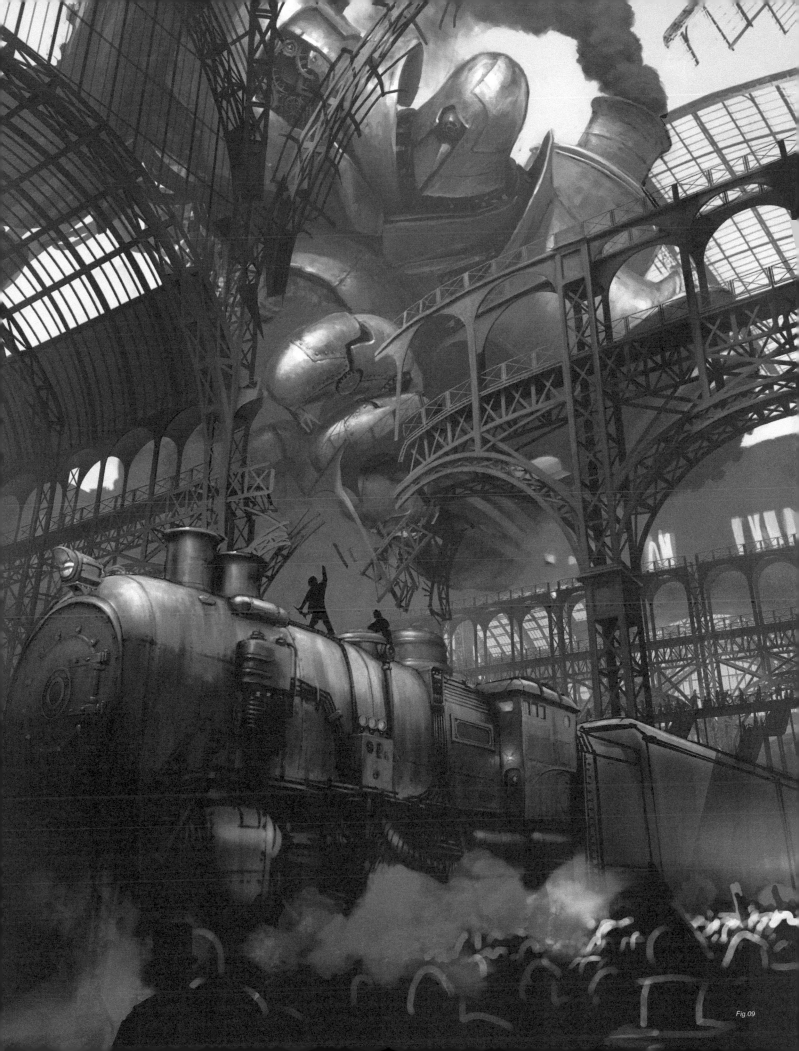

Fig.09

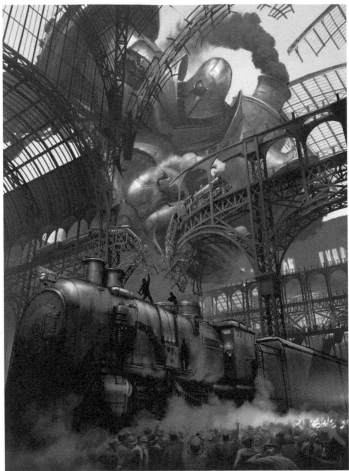

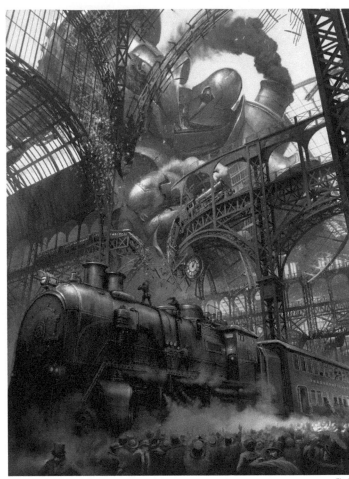

Fig.10

Fig.11

Some textures assigned in Overlay mode provided a little variation that inspired me to experiment with additional colors. I added the details gradually using just a few simple brushes and no special tricks. Some of the key steps are illustrated in **Fig.09 – 11**.

Maybe the thing worth mentioning is that for shiny metals and glows I often use a brush in Linear Dodge mode with a low opacity. I paint directly on the layer incorporating the

metal object, which gives better results compared to making highlights on a new layer set to Linear Dodge or Screen mode (**Fig.12**).

To create a clear sense of depth and avoid any distracting details, I employed steam as a structural device. It helps to smoothly integrate different spatial planes in the scene, softens the image and brings with it a specific mood that is so important to the steampunk world. The steam looks more interesting if it's opaque and consists of dynamic puffs or twists. I painted it with an irregular but simple brush and smudged it a little in some areas. As for the base colors, I picked out a range from grey through to blue but dismissed white. For simulating a light dispersion within the steam, I locked the transparency and lightened it with a round and Soft brush in Overlay mode.

> " AS A RESULT OF THE BATTLE I HAD WITH THE PERSPECTIVE AND GENERAL CONSTRUCTION, I HAVE DECIDED TO USE 3D SOFTWARE IN THE FUTURE "

Fig.12

CONCLUSION

I managed to create a satisfying image before the deadline. The image was interesting as a whole as well as in the details. As a result of the battle I had with the perspective and general construction, I have decided to use 3D software in the future just to make complicated things easier. I feel as if the dark side of the Force has evolved in me!

FANTASY

© James Paick

Sci-Fi

There are many subgenres and themes within science fiction that make it difficult to explain and categorize, but a successful painting will guide a viewer to the exact moment in an artist's story. Because these paintings are unique to the artist, there are endless possibilities of design that can be examined. There is no perfect formula, so exploring options and finding inspiration can help one get on the right track. It is important to have a vision and a point of view in each painting. This chapter is filled with many examples of successful paintings that tell a story from the artist's perspective.

James Paick

james@scribblepadstudios.com
http://www.scribblepadstudios.com

© Andrée Wallin

Deep Impact
By Andrée Wallin

Job Title: Concept Artist – Andree Wallin Art
Software Used: Photoshop

Introduction

For those familiar with my work it may not come as a surprise that I'm a sucker for big shiny robots and stuff exploding. *Transformers* may not be Oscar-worthy material but it certainly provides me with a lot of inspiration and ideas for these paintings. With *Deep Impact* I really wanted to create a very intense shot of a robot landing in the middle of a chaotic battle, clearly set on a target and with no intentions of letting a few missiles scare him. As with most paintings I do, I went with a very cinematic style, mostly because I always visualize my paintings in movement. You could say that I try to find the most intense, epic frame of the movie playing in my mind and then just do my best to make it come to life.

> ❝ You have to really pay attention to how light behaves when you study your reference material, because it will pay off in the end ❞

Workflow

When starting a new piece, I normally begin by working out the composition, usually in the form of a very rough speedpaint in which I also try to paint the main light sources. If I'm having trouble finding a good composition I might stay away from colors at first and just paint some

Fig.01

Fig.02a

Fig.02b

line art and then take it from there. It produces a very rough image, as you can see in **Fig.01**, but you can still get a good feel of how the end result will look. For this painting I wanted the composition to be very easy to read, which is why I kept my main object in the left third of the canvas. Thanks to the lighting and the amount of smoke/dust in the air, the background was very light and made the robot pop out more. I wanted the main focal point to be the robot's head, which by the rules of composition is a bit offset but worked pretty well in this case.

It was now time to start on the details (**Fig.02a – b**). First of all, painting metal requires a bit of practice. The best way to learn is to study photos of engine parts, old armor or – better yet – stills from movies like *Transformers*. It is very easy to go crazy with rimlights and highlights but that's where you have to be careful – remember your focal points and the fact that metal does not always reflect light in the most "obvious" way. You have to really pay attention to how light behaves when you study your reference material, because it will pay off in the end.

Fig.03

Now, if this was a shot from an actual movie, this robot would've been at the concept stage long before being put into action. But since I didn't have time to do line art on this one I really had to use every trick in the book to make it look well-designed, which means it was not proportionally correct and was a bit asymmetric. Thanks to the pose, however, the viewer probably won't notice this at first glance. Also, the dust being thrown up in the air covers up a lot of his legs and left arm, which of course saved me a lot of trouble.

As you can see in **Fig.03 – 04,** I made some slight adjustments to the different body parts as I went along. This was just because things that looked good at the sketchy stage didn't necessarily look as good in full detail. Also, I consistently tried to find the most badass pose for this guy.

Fig.04

" **I FELT THE SILHOUETTE NEEDED SOME IMPROVEMENT, WHICH IS ONE OF THE REASONS I MADE HIS RIGHT ARM INTO A WEAPON** "

Detailing this painting was a fine balance between adding too much and too little. The work-in-progress images don't really show this, but I had to go back and repaint certain areas a few times because they drew too much attention and messed up the composition. At this stage (**Fig.05**) I felt the silhouette needed some improvement, which is one of the reasons I made his right arm into a weapon instead of the hand from the sketch stage (but also because of the obvious fact that he is a war bot without any visual signs of his purpose).

My initial plan for this painting was to make the background just as detailed as the robot, but when I'd been working on the robot for a while I got the idea to

Fig.05

Fig.06

make the background in a more speedpainted fashion (**Fig.06**). This was partly to save some time but also because I'd never tried it before and I thought it might look cool in a more stylized way.

Towards the end of the painting I threw in a bunch of grungy textures on separate layers and switched the layer mode to Overlay with a very low opacity to give it a dirtier look. I also added a few more details in some places and made others a little rougher to make sure it was comfortable for the eye to read (**Fig.07**). Remember to zoom in and out during the process to keep an eye on the composition, and also flip the image every now and then to find errors in perspective and refresh the eye.

CONCLUSION

A few bumps along the way, as always, but all in all a very fun painting to make. It's always a little tricky to make these semi-detailed paintings. Like I said, sometimes there's a fine line between too much and too little, but that's usually no problem if you just have some patience. You'll then be able to spot those errors and flaws sooner or later. And also, most importantly, remember to have fun!

Fig.07

ICARUS DAY
BY TOMASZ JEDRUSZEK
JOB TITLE: Digital Artist
SOFTWARE USED: Photoshop

INTRODUCTION
My name is Tomasz Jedruszek and what follows
is a comprehensive look into the working process
behind of one of my latest and most successful
images, *Icarus Day*. The image was created for the
CGSociety "Steampunk" challenge and luckily it won
the "Digital Painting" Category along with a "CGS
Choice Award". Aside from the technical issues, you may be interested in
why this image is so powerful and so I will try to explain this also.

THE APPROACH
Just like for all the other CGS challenges, the most difficult part of
creating an image was coming up with an idea. In this particular
challenge the task was to take a mythological story or legend and
translate it into a steampunk style, creating something fresh and new. I
had some candidates of course – mainly from Slavonic mythology – but
as it is less commonly known I opted for Greek mythology, using a more
widely known story about Daedalus and Icarus.

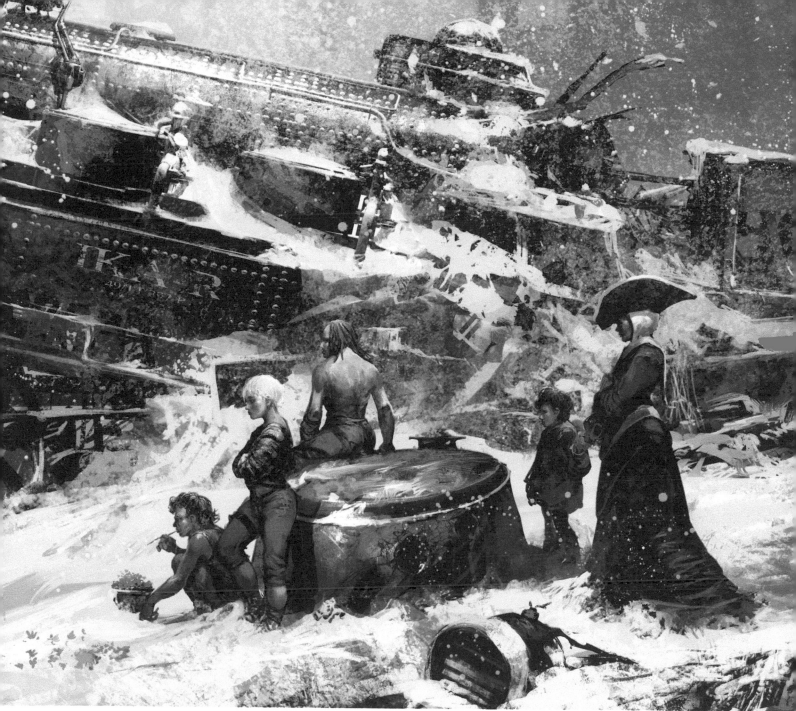

"WHAT IS MOST IMPORTANT IS THAT I HAVE A LOT OF EMOTIONAL TIES TO THIS WORLD AND ITS CHARACTERS, WHICH IS CRITICAL TO THE FINAL SUCCESS OF THE IMAGE"

STUDIO LEVY AND SONS

Fig.01

Those who know me might already be tired of me talking about my Venhelis project, but it's actually appropriate on this occasion. Why, you may ask? Somehow those CGS challenges and their subjects always seem to match my story perfectly, but what is most important is that I have a lot of emotional ties to this world and its characters, which is critical to the final success of the image. For this challenge I decided to tell a story that takes place in my Venhelis world to make it easier due to its familiarity, but with a link to Greek mythology – simple, isn't it?

Now don't get me wrong – I undertook this challenge in haste. But this approach would have enabled me to solve any issues, even with months to complete the image. Making

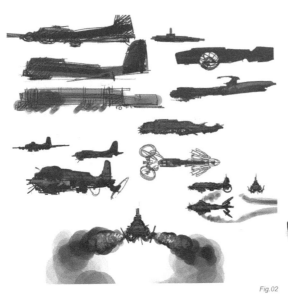

Fig.02

it straight forward, simple and readable was vital once the idea was established, and then I was able to go into details and specific characteristics.

REFERENCES

Before I started, I needed some background material – or, as we architects call it, foundations. The stronger the foundations, the more solid the building and, likewise, the more accurate the background material, the more tangible the "fantasy" feeling in an image. These should always contrast with each other, but if you explore a fantasy theme then be sure to give people something real that they can relate to. The opposite also applies – if you paint something real, be sure to give viewers something fresh through a touch of fantasy, eroticism or even madness. Otherwise you risk your image becoming boring and purely factual.

So, on the one hand I needed firm technical material, and on the other I wanted to let my imagination run loose to inject as much life as possible into the scene. I found a lot of photos matching my concept, mostly of locomotives, but also some simple scenes such as a frozen forest in

Fig.03

Fig.04

the morning. The most important reference image was an old photo showing something from the past, which proved key to the narrative success of the scene. I chose to convey the myth in a different context and from a completely new angle, focusing on the celebration of "Icarus Day", with Icarus referring to a ship that was shot down in a previous war. You can find the complete story on my website or the CGS challenge entry (**Fig.01**).

DESIGNING THE WRECKAGE

Wreckage is basically a mass of destroyed metal and other materials, which is of course true, but more importantly wreckage marks the remains of what an

object once represented. I tried to show a very believable model of an ancient ship styled in a steampunk fashion, with evidence of its previous beauty and power when in service. Now destroyed and forgotten, I was tasked with creating the ship's personality and encouraging the viewers to feel sympathy for the destroyed wreckage, missing the days when it flew overhead. In other words, I had to create a convincing narrative.

> ## NEVER BE AFRAID TO LOSE SIGHT OF THE IDEA IF YOU FEEL THERE COULD BE A SUCCESSFUL SOLUTION; IT ALWAYS PAYS OFF IN THE END

That's why I needed some recognizable shapes, my choice being the famous B-17 Flying Fortress bomber, with its almighty beauty. There was, of course, always a risk that no one would share a similar passion for this machine, but it was my job to convince them. I had the challenge of inviting people who weren't fans of aviation to see the beauty of these flying machines. Luckily we are all dreamers and one of the most popular dreams concerns flying, but other things I hoped would help were the shininess of iron or even the gold finishing on the pipes and other elements such as glossy paint. These types of things are mostly pleasing to the eye, after all (**Fig.02 – 03**).

As you can see from these sketches, I had been struggling to combine the B17 with steam engines, and of course there are always a number of ridiculous, but not less important, ideas explored during this process. Never be afraid to lose sight of the idea if you feel there could be a successful solution; it always pays off in the

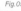
Fig.05

Fig.06

end. After some time I finally locked down the basic idea of the flying machine by copying a steam engine around one of its axes and duplicating it two or three times. This spawned a multitude of detailed design variations almost automatically.

One more thing came to mind while I was sketching – why not show the destroyed Icarus next to a new generation of flying fortresses, just to make the story more nostalgic? I had to go all the way back to pre-history for these types of machines … or did I? The answer was no, but again this helped to create something both logical and believable instead of a random design that could have made the story unnecessarily complex (**Fig.04**).

Sketching

Finally I could get down to the serious work: setting the scene for the image and its actors. My idea was to show the wreckage outside the city; not as a monumental statue of glory, but lost and lonely. I tried to think about places like Auschwitz, which has been left almost as it was after the end of the war. One can walk between blocks and barracks in the museum and almost feel the deaths of the hundreds and thousands of men, women and children killed there. I wanted to convey similar feelings in my image, showing the wreckage as a tomb containing the crew who had given their lives a long time ago.

The first idea revolved around a vertical composition, but it looked a little empty so I added a few kids in front (**Fig.05**). This was another key component for a successful narrative. Why not show this entire celebration

Fig.07

Fig.08

Sci-Fi

Fig.09

from the point of view of a band of homeless kids or orphans? The story actually had its start in the nostalgic world of Venhelis, which demonstrated these kinds of differences, but as you can see it almost accidentally worked in the image and fitted perfectly. Never be afraid to follow those spontaneous additions to your picture. Just be careful that they do not become too important, as in this case, where the kids have become more important than the Icarus itself, which was not quite what I wanted.

Consequently I tried a horizontal aspect, which although different was still a celebration. However, the VIPs were still more important than the wreckage. Apart from this, the frame was way too wide and I could barely see what was happening (**Fig.06**).

> ## PAINTING IS ALL ABOUT ILLUSION; AFTER ALL, EACH PAINTING IS A MOSAIC OF BRUSH STROKES THAT COMBINE TO CREATE AN IMAGE

Fig.10a

I tried another vertical composition, but this one looked too similar to the reference photo to me (**Fig.07**).

Finally, as always, success was the fruit of compromise. I used the settings from the first sketch but made it horizontal, which solved most of the problems (**Fig.08**).

The main two compositional accents take our attention from the wide view of the celebration towards the main character, the wreckage and then to a group of orphaned children who helped to decorate Icarus (**Fig.09**).

BORING PART

All I had to do now was finish the image. I know for most beginners this might be painful – hours of painting details and cleaning that loose sketch work. Well, it doesn't have to be like that at all; remember, you decided to become a painter because you loved it. Even later in life when you paint for a living as a freelancer or regular employee, it is still something you like to do more than anything, isn't it? By thinking this way the image almost grows naturally in your hands. Just keep these few tips in mind; they may well speed up your workflow and save your health:

- The level of detail needed depends on what is recognizable. You do not have to paint each hair on a character's head; instead, ask yourself what is important. How many hairs are there on that head and what is their color? Think this way and paint it this way.
- Use textures and custom brushes to add dust, natural textures or crispness to your objects, as they imitate the effect of detailed surfaces and in most cases the human eye won't even be able to tell the difference. Painting is all about illusion; after all, each painting is a mosaic of brush strokes that combine to create an image.

• Establish an order of importance and do not paint details where they are not required.

Another key to successful images, and something that is fun is to try, is to assume the roles of your characters. When you paint those soldiers, try to feel their pain as they stand there for hours, maybe cold, and their hands probably frozen to those standard poles. Think along these lines when painting and you will add life to your image.

FINISHING

It is important to keep your image on a consistent course during the entire creation process. Once you've reached this point, there is no time to make changes – it's all about crystallizing the scene. Adding depth of field, fixing the light, painting details and adjusting colors are areas to focus on. Most of these are as simple as adding global effects in your Photoshop layers. You gain full control in this way and if you do not like the effect you simply turn off the lighting layer, for example. I usually spend another few hours on finished images adjusting and adding effects (**Fig.10a – d**).

FINAL

I must say that, even though I was very happy with the final version of this image, I never expected it would be so well received by viewers. What was crucial here I think was the deep story, a simple but effective composition, and a fresh approach to an old myth. In this "making of"

Fig.10b

Fig.10d

Fig.10c

I've been trying to direct your attention to those moments that determine whether an image becomes stunning or just remains good. I also learned through painting *Icarus Day* that thorough research and a collection of good references are important. Creating a strong narrative to support the image and giving life to your characters will be well rewarded. I hope you will also learn from this too.

SCI-FI

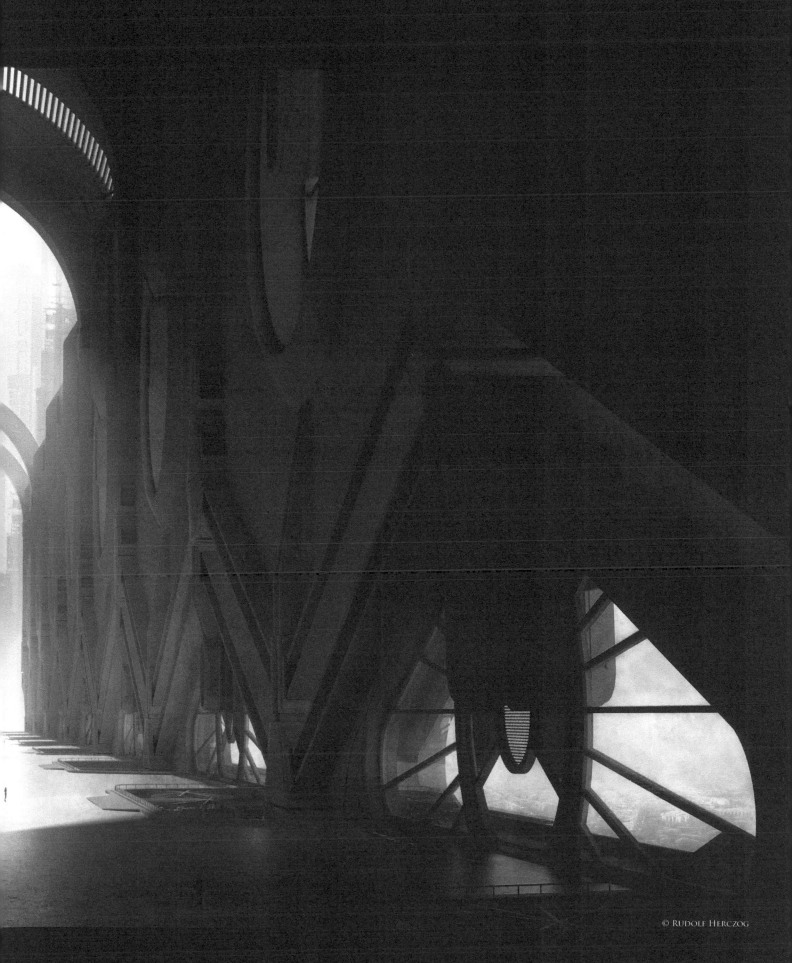

THE GATEWAY
BY RUDOLF HERCZOG

JOB TITLE: Freelance Artist

SOFTWARE USED: Cinema 4D, Maxwell Render, Photoshop

INTRODUCTION

You've all heard of the mysterious "tunnel of light", a near-death experience in which people find themselves floating in a long tunnel with a beautiful luminous light at the end. The idea was to depict this experience, but instead of using a clean tunnel I wanted the scene to take place in a massive futuristic gateway of sorts, which would allow the souls to pass through. I also wanted to show a glimpse of the afterlife. Rather than just using a bright light, I decided to put skyscrapers and a high-tech world on the other side.

MODELING

Normally I would take every empty surface as an excuse to fill in loads of detail, but in this case I decided to go for a much cleaner look and use a modern yet slightly industrialized architectural style with huge support beams and large, clean surfaces. Before I started, I did a few rough sketches of some of the detail to have a base to work from (**Fig.01**).

I started out by modeling the support beams using basic primitives and box modeling. I've always preferred to

Fig.01

Fig.02

have my scenes made up from many objects rather than keeping them to a minimum. The reason for this is that I find the models easier and quicker to texture later on. As I rarely use UV maps, I can use simple cubic mapping on most of the objects.

The intention was to model one set of walls with beams, all of which I could then replicate and use to build a long tunnel. As I wanted an industrial look, I added a lot of bolts and supports both inside and outside the beams. I also made a number of openings in the wall to allow for huge windows and to let more light into the tunnel (**Fig.02 – 03**).

After having added window frames on both the upper and lower parts of the wall, I wanted to put in a little detail around the large circular opening. This area looked way too empty, but instead of filling it up with greebles,

Fig.03

Fig.04

pipes or similar components, I opted for some simple wall plates and fixings. I also put some detail into the windows so that they were made up of more than just a few frames (**Fig.04**).

Once I was happy with the set, I started to build a longer tunnel using copies of what I had modeled by positioning them side by side. I continued with a curved roof structure and extended the floor plane. I made a few holes in the plane to allow for the large beams to continue down to a floor below and so I modeled some edges and railings around the openings and filled them up with greebles. These were composed of either primitive objects or very simple shapes (**Fig.05**).

LIGHTING & TEXTURING
This part was a fairly simple process. Normally I prefer to use a few simple materials in a scene, with moderate patterns, to achieve a uniform look throughout the structures. That was also the case here, where I used a material with a barely visible concrete

texture across everything apart from the floor and wall fixings. I chose a concrete texture with a slight amount of gloss for the floor and a more prominent, reddish metal texture for the fixings, which was just enough to make them stand out from the surrounding structures.

For the lighting, I used Maxwell Physical Sky and a slightly oversaturated sun as the only light source.

Prior to the rendering, I made the tunnel even longer, leaving out most of the roof in the section furthest from the camera, except for a few support beams that marked the exit. This allowed the sun to light up the scene even more.

After this, I set up the main camera and sent it to Maxwell to render overnight (**Fig.06**).

POST-PRODUCTION
The first thing I did once I had brought the render into Photoshop was to use several different layers to set up the base mood and color scheme.

The Maxwell output was way too cold and uninviting and I wanted to use some warmer colors in the scene, so I made a few layer duplicates and played around with different colors and layer effects. Using a huge number of layers may sometimes seem a little crazy, especially when working in higher resolutions, but I prefer working in a non-destructive way and using more layers rather than baking them together. This way I have total control and can easily make corrections on every single layer from start to finish if need be (**Fig.07**).

Once I had a base to work from, I went ahead and applied dirt to some of the areas, such as the walls and floor. During this stage I used various black and white dirt maps with different filters and opacity values. I prefer using this technique for the large majority of my scenes, as it gives me the greatest sense of control over placement, shape and transparency levels.

Fig.05

Fig.06

Fig.07

For this scene, I made a mix of several concrete and metal dirt maps, making sure that the end result displayed a random pattern to avoid any obvious repetition, which was important considering that it would be applied to a fairly large surface (**Fig.08 – 09**).

The last step was to put a large city in the opening at the end of the tunnel. I wanted to preserve the strong light, so instead of creating a set of detailed buildings I used some faint silhouettes. I used pieces of several skyscraper and construction photos to create a few different silhouettes, applying these to different layers. I played around with placement, filters and opacity values until I had a set of very tall buildings filling up the tunnel opening.

I then placed a few large, faint white ellipses, with heavy Gaussian blur, over and around the opening to simulate some level of sun haze. This was used to not only open the end of the tunnel but also to smooth the transition between the exit and the city backdrop (**Fig.10).**

Fig.08

Fig.09

Fig.10

CONCLUSION

I normally have a habit of creating scenes with a massive amount of small details, so it was really fun to work with much simpler shapes and clean surfaces for a change. It actually turned out to be one of the images I'm most satisfied with. I was also quite pleased with how the scale worked out, and will definitely do a few more in a similar style.

SCI-FI

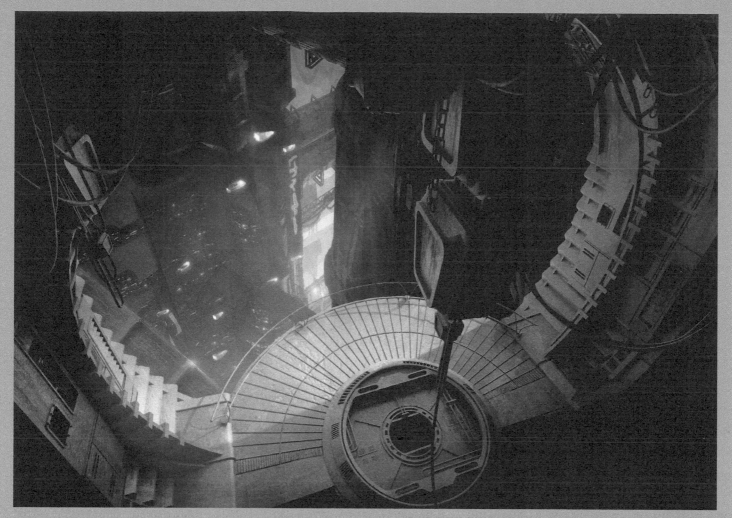

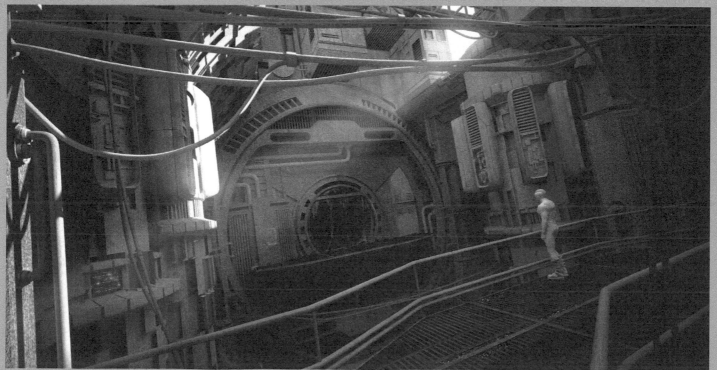

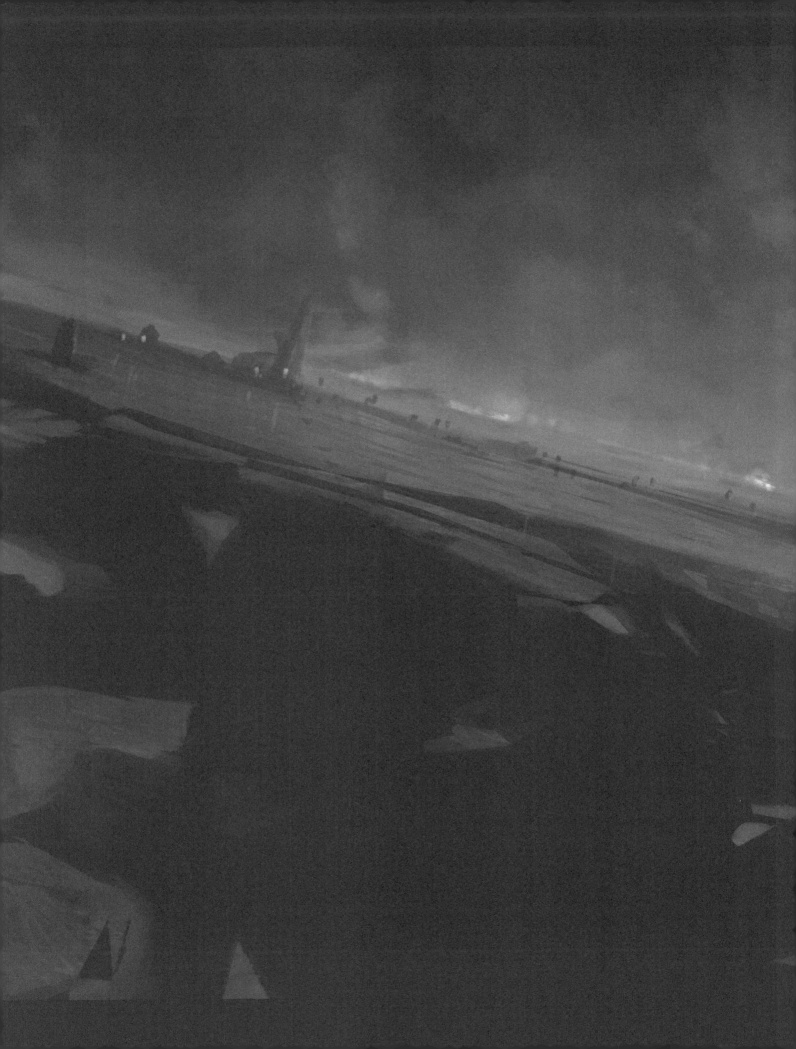

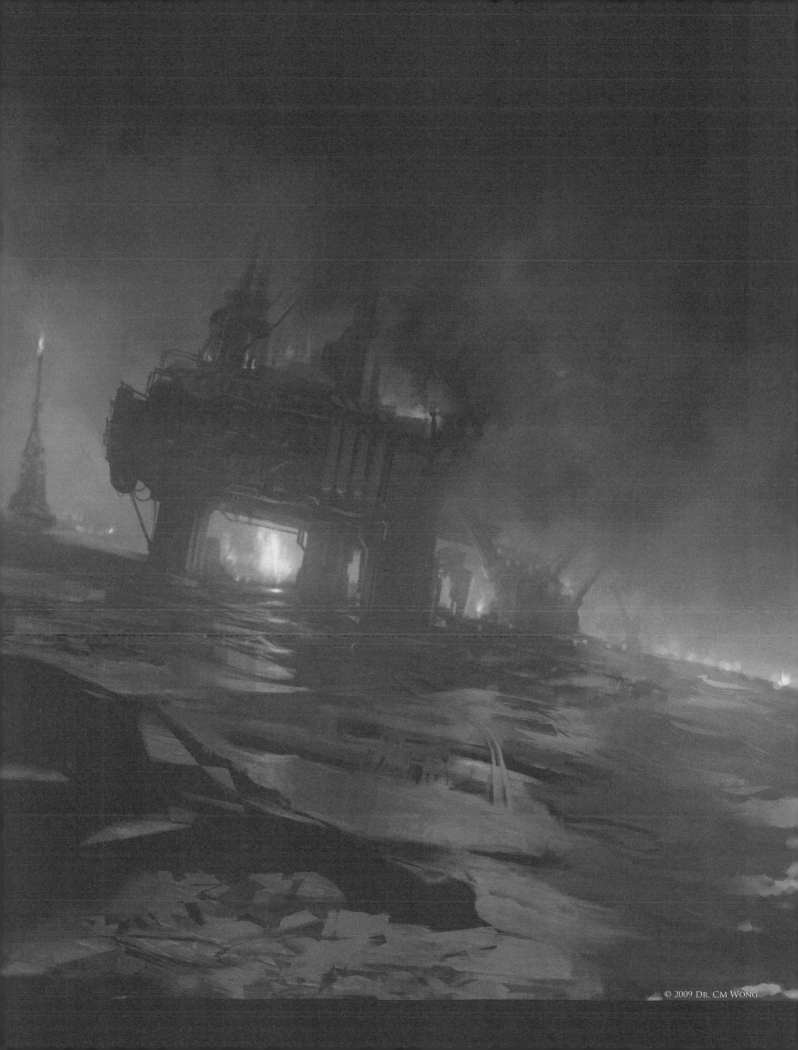

A Frozen Caisson Under Construction

By Dr. Chee Ming Wong

JOB TITLE: Art Director & CEO - Opus Artz Ltd
SOFTWARE USED: Photoshop

INTRODUCTION

When producing a piece of art it can sometimes be difficult when you have to adhere to a design brief while also being constrained by various considerations such as visual aesthetics and functionality.

I'm therefore going to consider this issue in the following article, as well as describing the process behind the creation of *A Frozen Caisson Under Construction*.

THE VISUAL TRIAD OF ART

When considering the design and visualization of a new piece of art, it can often be a small tug of war between where to start and what aspect to work upon. Much like the enigmatic question of the chicken and the egg, which came first? Perhaps one can even approach this as a form of entanglement; i.e., as a fried egg wrapped with slices of chicken congealed in egg white.

Here is a simplified representation of the various aspects that can be taken into consideration (**Fig.01**):

- Research
- Design
- Illustration.

1 - RESEARCH

When considering a place to start, perhaps it is best to begin with research. This can involve gathering as many

Fig.01

> DEVELOPING A STRONG VISUAL DATABASE OF REFERENCES CAN ALLOW THE ARTIST TO PRODUCE A SPECIFIC AND INFORMED IMAGE WHEN DESIGNING AND ILLUSTRATING THEIR PIECE

visual and factual references for the object in question as possible before you even lay pen to paper.

Certainly, this has its uses. The methodology has been proven time and again, and developing a strong visual database of references can allow the artist to produce a specific and informed image when designing and illustrating his or her piece.

Research can cover many aspects:

- **Knowledge base**: Understanding various technologies and how the inhabitants live can help one to develop a unique visual style
- **Functional base**: Functional design looks at how

Fig.02

various forms interact and function. This helps sell the overall believability of an object (especially when it combines various styles/functions from different eras).

- **Aesthetic base**: Involves determining how the language of overall forms and shapes influences the "readability" of an object. This can include textural qualities, wear and tear, and overall finish, which can help to determine how believable an object appears within its surroundings.

With these principles in mind, let's now consider the illustration in question: *A Frozen Caisson Under Construction*.

CAISSON

Simply put, a caisson represents a watertight casing used in underwater work. It is open at the bottom and contains air under sufficient pressure to exclude the water (passively or actively pumped out). Caissons are often used to construct the foundations of river bridges, concrete foundations and pilings of deep sea oil rigs, or simply to repair ships (**Fig.02**).

It was the idea of building an underwater city and influence from the adventure horror story *Bioshock* that got me thinking, how could one feasibly construct

Fig.03

and build an underwater city? There were various architectural and engineering works in Dubai that were in production at the time (namely the Hydropolis Underwater Hotel); however, to produce a more stylized 1940s construction would involve various construction rigs that were bulkier and less streamlined in shape.

Nevertheless, the use of materials such as reinforced plexiglass, concrete, steel and various dome-shaped structures meant that the construction of skyscrapers and a virtual city connected by tubes and domes could become a real possibility. So therefore I could start with a simple sketch.

Fig.04

Sketching: A Masterplan

I love sketching. Having a pen and paper and some of the best plans/designs can mean a design starts to come together even in the form of a simple and crude drawing.

For an artist, the ability to rapidly sketch and draft out a crude design or plan helps to provide the bones of any construction. The end product is often an amalgamation of the preliminary sketches, a cleaned-up line drawing and the final rendering of the finished product.

Fig.03 shows a preliminary sketch of the top view (plan) and three-quarter view of the caisson drilling platform. I imagined that the drilling platform could be a multi-tiered, multi-level platform consisting of various walkways and interconnecting control towers outfitted with large-scale hoists and construction cranes.

These would help house a large-scale pneumatic drill bit that could be extended via pipes up to nine miles deep. The platform itself would be stabilized via three gigantic supports linked to massive gravity-based structures (large prefabricated support structures held in place

Fig.05

Fig.06

by gravity; e.g., the *Hibernia* gravity base structure) whilst longer term supports are anchored to the ocean floor, to produce the initial pilings for a underwater city (**Fig.04**).

2 - Design

After developing a sketch it can be useful to actually refine the design. In my experience this is best achieved via a three-quarter perspective drawing, as it helps to explore

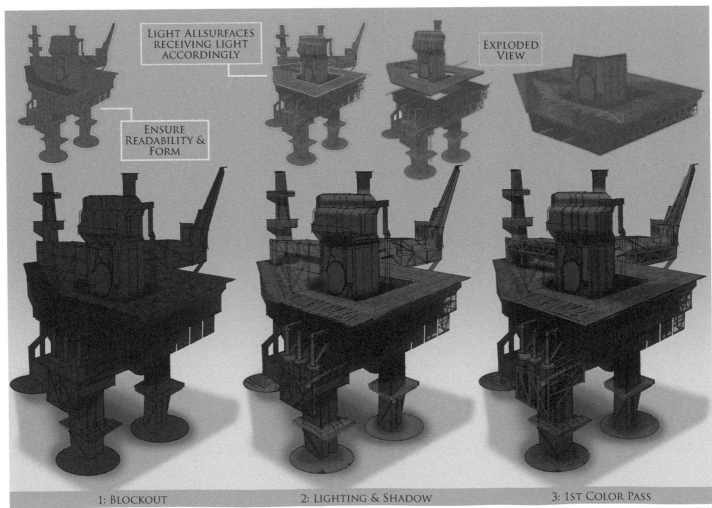

LIGHT ALLSURFACES RECEIVING LIGHT ACCORDINGLY

EXPLODED VIEW

ENSURE READABILITY & FORM

1: BLOCKOUT

2: LIGHTING & SHADOW

3: 1ST COLOR PASS

Fig.07

SCI-FI

the three dimensionality of an object in perspective. In contrast, other artists often find it easier to develop side and top view plans to develop their designs.

For this image I chose to produce a clean line drawing in perspective (best produced on a new layer) with the original sketch as a reference (**Fig.05**).

When you develop an image, the chances are you will enhance the design on the fly – drawing inspiration both from the original sketch and through the use of any photographic references. This will both help to accelerate the process and cut down on any initial confusion when establishing and developing the design.

The development of repetitive shapes is handy as these can be reused and transformed as required, relative to your perspective grid (**Fig.06**). A small point worth remembering is that a perspective grid doesn't need to be

1: ADDITIONAL RIGGING 2: EXTERNAL SUPPORT STRUCTURES

Fig.08

EXPLODED VIEW OF SELECTIONS

OVERALL FORMS

Fig.09

1: BLOCK OUT SHAPES & TONES

3: MULTIPLY + LAYER OPTIONS

2: LIGHTING

4: DIFFERENCE

Fig.10

too elaborate as long as it caters for your main vanishing point and both the vertical and horizontal axes.

SOLIDIFYING THE DESIGN

With the clean-line drawing completed, it was simply a matter of following this three-step process to produce a readable design (**Fig.07**):

- **Block out**: Use flat values or tonal ranges to establish the overall shapes
- **Add lighting and cast shadows**: A simple "top down" lighting setup, or one that is slightly angled from the left or right, will help sell the various key shapes
- **Basic color pass**: As long as your initial values are neither too dark nor too light, a faint wash of color can be applied (without loss of overall values).

Following the above points helped to establish the image in terms of basic values and color. The next step was to add some layers of complexity through additional rigging (**Fig.08**).

The considerations of external struts, piping and support platforms were included. When dealing with complex structures like this, it's important not to get carried away with complex detail as you'll risk losing the overall form and readability.

Throughout this part of the process I made various selections and masks of the various supports and layered structures. This helped to produce a more finished design (**Fig.09**).

3 - ILLUSTRATION

Fig.10 shows a four-part stage depicting the initial colored sketch and how this was developed into a dynamic composition.

When trying to refine and perfect a design it can help to produce a mood sketch. This can be achieved through a two-step process:
- Establishment of an initial sketch
- Further refinement into a final illustration.

INITIAL SKETCH

This can be a moderate-sized thumbnail, around 1200 x 900 pixels, which allows rapid exploration of color palettes and shapes whilst maintaining readability. This methodology of illustration can often involve exploration: organized chaos theory that is fortified with basic color and illustration techniques.

In this image the initial exploration utilized a layer set to Difference, which created various abstractions and shapes. This does, however, rely on a good pre-existing design in order to fashion plausible volumes from the various abstractions:
- **Color sketch**: A rapid block-in of tone and shape
- **Refined sketch**: Cast shadows and additional lighting

Fig.11

- **Iteration**: The same layer is overlaid at an angle and set to Difference mode
- **Difference**: Abstract shapes and forms are subsequently generated (**Fig.11**).

The next stage was to use this abstraction to generate a dynamic composition. I kept the aspects of the preliminary sketch and subsequent design in mind as this was a matter of refashioning the various masses and shapes into a coherent whole. A cool color palette was used for this approach, and the structure was backlit by various other platforms and generators similar to those seen on various offshore oil rigs. Once all the key components were blocked in, elements of ice and atmosphere were glazed in to create the initial caisson illustration. At this point I had a choice: the initial image could function as a rudimentary sketch or be refined into an illustration (**Fig.12**).

REFINEMENT INTO AN ILLUSTRATION

I chose to use the initial sketch as a springboard towards producing a more refined illustration by following these four steps:
- **Establish perspective**: To refine a sketch, a good starting point is to re-establish the perspective to ensure it reads well. Any aspect or form that is out of alignment needs to be addressed and corrected accordingly.
- **Hierarchy of values**: Check that the various foreground, mid-ground and background structures read properly.

Fig.12

SCI-FI

❋ SELECTIONS **❋ LAYERED INTERSECTIONS** **❋ BLENDED COMPOSITE** **❋ VFX ADJUSTMENTS**

Fig.13

- **Details**: Referring back to the sketch, ensure that the key features are suggested or hinted at in relation to the lighting and associated shadows.
- **Selections**: The secret to obtaining crisp edges – or, in my case, making the ice flows look good – is to establish a good grouping of selections via the Lasso tool. Ensure various shapes overlap in perspective and blend the composites accordingly (**Fig.13**).

The final aspects to this illustration involved the subtle use of various layer adjustments and color corrections. Key to this were the subtle adjustments of each facet; e.g., to improve contrast, I applied a tiny nudge to either increase or decrease it. In addition, the subtle layering of multiple atmosphere, smoke and fog elements helped to ground the image with the use of atmospheric perspective.

Artist Portfolio

DESERT STATION
BY NEIL MACCORMACK

JOB TITLE: Creative – Bearfootfilms
SOFTWARE USED: LightWave 3D, Photoshop

INTRODUCTION

The *Desert Station* image is a futuristic sci-fi environment in which I have tried to blend a mix of futuristic elements with respect to the buildings and ships, and yet also retain an Earth-like feel to the landscape. This, I think, allows the viewer to fantasize about the location of the station on Earth and yet be able to relate to more recognizable elements that help make it more believable.

Generally I start all my works with a basic concept sketch, concentrating on the composition and how I see the final image taking shape (**Fig.01**). I think it's much better to have this down on paper in front of you before starting. I find that working from a purely mental picture takes longer and the scene is more prone to being changed and tweaked.

MODELING

The majority of my modeling time was spent on the ship using poly modeling in LightWave. I deliberately made the shape of the ship ambiguous so it was difficult to see which was the top and bottom. This gave me a little freedom as to how the ship would fly, land, take off, etc., so I could find a position and angle for it that would fit in with the composition.

No special techniques were used to model the ship. I started with a simple box and, by using the Smooth Shift, Bandsaw and Extrude tools, I arrived at the final mesh. I

Fig.01

Fig.02

> ## I FIND THAT WORKING FROM A PURELY MENTAL PICTURE TAKES LONGER AND THE SCENE IS MORE PRONE TO BEING CHANGED AND TWEAKED

probably ended up with more detail than was necessary given the final image, but I was so happy with the final model that I thought I could re-use it in the future.

To fill up the rest of the scene I used some very basic objects made from primitives and old stock models. The objects were then cloned throughout the scene to keep a consistency between the buildings and landscape. This also allowed me the freedom to move objects around to find a balanced composition (**Fig.02 – 03**).

TEXTURING

Creating the textures for the objects was quite simple as I knew I would be painting some extra textures onto the final render in Photoshop.

Fig.03

I decided to use tileable image maps that I created in Photoshop, and map them to the objects using Cubic mapping, which ensures the object is covered without any texture distortion.

The principal technique for texturing the ship followed a similar approach to the other objects. In this case I used some metallic texture maps for the body, which were mapped in the same way (**Fig.04 – 05**).

LIGHTING

By far the most important 3D aspect of this project was the lighting. I had already made notes on the intended time of day and the position of the sun, etc., so I knew the basics of how the scene would be lit.

I added my painted Photoshop background to the scene and positioned my area light where the sun would be positioned and then set it to the same color value as the background. I chose a soft reddish-gray color for the shadows and enabled Radiosity to simulate the bounce light apparent during daytime conditions.

I used this painted sky background image as my HDRI map to ensure that the bounce light had the correct color values and tweaked the intensity until I was happy with the result. The background fog also helped to make the scene appear more realistic as outdoor environments generally have a lot more haze and atmospheric elements than people realize (**Fig.06 – 07**).

RENDERING

I rendered the image using FPrime renderer for LightWave as I was able to obtain a slightly softer feel to the image than when using the native LightWave render engine.

Fig.04

Fig.05

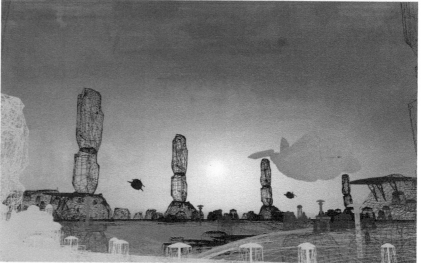

Fig.06

Fig.07

The Photoshop work really brought all the elements together and I spent quite a while on texturing and recoloring the image. I painted highlights on some elements and added shadows on others as well as overlaying textures across the image in general. I tweaked the brightness/contrast and then added some fog, mist and dust to create the final look (**Fig.08**).

POST-PRODUCTION

Normally, different render passes are saved out and then layered in the post-production process to allow changes to aspects such as shadow values or fog depth, without the

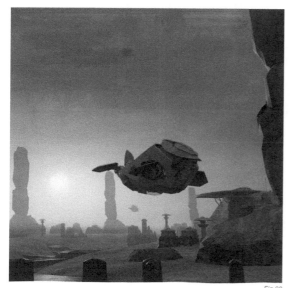

Fig.08

Fig.09

need to re-render the entire image. For this project, however, I knew this wasn't necessary as I wanted to paint over the image, giving it a looser and more stylized look.

I brought the final render into Photoshop and started to work on recoloring it, changing the brightness and contrast and then adding in some extra textures. I used the Faux Finish brushes and some custom

brushes to add the extra fog and mist to the landscape and sky. The foreground building lights and people help to add a sense of scale to the image (**Fig.09**).

I overlaid some color maps on both the rocks and ship to bring out the colors a little and highlight parts I wanted the viewer to focus on. The yellow overlay layer completes the overall mood and final look (**Fig.10**).

Fig.10

The final steps in Photoshop involved first flattening the image and then applying the Sharpen and Add Noise filters. Saving the file as a copy is also a good move as it keeps your original layered image intact. I think these two filters give the image a slightly film-like quality and mimic how a real film camera may have captured the scene (**Fig.11**).

CONCLUSION

I think that for this image I achieved the look and feel almost exactly as I had envisaged at the outset. It shows me that it is possible to achieve a successful concept design without getting bogged down by the detail of the 3D elements and instead using lighting and texture to portray a believable mood and feel.

Fig.11

ARTIST PORTFOLIO

© NEIL MACCORMACK – HTTP://WWW.BEARFOOTFILMS.COM

STEAMPUNK VILLAGE
BY ROBH RUPPEL

JOB TITLE: Art Director – Naughty Dog
SOFTWARE USED: Photoshop

WORKFLOW

When starting a new image, I generally begin by making a series of simple compositional sketches. I look for a pattern that's both dynamic and interesting. I do several on a page so I can compare them and not fall in love with one idea too quickly or keep repeating the same idea. I followed this same process with *Steampunk Village* (**Fig.01**).

When I was happy with the initial sketches, I worked out a quick color sketch. I like to do this because the values tell me whether it is a good composition or not, at which point I know it's time to establish some mood and light. This isn't something I do in a lot of detail; it's more a way to develop the look in my own mind so, when it comes time to finish the picture, I have a clear idea of what it is I'm trying to achieve. You'd be surprised how important that is. For something this finished, I wanted a clear goal and not to wander around hoping to find it. That's what the sketches were for (**Fig.02**).

I blocked out the entire image in big, simple tones and shapes before getting into any detail. This is very

Fig.01

> IF EVERY HIGHLIGHT AND EVERY SHADOW IN EACH AREA IS EITHER PURE BLACK OR PURE WHITE, THE IMAGE WILL HAVE NO SENSE OF BELIEVABLE SPACE

important and I did it for two reasons. The first was so I could keep the details within their correct value ranges and the second was that I wanted all the big geometric shapes established first with their correct colors/values. If every highlight and every shadow in each area is either pure black or pure white, the image will have no sense of believable space. It looks like a checker board instead of the simple value plan I established in the first sketch. If you get this part right, the painting has a complete look to it right away. This is extremely important and I spent some time adjusting colors and

Fig.02

values until it looked "real" to me. I was also looking for a simple separation of the planes. In other words, the light side, shadow side and roof tops for the buildings (**Fig.03**).

I next started to work on the details of the small village. Since this was one of the main areas of interest, it was important to get it working right away. I redid the first roof tops a few times until I found the right level of detail. I was also looking to establish scale which, if successful, would lend a consistency and believability to the piece. This is another very important and often overlooked part of the painting process (**Fig.04**).

I worked on the rest of the town, keeping a careful eye on scale. For example, if the windows and doors of

Fig.03

Fig.05

Fig.04

the buildings in the background are three times bigger than the foreground, the illusion of perspective will be destroyed. I worked my way towards the ship, adding elements such as chimneys (**Fig.05**)

I also started to add some finer details near the bottom of the ship and along the bridge structure leading to it. I did these on their own layers using a flat color so I could judge the silhouette and shape alone. If the shape wasn't interesting, I worked on it until it was. It's so much easier to judge this without any modeling or detail to distract from the abstract shape (**Fig.06**).

Adding detail was more of the same. A friend of mine is one of the top matte painters in the business and I asked him once how he achieved a particular effect. I thought there might have been an easier way than laying the finished textures in, one plane at a time, but when he answered, "No, it's just tedious", it made me realize that most of the time you just have to work through it. So, the details in this image were made by getting the larger tones to work, modeling the smaller details, and then adding the texture, one roof at a time, one section at a time, one building at a time (**Fig.07**).

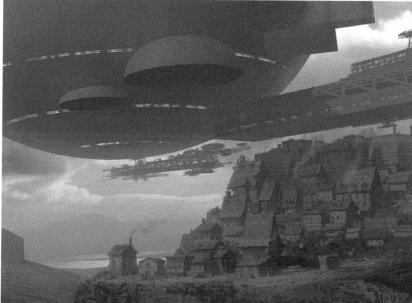

Fig.06

I included a few of the hundreds of paths I used to get the drawing right on all levels of detail. For all the vertical and horizontal "sections" of the ship, I built scores of paths that I used as masks, selections or "strokable" paths. There isn't just a single technique employed here; I used anything and everything I could to achieve the effect, adding dozens of layers with many different blend modes until it had a complex visual look (**Fig.08**).

> IF THERE IS A "SECRET" TO MY PAINTINGS IT'S IN MY WILLINGNESS TO TAKE ANY STEP TO MAKE THEM AS SUCCESSFUL AS POSSIBLE. THERE ARE NO SHORT CUTS WHEN YOU'RE MAKING COMPLEX IMAGES

I also used the paths to check my perspective. Here I got them running to the vanishing point for the village buildings on the left side of the image. If there is a "secret" to my paintings it's in my willingness to take any step to make them as successful as possible. There are no short cuts when you're making complex images. They are complex and believable because I'm willing to take

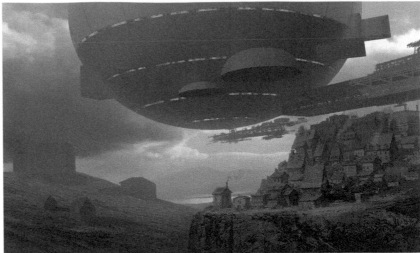

Fig.07

Fig.08

Fig.09

the time to make them so. I use the most basic tools, tone and perspective, and avoid building up dozens of little inaccuracies that eventually make the piece sloppy and poorly drawn (**Fig.09**).

Here's the final stage. I ended up reworking the cliff side quite a bit from my initial block-in. I liked the initial pattern but the scale wasn't working once I started finishing the buildings and compared it to my first block-in. All in all this turned out to be one of my favorite pieces and I really retrained my eye to be more accurate by checking the way everything was drawn as I painted (**Fig.10**).

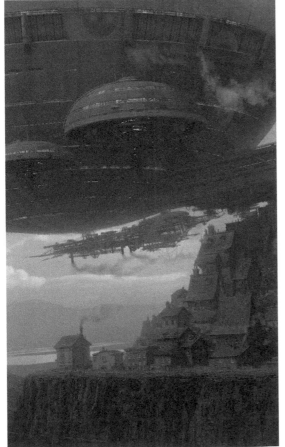

Fig.10

SCI-FI

TREE
BY TOMASZ STRZALKOWSKI

JOB TITLE: Lead Asset Artist – People Can Fly
SOFTWARE USED: ZBrush, Maya, Photoshop

INTRODUCTION

The idea behind creating this graphic art piece was the coupling of technological and organic elements; i.e., plants, more specifically a tree. I wanted to erase the boundary between them and show a kind of evolutionary marriage between the two. I have always been fascinated and inspired by trees, especially by the diversity and uniqueness of their shapes. At the same time I am also inspired by different kinds of machines and their appearance; i.e., jumbled up wires, screws and other constructional elements. Therefore, the combination of an industrial robot, or rather a tree mimicking the shape of a robot, seemed like a suitable idea.

I also wanted to create an air of mystery in the image as well as use the opportunity to expand my skills. Just as with any new project, unexpected situations arose and resolving these posed a challenge, but they also resulted in an improvement with regard to future projects.

THE PROCESS

I created a few drafts in order to develop the right shape and ambience. Unfortunately, I did not manage to clarify the essence in the first attempt, but after numerous trials I found what I had been looking for. It was a simple

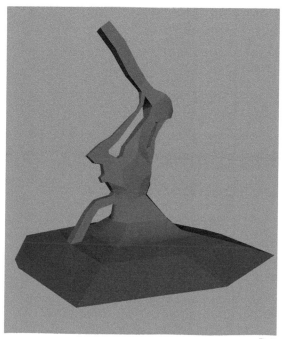

Fig.02

Fig.01

> **I ADHERED TO THE DOCTRINE THAT, IF SOMETHING SEEMS INTERESTING, JUST GO WITH IT, EVEN WHEN IT MEANS A SIGNIFICANT CHANGE**

draft, but provided me with a vision of what I wanted my tree to look like and aided the modeling process (**Fig.01**).

The next step was to create the basic low-polygon geometry in Maya (**Fig.02**). My aim was to create a solid base for a ZBrush sculpt, and at the same time build a tree shape closely resembling the drawing.

After transferring the smoothed model into ZBrush, I tried to sculpt the main object, as well as find the right proportions and appearance. During the modeling process the idea was constantly evolving. I adhered to the doctrine that, if something seems interesting, just go with it, even when it means a significant change. The moment I managed to achieve a satisfying effect I started sculpting the details. In the meantime I exported the low-poly Maya model in order to set up the composition, camera position and initial lighting. This helped me to see which parts of the model should be more exposed compared to others. Tons of interesting ideas came to my mind while modeling the detailed elements, but not all of them turned out to be successful. From time to time I

exported a test model and checked how it looked in a scene prepared for rendering so I could assess whether they worked together and what was missing, needed changing, etc.

After some time I arrived at the final high-poly version of the tree model (**Fig.03**).

I also created the final low-poly mesh (**Fig.04**).

I imported it into Maya and unwrapped the UV map there. I then proceeded to bake the Displacement and Ambient Occlusion maps onto it, which were generated from the high-poly ZBrush sculpt. I subsequently added a displacement approximation in Maya and thickened the mesh to a reasonable number of polygons, so that after rendering the model with displacement it was optimized and looked as good as possible. This technique kept the rendering time within sensible limits as well as ensuring an acceptable quality (**Fig.05**).

Texturing was the next step. In general, I mix a few textures in order achieve the desired effect, using the Ambient Occlusion map for darker textures. After texturing the main object and creating the right shader, I modeled and adjusted the ground object to match. I wanted to achieve a smooth transition between the two. For the ground object I used a separate UV channel, which took advantage of an alpha mask and gradient (**Fig.06a**).

Fig.03

Fig.04

Fig.05

Fig.06b

Fig.06a

I made an adjustment to the geometry to give the impression of a smooth transition between the tree and the ground (**Fig.06b**).

I created the hazy background effect in a similar way. I chose this particular approach because it was important that I used a pre-prepared background, which was simply a texture mapped onto a plane (**Fig.07**).

This enabled me to control this part of the scene more effectively. The next stage was to add the branches and other details in the composition. The branches were created

SCI-FI

on plains with an Alpha channel and Bump map, which added subtle volume. This method also shortened the rendering time while maintaining the desired effect (**Fig.08**).

The bush in the background was prepared in a similar way, whereas bigger elements and branches were made in 3D including details such as wires, pebbles, sticks, etc.

At every stage of the process I made various trial renders, which gave me an insight into the general direction in which I was heading at any given moment. I used this as a gauge to locate any errors, enabling me to react quickly and subsequently eliminate them or simply correct the problem. I tested the lighting and rendering settings in a similar fashion.

The most important stage was the final refinement of the image as a whole, of colors, lights, textures and anything that could improve the appearance of my work. Consequently, I put away the work for a while to gain a fresh perspective before getting down to finishing it. When I decided that the overall effect was satisfactory, I completed it in order not to over-pamper it. It is essential to know when to say "enough" and find a compromise between quality and duration.

Fig.07

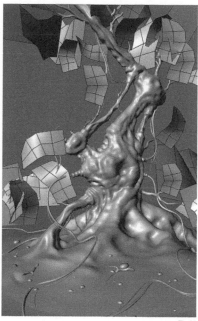
Fig.08

CONCLUSION

The actual, overall time of completion was one week, but as I did it after work, during the evenings and at weekends, it was spread out. I undertook the work out of the simple need to create and it was done solely for my own pleasure and to also practice my skills. It afforded me full freedom to do the things I imagined.

I learned many new things during the project and obviously I now have a handful of new ideas, relating both to the content and the technical issues, which I will pursue.

ARTIST PORTFOLIO

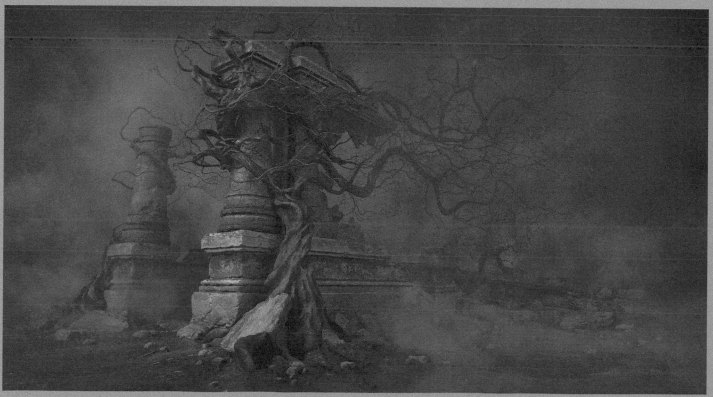

A SMOKE
BY EDUARDO PEÑA

JOB TITLE: Design Professor / Visualist
SOFTWARE USED: Photoshop

CONCEPT

In general, it all started when I imagined a future of fiction, not dark but decadent; a cold future with a friendly aura and a sense of quality, and yet with a feeling of quiet aggression too. What I really wanted to express in this piece was something very complicated, using the art of visual language.

Before conveying something in an image, I try to understand the narrative value behind the picture, and what would lead me to feeling what I really wish to express. I'm aware that sometimes the content doesn't define the entire piece, and that a solid visual foundation can cement the narrative gaps if I try to articulate the value of the story. Therefore, the image can hopefully be appreciated on an aesthetic level when viewed.

As previously mentioned, my idea was set in a futuristic context incorporating both cyberpunk and steampunk trends. I understand that each person has their own strict guidelines regarding aesthetics, which I greatly respect, and this is why I've tried to clearly specify my own influences and orientations.

Behind this theoretical framework, my ideas reflect a piece the content of which I hope exists in its own right, rather than appearing as something that everybody would appreciate.

Fig.01

> I LIKE TO INVOLVE SEVERAL SENSES WHILST WORKING, FOR EXAMPLE BY LISTENING TO MUSIC TO STIMULATE MY STORY AND EVEN RECALLING SENSATIONS AND SITUATIONS

WORKFLOW

As for the actual painting, I started with a process of swift sketching in Adobe Photoshop CS3 in which I left the improvised lines and gestural marks that often suggest a direction and possibly evolve into something (**Fig.01**). I know this is complex and contradicts what I've written earlier with regard to planning the content, but I feel that it works simultaneously. I like to involve several senses whilst working, for example by listening to music to stimulate my story and even recalling sensations and situations that will help me to better focus on the artistic scenario. This technique allows me to improve the aesthetic value of the work and enables me to be part of it.

Starting without any limitations, I began with a document around 2000 x 1500 pixels, with the format often changing as I progressed. This acted as my initial guide and is a standard way of working for me.

Fig.02

Fig.03

I continued with the process of sketching and trying to work in only one layer, taking advantage where possible of any mistakes (**Fig.02**).

I worked with single brushes and started to flesh out something in the composition, perceiving forms and strokes that could constitute what type of character it could be and whether it became a focal point or simply another element in the image.

It looked like the piece was taking on a spherical form (**Fig.03**) but I tried to make some sort of structure out of it because I wanted it to have a certain characteristic, which in this case was … a robot.

Well at least I now knew that it was a robot (**Fig.04**) and, taking this into account, I started the duty of adding substance to the image as a whole.

I don't have a precise order in defining an image like this; I like to develop a more instinctive approach that offers possibilities to experiment with the result. It's interesting to create any type of piece using this software as the medium affords a certain freedom.

Having already established the chromatic pallet, I now began the process of detailing some areas, looking for the more important focal points, which in this case were the robot, and, oh, wait a minute (**Fig.05**)! That could even be a, yes, a lady – perfect! The image was starting to have some intrigue, which was exactly what I wanted to achieve.

Fig.04

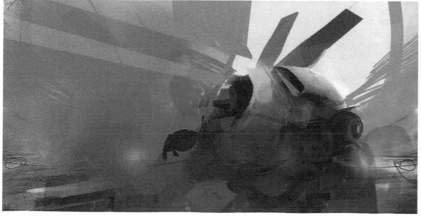

Fig.05

I tried to add a touch of color because I didn't want the image to have a melancholic mood. I used cold colors in the context of a warm ambience, which provided a more pleasant dialectic (**Fig.06**).

At this point I was trying to define some of the forms by giving them some plausibility and consistency. At the same time I added more ambient elements such as fog, smoke, particles, lights, highlights and some birds (**Fig.07**).

Since the subject matter was purely instinctive, there were not a lot of technical tricks I can divulge, but I can suggest you put aside a structured approach and try to develop your own language and aesthetic, which is what really matters. Training will teach you technique, but an artistic temperament is achieved over time and through the love you feel for what you do (**Fig.08**).

At this point, the story could have been that the robot was some kind of recycler of garbage, too effective for its time, and due to global warming the tide had risen considerably, submerging huge parts of inhabited areas. Unfortunately, due to their volume, these machines were

> ❝ AS WE ARE LIVING IN A FAST-MOVING AND EPHEMERAL SOCIETY, IT IS OFTEN A GOOD IDEA TO SPEND SOME TIME IMMERSED IN A GOOD STORY ❞

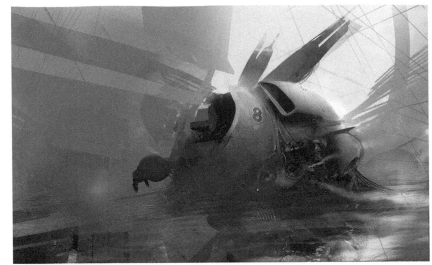

Fig.06

Fig.07

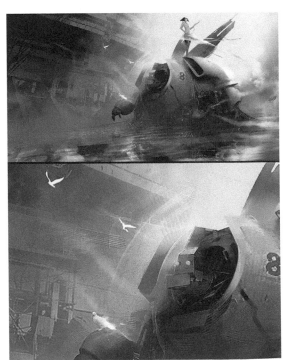

Fig.08

unable to move to more remote areas. While they remained operational, some became stagnant in an absolute state of stillness. One day, a beautiful lady named Dr. Lung found herself smoking a cigarette on the back of our iron friend. At that moment some birds appeared and, while the sun wasn't quite as stifling, the robot woke up to find himself trapped in the same monotonous and decadent landscape. But sooner or later he is going to escape that place, as Dr. Lung is thinking of repairing the robot to make a trip to Furgona, the land of iron.

I hope that this text, along with the supporting images, has been good reading material to accompany the development of this image, be it illustration, concept art or any other artistic branch.

I look forward to this account not only helping to answer your technical concerns, but also helping you to enjoy something as simple as an image by just sitting and letting a story evolve and come to life. As we are living in a fast-moving and ephemeral society, it is often a good idea to spend some time immersed in a good story.

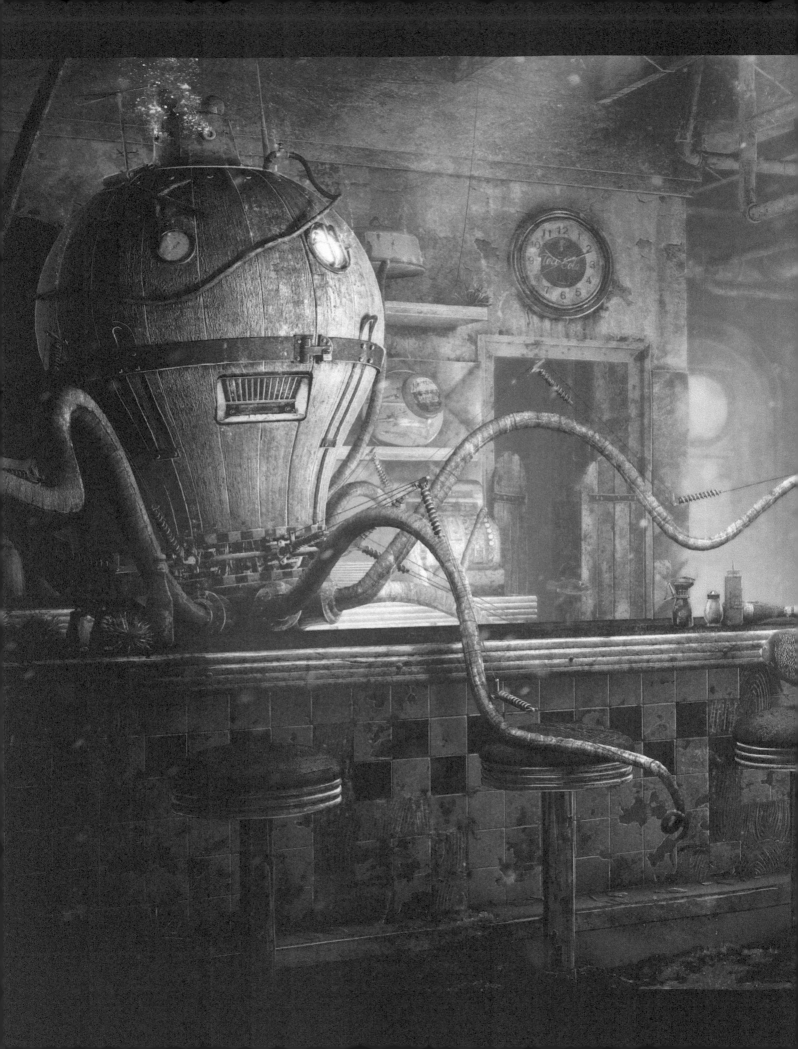

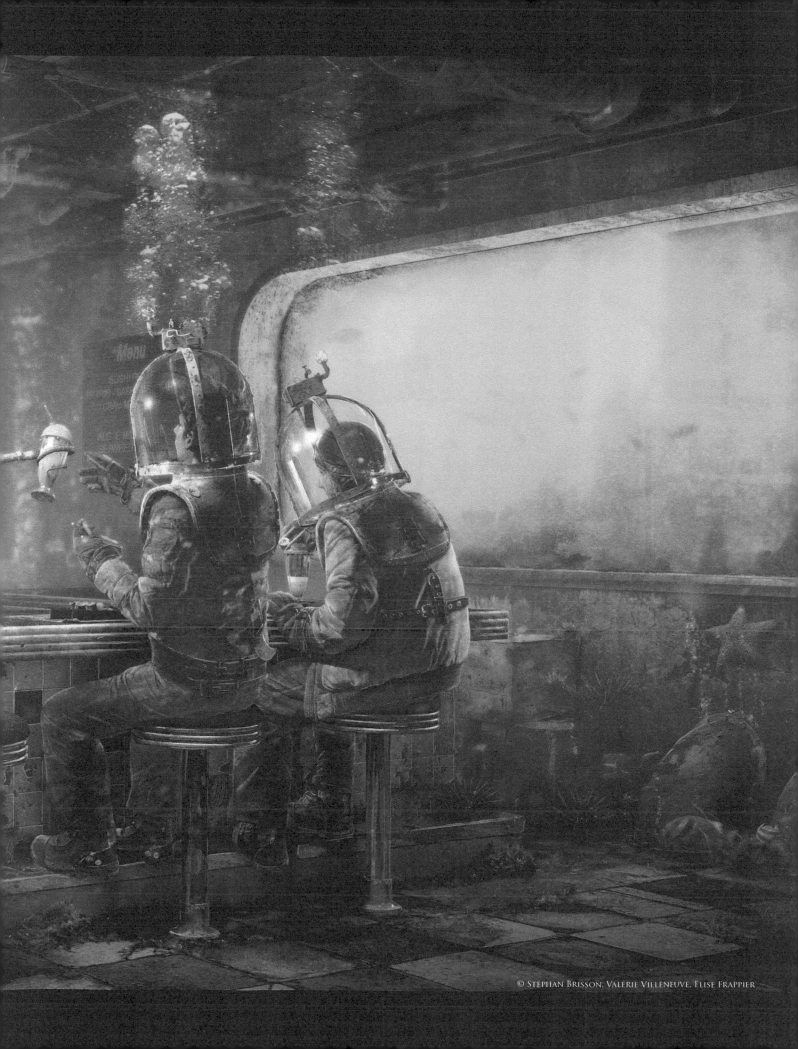

Octopus's Diner
By Stéphan Brisson, Valérie Villeuneuve, Elise Frappier

Job Title: CG artist – RodeoFx Montreal | 3D Artist – Hybrides Technologies | Illustrator – Meduzarts / Alpha-Vision
Software Used: Maya, Mental Ray, Photoshop

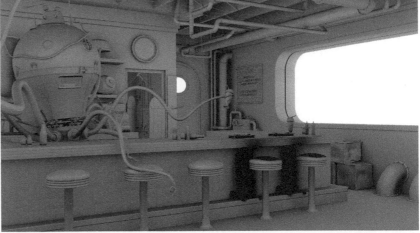

Fig.01

Fig.02a

Introduction

This personal project was done at Meduzarts Digital Environment Studio by Stéphan Brisson, Valérie Villeneuve and Elise Frappier. Stephan combines formation in architecture, cinema and 3D animation. He has worked in an architectural pre-visualization studio for eight years, first as 3D artist, then as project leader. He's now working in the film industry. Valerie Villeneuve has completed training in interior design and holds a bachelor's degree in Film Animation from Concordia University in Montreal. She has worked as a 3D digital artist and, later on, as a project leader. Elise Frappier has been doing illustration for the past seven years, works as a matte painter and texture artist, and graduated in Illustration & Design from Dawson College.

Fig.02b

Fig.02c

Concept

The initial idea behind our image was to portray the effect of global warming on day-to-day life. It was intended to be humorous, and to show how life could gradually change if we were suddenly confronted with the melting of the poles to the point where we had to live under the sea. We imagined how people would gradually adapt their lifestyles, creating new tools and houses with what was available around them, showing that humankind is foolish enough to destroy its own environment but is also intelligent enough to adapt to any circumstances.

All three of us put our heads together to come up with the concept and sketched out all kinds of ideas to make it work. Stéphan and Valerie modeled, textured, shaded and lit the scene, and Elise worked on the textures and matte painting.

We began by brainstorming about the look and the setting of our scene. We did not wish to portray a recognizable time or place, so we went with a timeless setting: a retro diner. We tried to imagine how people living under the sea would dress, eat and live. We conceptualized a lot of accessories such as the mechanical octopus waiter, which we derived from an actual early submarine design. You may notice some steampunk influences – we thought the style would visually express this chaotic existence well.

The first step of modeling was a quick layout of the restaurant. This helped us to figure out where to place the camera. Once we were agreed on the composition, we started to model the various elements in high resolution (**Fig.01**).

Fig.03

We then textured and designed each element as it would appear in a diner, only much more damaged by its underwater setting. We didn't spare any detail; from the stainless backsplash to the old cash machine, the vintage clock, the red vinyl stools and milkshake glasses, we stayed true to a typical retro feel.

A little tip along the way: when you plan to have a blue atmosphere, don't correct your textures in blue, but rather add blue in post-production. You will get a more accurate result and save a lot of time and trouble (**Fig.02a – c**).

The challenge with the lighting was to combine a restaurant's normal lighting with the very peculiar glow of an underwater setting. To make sure we had as much control as possible, we rendered all the lights on a different pass and then adjust the intensity of each one in Photoshop. For the fog effect, we used a technique that simulates a room full of dust. Thus, we could adjust the fog globally in the scene instead of adjusting for each light separately.

However, there was still one thing missing to create the impression of a place filled with water: particles. Instead of using 3D tools, we simply shot snowflakes falling from the sky to efficiently reproduce different depths of particles and integrated them into

our image. We then blurred the scene further in the background to enhance the sense of depth (**Fig.03**).

For the Photoshop portion, the longest but most important step was to break up the 3D; edges needed to be broken using stamping and painting. We overlaid textures to create more realism, dirt and damage. We also made sure there was low frequency to counteract the high frequency created by the density and noise of the textures. For our final 3D touchups, we painted highlights arbitrarily. Then the background was created, along with sea elements such as fish, algae, clams, bubbles, etc. Adjustments and color corrections were done throughout the entire process to get everything to fit together, to create the appropriate mood and to maintain a color palette that matched our theme (**Fig.04**).

Because we lacked the time required to complete two CG characters of sufficient quality, we took photos of Stéphan in winter gear and made him stand in as our two customers. We integrated the resulting images into the scene by adding CG helmets, painting extra diving gear such as leather straps and diving boots, and distorting the features so that the characters do not look the same (**Fig.05**).

CONCLUSION

We are very pleased with the quality of the work we achieved and the final image we created. We spent over 150 hours in total on this project, yet none of these were wasted thanks to our management of time and resources (having two team leaders on our project certainly helped!). Spending a little extra time on scheduling and planning ahead certainly saves a lot of headaches down the road. Teamwork was a very enriching and stimulating experience, and helped to keep each of us within the initial timeframe we had set.

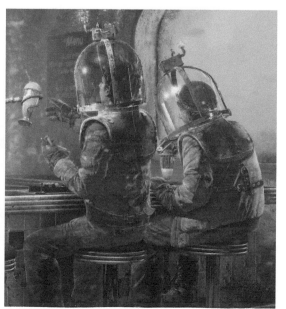

Fig.04

Fig.05

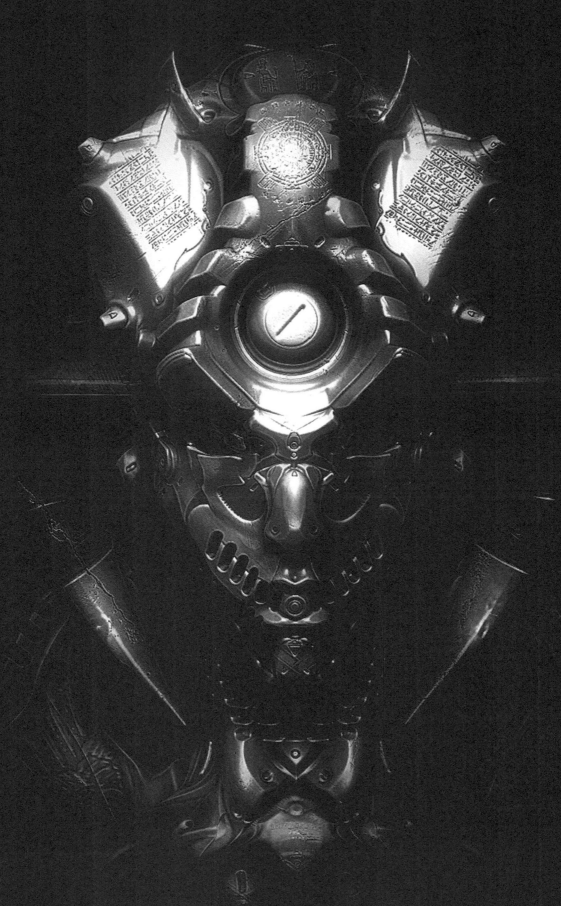

Nebt-Het
By Vitaly Bulgarov
Job Title: Cinematic Artist – Blizzard Entertainment
Software Used: Softimage XSI, ZBrush, Photoshop

Introduction

Nebt-Het is also known as Nephthys in Egyptian mythology. She is the daughter of Geb and Nut, the sister of Asar and Aset, the wife and sister of Set, and the mother of Anpu by Osiris.

Nebt-Het is often featured as a ferocious and dangerous divinity, capable of incinerating the enemies of the Pharaoh with her fiery breath. Being inspired by such a character and the story behind her, I was also thinking about mixing different ideas from different cultures and styles.

> ❝ MY PRINCIPAL GOAL WAS TO MAKE A SCI-FI PIECE, BUT WITH AN ALTERNATIVE, ANCIENT FEELING AND A SENSE OF HISTORY ❞

I love how the name sounds and so I took that as a symbol and starting point. My principal goal was to make a sci-fi piece, but with an alternative, ancient feeling and a sense of history. Mysterious cultures and ancient Egyptian sarcophagi with all their ornamental decoration tell you stories just by looking at them.

All I knew from the beginning was that the image had to be of a female, contain a steel mask and have a strong dark feeling. It had to convey both fantasy and sci-fi elements and of course one of my goals was to have fun and explore ideas, which was a priority!

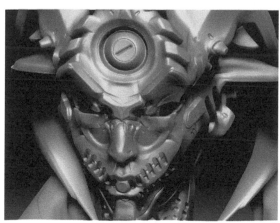

Fig.04

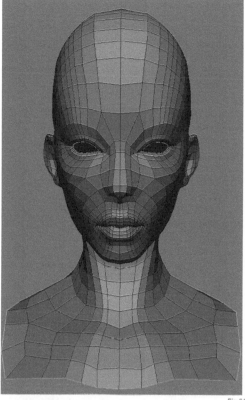

Fig.01

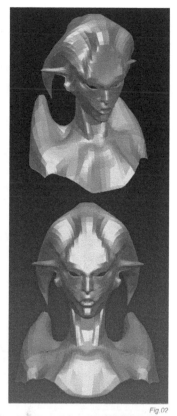

Fig.02

Fig.03

Modeling and Sculpting the Base

I started by modeling a generic female head in Softimage XSI. I didn't draw any preliminary sketches because I wanted to jump into the design right away during the sculpting stage. The base mesh of the head was built using a poly-by-poly modeling technique. This means that the mesh is built by basically extruding edges from existing polygons, after which the new points are moved to form the required shape and so on. I kept the overall shape and surface pretty smooth so I could push things drastically in ZBrush later.

The base mesh I built had more than enough detail to get me started (**Fig.01**).

I then imported the base mesh into ZBrush and used the Move brush to change the proportions and develop some crazy shapes. At this point I didn't care too much about stretched geometry. Once I got some interesting shapes I imported the mesh back into XSI and added more edge loops in areas that had become too stretched. The basic premise behind a clean sculpt is to keep your polygons in as many quads as possible. **Fig.02** shows my earliest low-poly concept model, which gives you an idea about the overall shapes that were sculpted using the Move, Standard and Inflat brushes.

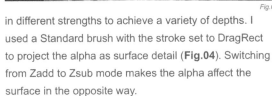
Fig.05

REFINING THE SHAPE AND ADDING DETAILS

Now it was time for the real fun. I divided the mesh four to five times, just to make sure I had enough geometry for the small, crisp details. At this point I started to concern myself with the surface. Piece by piece I carefully formed the shapes, starting with large areas and going down to small. You can see the brushes I used for sculpting the hard-edged surface in **Fig.03**. These are very powerful tools for creating crisp and sharp surfaces.

At the same time I kept looking at different kinds of Ancient Egyptian ornaments used in rituals, just to keep myself inspired. I wanted to keep the overall profile simple and easy to read, but add a unique sci-fi aspect to the details. When sculpting the hard surface I used a lot of alpha projecting. This technique involves drawing grayscale shapes in Photoshop and then importing them into ZBrush as alpha maps, which are then applied

> THE GOOD THING ABOUT THIS IS THAT
> I DON'T HAVE TO CREATE UVS AND
> THEREFORE STAY FOCUSED PURELY ON
> THE VISIBLE PARTS. THIS MEANS I CAN
> SAVE A LOT OF TIME WHEN DOING AN
> ILLUSTRATION

in different strengths to achieve a variety of depths. I used a Standard brush with the stroke set to DragRect to project the alpha as surface detail (**Fig.04**). Switching from Zadd to Zsub mode makes the alpha affect the surface in the opposite way.

Fig.06

In **Fig.05** you can see some of alphas I drew in Photoshop and that were used later to create this artwork. I especially love combining this approach with the new brush features in the latest version of ZBrush. It's so much fun just to experiment and explore different ideas. Sometimes I saved different versions and then just left the one with the best design.

Fig.06 shows the work in progress with almost all of the details complete, barring scratches and metal damage. I also thought that it would be cool to add some kind of manuscript or hieroglyphs to make it feel more Egyptian. I saved my ZBrush tool as a *.zbr file to convert it into pixels. This meant I could project more detail in 2.5D mode, even if I didn't have enough polygons. It's a very cool trick if you need to present your model in a better way without spending too much extra time.

Fig.07 shows the final model ready for rendering.

RENDERING

When I render in ZBrush I use a standard light with Render set to Best and Shadows turned to On. I render my model using several materials and then combine them in Photoshop using different blending modes and masks. I usually use from ten to fifteen materials to get a pretty big base of different shading behaviors that I can play with in Photoshop. The good thing about this is that

Fig.07

I don't have to create UVs and I therefore stay focused purely on the visible parts. This means I can save a lot of time when doing an illustration.

You can see the materials I used for rendering this image in **Fig.08**.

As you can see, some of them have cool middle value gradation, some have extremely intense reflections and the others have good occlusion effects. Through different combinations in Photoshop it is possible to simulate very complex materials. You can see how it works in **Fig.09**.

Combining Color Dodge and Overlay modes can produce a nice blending effect, but I also used Multiply, Soft Light and Normal blending modes. Once I had achieved the desired look for the metal, I started refining the highlights.

Fig.08

I created a new layer set to Overlay and manually increased the highlights in the necessary areas by drawing with a white brush set to a low opacity.

At the end I added in some dirt and photos of metal on new layers. I also refined the gold luster of the metal by creating another layer that was a blurred copy of the image with an increased saturation towards a red-yellow range. I also created a layer to control the light, which was set to Multiply with black areas manually added in varying intensities. This was done to remove that over-exposed look and to create a focal point, something extremely important in a composition.

CONCLUSION

I had so much fun doing this work. During the early stages I did not have a specific idea about how the final piece was going to look. I tried not to restrict myself too much and explored new possibilities throughout the process, discovering some random design elements that seemed very fresh. That was the most enjoyable part.

On the other hand, it was also very useful to test the new features of ZBrush 3.5 R3. I'd like to mention that the new Polish brushes worked just perfectly every time I needed to achieve a very clean, hard surface.

Fig.09

ARTIST PORTFOLIO

THE OATH
BY YIĞIT KÖROĞLU

JOB TITLE: Illustrator / Concept Artist
SOFTWARE USED: Photoshop, Google SketchUp

INTRODUCTION

This image was done for a past contest entitled "Natives of the Lifeless Forest". For most people the word "lifeless" may represent something dead, but it reminded me of machines.

What kind of a scene would we witness if a huge scary machine meets an innocent child who is trespassing

> AS AN ARTIST IT IS REALLY IMPORTANT NOT TO STRAY TOO FAR FROM THE MAIN IDEA BEHIND THE IMAGE; ONCE THIS IS ESTABLISHED, THE REST IS EASY, REALLY

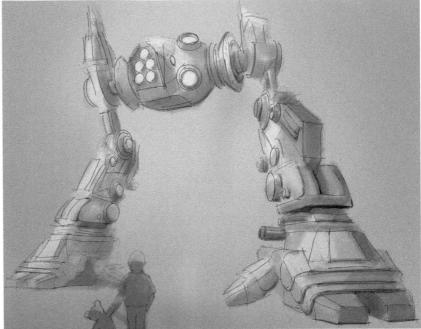

Fig.01

on its territory? I wanted to transport the viewer to the precise moment when the two meet. Moreover I wanted invoke their curiosity and interest in the story and pose the question of, "What happened next?". I chose the main characters to be a huge merciless robot and a small child so that I could create a strong contrast and emphasize the idea. During the planning stage, I had two words floating around in my mind: fascination and curiosity. I thought that these should be like portals between me and the viewer. As an artist it is really important not to stray too far from the main idea behind the image; once this is established, the rest is easy, really.

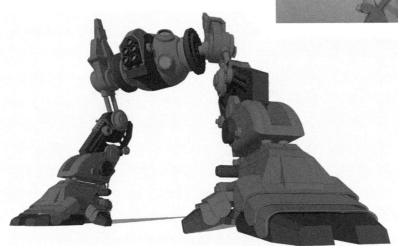

Fig.02

GETTING STARTED

I started the sketch in Photoshop and included all the details that I had imagined for the robot. The composition and perspective were of the utmost importance and I wanted the viewer to feel as if they were witnessing the child's curiosity just a couple of steps behind him (**Fig.01**).

After drawing the sketch, I decided to use Google SketchUp to model the robot so that I could go into enough detail without ruining the perspective and therefore make it look more realistic. After seeing the result, I concluded that using a variety of software is certainly worthy at times and speeds up the process

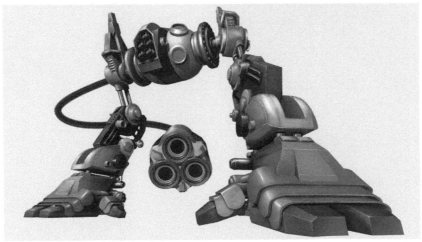

Fig.03

Fig.04

considerably. Since we are talking about digital art here, I believe that if the results are successful why not use the opportunities the digital world offers us (**Fig.02**)?

I was more than happy with the robot's structure so I moved onto the next step of shading it in grayscale. I exported the model and started painting over it in Photoshop. I like working in grayscale until all of the elements in an image are in place. This way I feel like I have more control over the composition and the overall volumes. I used

> " I WAS CAREFUL NOT TO ADD TOO MUCH DETAIL BY DRAWING EVERY SINGLE LEAF SINCE IT WOULD BE A WASTE OF TIME AND, MORE IMPORTANTLY, BECOME A DISTRACTION "

only a simple Round brush at this stage and also added a camera to the robot. While doing all of this, the background and child were starting to take shape in my mind (**Fig.03**).

I then started painting in the background, always mindful that the forest wasn't the focal point. I was careful not to add too much detail by drawing every single leaf since it would be a waste of time and, more importantly, become a distraction. I used some custom brushes to scatter the leaves across the ground, knowing that the observer's mind would complete the picture (**Fig.04**).

Once the startled child was added to the scene, the characters were settled. Even though I was not aware of it while painting, I later realized that I was being partially influenced by the movie *Artificial Intelligence: AI*. I painted him in pajamas and carrying a teddy bear so that the scene would look more dramatic (**Fig.05**).

COLOR, DETAILS AND TEXTURES

I made the forest look misty and also gave it a cold quality by adding a touch of cyan. In order to emphasize the robot, I chose a complementary color, which in this case was a reddish orange (**Fig.06**).

I felt that I needed to clarify that this was a mechanical forest as opposed to an ordinary one, so I added some details that would reinforce the background story a little.

Fig.05

I thought that there should be a perfect and harmonious balance between simplicity and complexity in the painting (**Fig.07**).

The details needed to be painted in such a way that they wouldn't distract the eye away from the focal point at first glance. However, without them, the painting could appear too flat and uninteresting. I was careful not to allow them to become too prevalent and overpower the main subject (**Fig.08 – 09**).

Using the same color values for the non-focal points is a really good way to avoid unwanted attention. The next step was to texture the image, which was done using some custom brushes on layers set to Overlay and Multiply. Overlay layers should be approached with caution since they can easily ruin the tonal values of your image. The surface of the metal plates shielding the robot would definitely harbor some moss and dirt in such an environment and so I applied the textures accordingly (**Fig.10**).

LIGHTING

Lighting can make a huge difference. If we consider that light determines how we see everything around us and

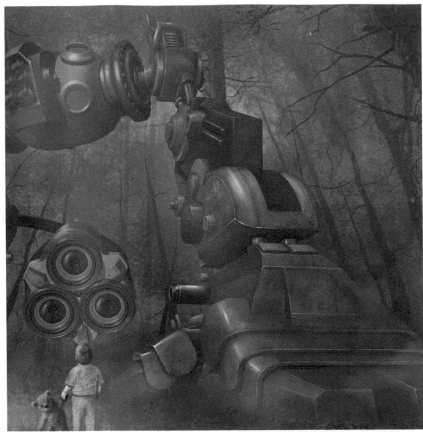

Fig.06

Fig.07

Fig.08

Fig.09

Fig.10

enables us to see things in three dimensions, we can assume it is a critical element above all else. God started creation by saying "Let there be light!" so it must be something important.

I added the base lights, just to clarify their positions (**Fig.11**).

This is a stage at which most people may think that this level of light might be enough. On the contrary, I thought that I should exaggerate it as much as possible to lend the image a more dramatic look. When you look straight into a spotlight it should have a nearly blinding effect, but in a painting this can mean sacrificing all of the detail. However, trust me; it is a risk that should be taken since the results are worth it most of the time. Also, don't forget that this is digital art, and so you can revert to an earlier stage of your work at any point.

I used the Gradient tool on a layer set to Soft Light and placed this above all the other layers to make the lighting effects look natural. It is important to remember that intense light casts strong shadows.

The natural radiation of light affects the whole painting with a cold bluish blanket of color. This actually creates an overall harmony between the colors and therefore creates a more natural and less distracting look. With the

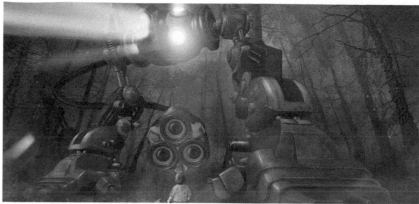

Fig.11

Fig.12

addition of the lighting, the image now had a more serious and dramatic look. With a little touch here and there, it could be called finished (**Fig.12**).

CONCLUSION

I think that I gave this image a feeling of drama and conveyed a moment that encapsulated a child's fascination with the curiosity of a robot. Most people who see this work are curious about what will happen next. Maybe the child will grow up in the forest alongside the robots and become a next-gen Tarzan, or perhaps he will teach the robots how to behave like humans? I really don't know, but this is the fun part left to one's imagination. My aim was to add another open-ended story that people could interpret in their own way, and I only hope I was successful.

ARTIST PORTFOLIO

© YIĞIT KÖROĞLU

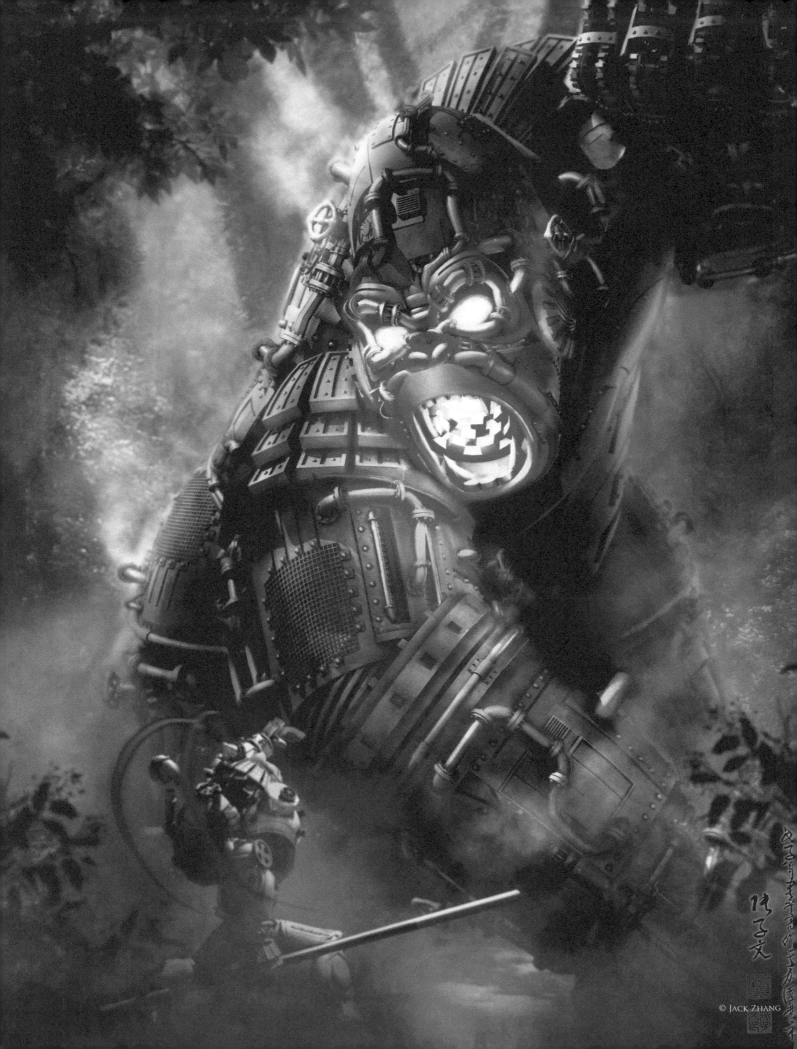

© JACK ZHANG

THE TWO MIGHTY KINGS

BY JACK ZHANG

JOB TITLE: Character Artist – Electronic Arts Montreal
SOFTWARE USED: XSI, Photoshop

CONCEPT

The idea behind this work was to create an illustration that used contrast to catch the viewer's attention. It was also my entry in CGSociety's "Steampunk" challenge. There were many different types of contrast I wanted to put into the work, such as big vs. small, bright vs. dark, savage vs. intelligent, eastern vs. western and ancient vs. modern.

I started by creating a quick concept sketch, based on these ideas (**Fig.01**). This was probably the most important part of the creation process because this roughly-put-together image became a strong guide that led me towards the success of the final image. I could already feel the energy from the concept at this point.

After careful consideration, I chose Wukong and Kong to be my heroes. The legendary monkey king from one of the most famous ancient Chinese stories and the mighty jungle beast from the well-known western novel were about to have a great face-off!

Fig.01

Fig.02

Fig.03

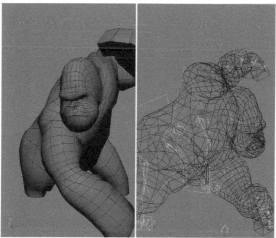

Fig.04

Fig.05

> ## THE POSE WAS CAMERA-BASED AND SO MIGHT NOT HAVE LOOKED AS GOOD FROM OTHER ANGLES, BUT, THROUGH THE CAMERA THAT I'D SET UP, IT LOOKED GREAT

MODELING

My time was short and so it was a challenge – how was I going to complete a work within a month and a half during my spare time? The odds were stacked against me!

I started with the modeling, working on Kong by creating a low-res gorilla (**Fig.02**). Once done, I rigged and weighted him to get the pose that I desired (**Fig.03 – 04**). The pose was camera-based and so might not have looked as good from other angles, but, through the camera that I'd set up, it looked great.

Fig.06

Fig.07

Once the pose was done I started to work on the gears, pipes and metal parts (**Fig.05**). Slowly and carefully, I put them onto the neutral-posed Kong (**Fig.06**) and parented the geometry to the skeleton (**Fig.07**). I then checked how they looked with the pose through the camera (**Fig.08**). If the piece didn't look good or create an interesting silhouette, I simply repositioned it in a neutral pose to achieve a better result. Another good thing about creating gear pieces instead of one big chunk of geometry is that I was able to reuse them as many times as I wanted. By rotating them I got many different variations and saved a lot of time.

Again to save time, I only worked on the visible areas apparent through the camera. The back of Kong was "naked". This is definitely not the best approach to use if you want to achieve a full character suitable for a turntable but, for a single still, this method proved easy and efficient (**Fig.09**).

Fig.09

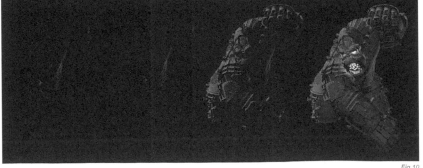

Fig.10

Fig.08

As for the monkey king, I spent a lot less time on him since he was relatively small compared to Kong and was only going to be a supporting character. As soon as I got a good silhouette for the character, I stopped.

LIGHTING

The lighting also kicked in at an odd stage. Usually I deal with the diffuse map before lighting, but in this case I took a different approach in terms of the texturing.

The lighting rig was quite simple and, as with the modeling, was driven by the camera. I decided where the backlight would be situated behind him and then put in

two spotlights to create a rim light on either side of Kong to pronounce his silhouette. I used one dimmer light in front of Kong to simulate the ambient light and that's pretty much my lighting setup. I honestly don't even know if they make sense, but they looked fine on the character to me.

Fig.11

> ## THERE'S NO TEXTURE! CAN YOU IMAGINE UV MAPPING AND TEXTURING A CHARACTER THAT HAS OVER A HUNDRED SEPARATE PIECES?

I also put in a few Point lights with some small falloff near Kong's mouth and eyes to simulate the glow, just to add a bit more interest to the character (**Fig.10**).

TEXTURING

There's no texture! Can you imagine UV mapping and texturing a character that has over a hundred separate pieces? That would take ages to complete and therefore that approach was definitely a no-no. So here's an alternative method that proved handy: shaders.

I created three complex shaders in XSI, each of which simulated a certain metal effect (**Fig.11**). The shaders were also light-based and reacted best from the camera angle. Each of them took an average of nine hours to render with a nearly five-year-old workstation.

I also used two other common shaders: Lambert and Ambient Occlusion (**Fig.12**). I used Lambert twice, one with the three spotlights and one with all the lights. By putting the six different layers together in Photoshop, I had something decent to begin working with.

Fig.12

Fig.13

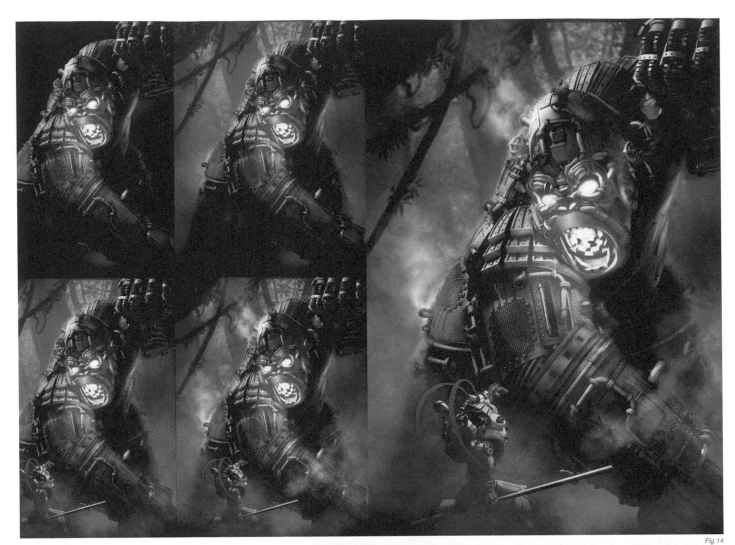

Fig.14

COMPOSITING

Compositing took up a huge part of this project. I wouldn't label the final image as fully 3D, but rather a mixture of 3D and 2D. I painted the flame and glow, color corrected Kong and Wukong, and fixed the lighting in certain areas (**Fig.13**). The environment itself was fully composed in 2D. It's really hard to describe in a word how I go about the compositing stages in a step by step process, but I hope the work-in-progress images will convey a reasonable picture of how I approached and arrived at the final result (**Fig.14 – 15**).

CONCLUSION

The Two Mighty Kings is by far my best finished illustration from my personal work. The creation process was both fun and frustrating, but I feel it was worthwhile. The work has received many rewards and recognition in various forums and books, which is awesome. However, I've been living and feeding on the glory of this old work and it's time to move on and challenge myself again. I will definitely do more than my best for the next one and share it with you guys!

Fig.15

CARTOON

Breathing life into the implausible is no small feat, and even more so into the cartoon world. After all, the proportions are often out of sync with what we deem to be real. Disney was a master at understanding how our brains worked. He surrounded the implausible with the plausible, bringing elements of the real world to surround the characters. Evil characters tend to have small beady eyes that will almost converge at the front, whereas the young and vulnerable have large, offset eyes. The great thing about this is that these are long-established character traits that are now ingrained in your subconscious. This is a character from a book, *Here Nor There*, that my wife has been writing for the past few years. As I said at the start, designing any character is hard, but if you allow yourself the fun of experimentation and most importantly the freedom to explore the elements within any given image, you will undoubtedly come up with gold. In this chapter, various artists have created exciting pieces of artwork that transport you within their own individual worlds. I thoroughly enjoyed seeing the approaches these artists employed in their craft.

CESAR DACOL JR

marcia@cesar-dacol-jr.com
http://www.cesar-dacol-jr.com/

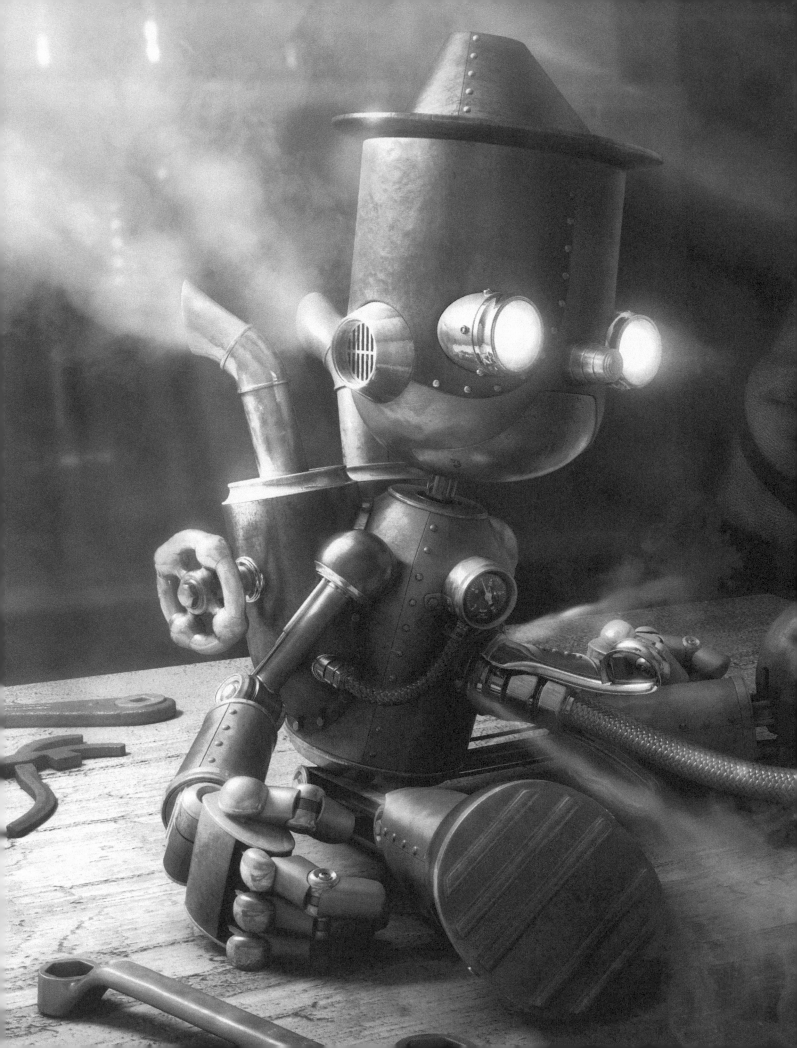

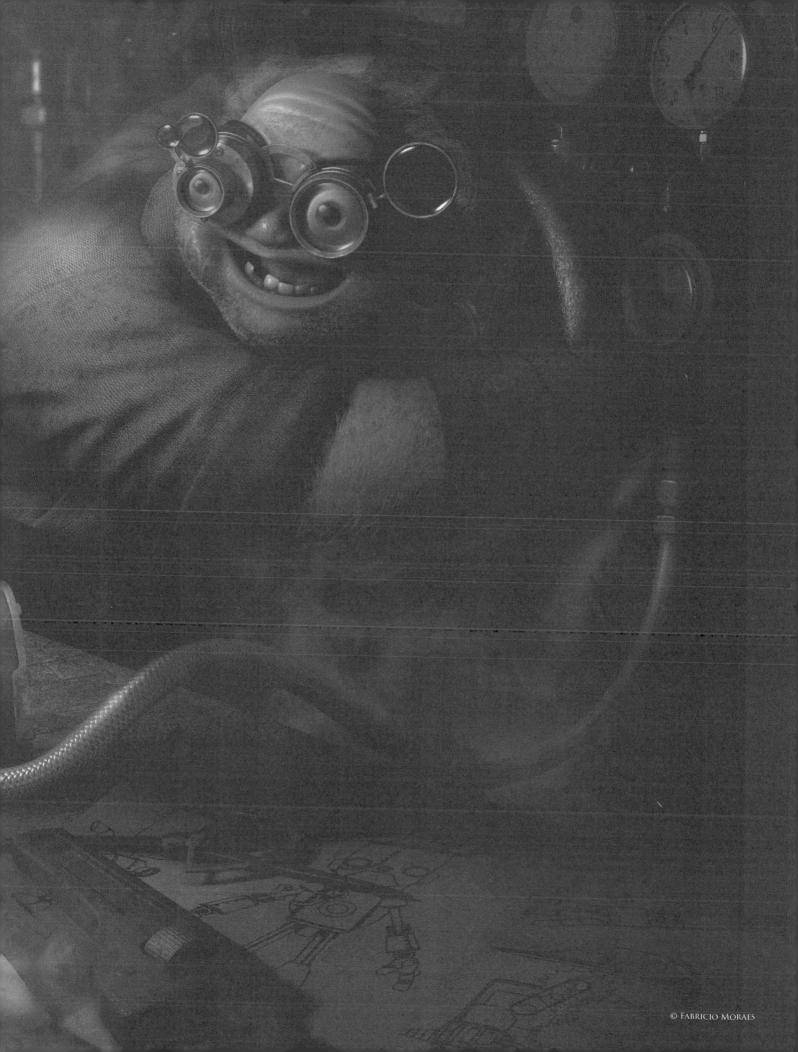

© Fabricio Moraes

Steamnocchio
By Fabricio Moraes

Job Title: Character Artist

Software Used: 3ds Max, Mental Ray, ZBrush, Photoshop

Introduction

I have always thought that the steampunk theme is a very interesting one. When CGSociety decided to create a new challenge using this subject, I asked myself: why not give it a try?

I chose Pinocchio because he is a well-known character and because of his artificial nature. He is a wooden marionette, so I imagined it would be nice to turn him into a mechanical steam robot. In this version, Geppetto is a mad and lonely old man. Since he has no friends at all, he decided to make one. With no magic or "abracadabra", he brought his creation to life with steam power. I didn't want to make these characters too similar to any existing representation, which is why Geppetto is fat with a crazy look.

> ❝ He needed to be the centre of the image, grabbing the viewer's attention and leading it across to Geppetto ❞

From the start I wanted to make the work look simple, with nice details, but I also wanted to focus on creating an easily readable composition with Pinocchio as the

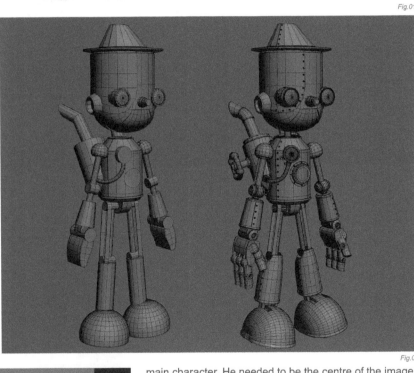
Fig.01

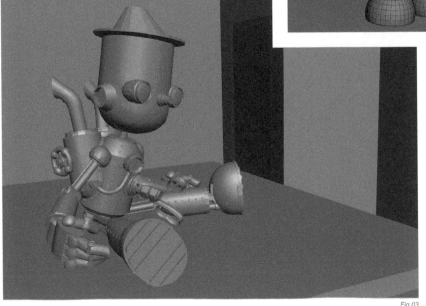
Fig.02

main character. He needed to be the centre of the image, grabbing the viewer's attention and leading it across to Geppetto. I also wanted to make a realistic caricature, with strong expression and movement.

I did some research and tried some sketches until I came up with this one (**Fig.01**). It is more a sketch than a concept, but it was very useful when it came to developing the idea.

Modeling

I started the modeling with Pinocchio, who is very basic and made up of simple geometry. I positioned the primitives to set his proportions and refined each one of them to assemble the final form (**Fig.02**).

Fig.03

CARTOON

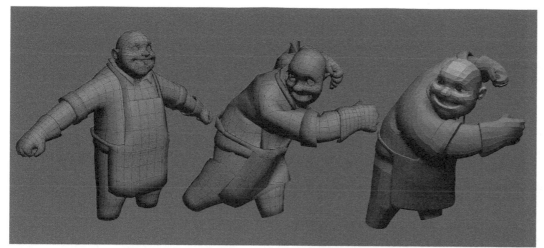

Fig.05

Fig.04

Fig.06

Before I finished the model, I placed it in its final position, as shown in **Fig.03**.

The posed Pinocchio helped me to find the right camera position and set the proportion of the environment. For me, working with posed models in the final camera view is the best way to see which details will have focus in the scene and which elements will be unnecessary. The box on the left was a proportion reference for Geppetto.

With the camera and environment proportion set, it was time to start Geppetto. He was much more complex to model because of his pose and expression. I wanted to make a strong and exaggerated pose expressing strength and madness, but at the same time conveying a cartoonish look.

I started by making a base mesh in a neutral position. Next I applied a basic rig to "sketch" his pose, which was then refined in ZBrush (**Fig.04**). It was easier for me to bring an already posed mesh into ZBrush to tweak it.

Fig.07

Fig.08

I made the goggles using a box modeling technique and positioned them according to Geppetto's initial low-poly pose (**Fig.05**). I didn't use any special techniques to make the goggles. They were based on some references taken from the internet and I began modeling them from two cylinders, which were very fun to make. The eyes were very important for this character because they showed his personality. He is crazy so I wanted to make very big, round eyes, refracted by the goggles. Refracting the original eyes through the goggles looked weird so I made a separate mesh for the eyes and eyelids and positioned this closer to the lens, as shown in **Fig.06**. When this mesh was refracted it exaggerated the effect.

Back in ZBrush I started to add details to Geppetto (**Fig.07**).

When he was done, I simply exported the high-poly mesh back into Max. It wasn't necessary to work with a displacement map as I think a very high-poly mesh is easier to render than a mesh with a Mental Ray displacement.

I made the teeth later in Max, again using the box modeling technique (**Fig.08**).

For the hair, the native 3ds Max Hair and Fur application, rendered with Scanline in a separate file, did the trick.

Now, with both of the characters modeled, I was able to focus on the environment. I was cautious with the elements because I didn't want anything to appear in the scene that wouldn't make sense. Some tools on his table, shelves full of gadgets and machinery based on a locomotive fit into Geppetto's workshop. I didn't pay much attention to details since the environment was secondary and I didn't want to draw too much attention to it (**Fig.09**).

> ❝ **IN ALL STAGES OF THE CREATION PROCESS I WAS WORRIED ABOUT THE BALANCE AND SIMPLICITY, AS THE FINAL RESULT HAD TO BE EASY TO UNDERSTAND** ❞

TEXTURING

The UV mapping was quite easy. For Geppetto I used regular unwrapping tools and for the rest of the scene, including Pinocchio, I used simple UV mapping coordinates such as Box and Cylindrical.

I collected some dirty metal, wood, gauges and fabric maps and blended some in Photoshop to make the textures. I downloaded some of the maps from CG Textures. For the background I repeated some textures since they would be blurry. The main idea here was to make neither a very clean environment nor one that

Fig.09

Fig.10

was too dirty. In all stages of the creation process I was worried about the balance and simplicity, as the final result had to be easy to understand.

Fig.10 shows a walkthrough of how I created Geppetto's diffuse maps. At first I made a base for the skin by mixing procedural maps. I took the green channel of a World Space

SPECULAR MAP

DIFFUSE MAP

Fig.11

CARTOON

normal map on his face and set it to Multiply to add volume and more contrast and then added the dirt layer.

Geppetto is in a closed, warm room and so he should look like he is sweating. To achieve this I added a specular map in his material and set a higher specular intensity. After that, I used this specular map to mask the dirty layer on his face, meaning that, where the sweat had run, his skin looked a little cleaner (**Fig.11**).

I also turned the shirt's diffuse map darker under the arm and on his back to make the shirt appear sweaty too.

Fig.12 shows Geppetto's head material.

After almost losing my mind over figuring out how I would model the hose attached to Pinocchio, I came up with the idea of using a normal map. It worked better than I expected. I generated a procedural fabric map from Maya and used Nvidia's plugin for Photoshop to make the normal map (**Fig.13**).

LIGHTING
I used Mental Ray to render, and used one single Omni light to illuminate the whole scene (**Fig.14**).

Fig.13

Fig.12

Fig.14

Fig.15

I wanted to convey the feeling of an enclosed room illuminated by a lamp, but without it feeling too claustrophobic and dark. The Omni had a far attenuation set to falloff stretching into the background.

Pinocchio needed to be the most illuminated element in the scene to draw attention to him – as mentioned earlier, I wanted him to be the first thing the viewer noticed in the image, followed by Gepetto. I therefore put him in a darker area within the middle range of the main light falloff.

I forced Final Gather to generate the secondary light source, therefore lacking the need for any other lights (**Fig.15**).

I gave almost all the materials glossy reflections so that they really reflected the walls, table and other elements, generating a better interaction between them.

COMPOSITION

For me this was the most important stage in this work. Here I could calibrate the light and supply the extra mood that was missing. The final render didn't even get close to the end result, but I didn't worry because in Photoshop I could make things look right.

I made six render passes (**Fig.16**).

Before rendering, I separated the objects into 3ds Max layers, leaving one layer visible and all others invisible to the camera. This meant that all the objects would cast shadows and be reflected by the rendered elements, but would not appear in the render pass. It is much easier to control the entire composition using separate passes like this.

The hair pass followed later (**Fig.17**).

Then the raw render (**Fig.18**).

Fig.19 shows the color correction and occlusion pass set to multiply.

Glow, depth of field and light effects done by hand can be seen in **Fig.20**.

Steam made by Photoshop brushes can be seen in **Fig.21**.

The final composition culminated in placing all the passes together, then applying some color correction towards warmer tones and adding contrast and effects such as glow, depth of field and smoke.

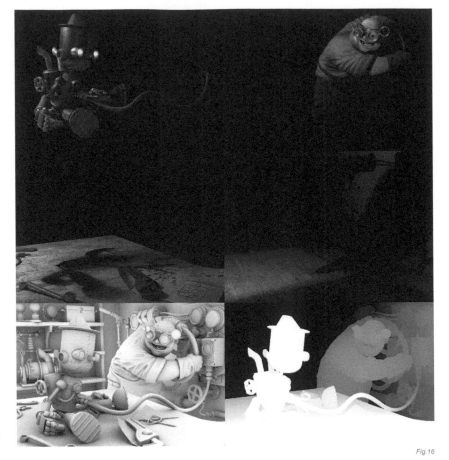

Fig.16

CONCLUSION

From the very beginning I was always worried about the clarity of the main idea. I wanted people to see it and know immediately what was going on. That's the reason I blurred the background and put a light right on Pinocchio so as to draw attention to him. Considering the feedback I got, I believe that I achieved my objective.

I made this twisted version of Pinocchio with full respect to the original creator of such an amazing story: Carlo Collodi.

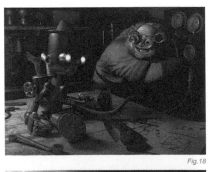

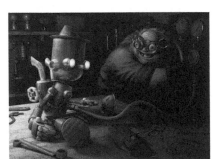

Fig.18

Fig.19

Fig.17

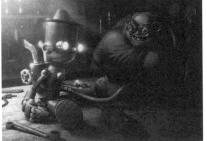

Fig.20

Fig.21

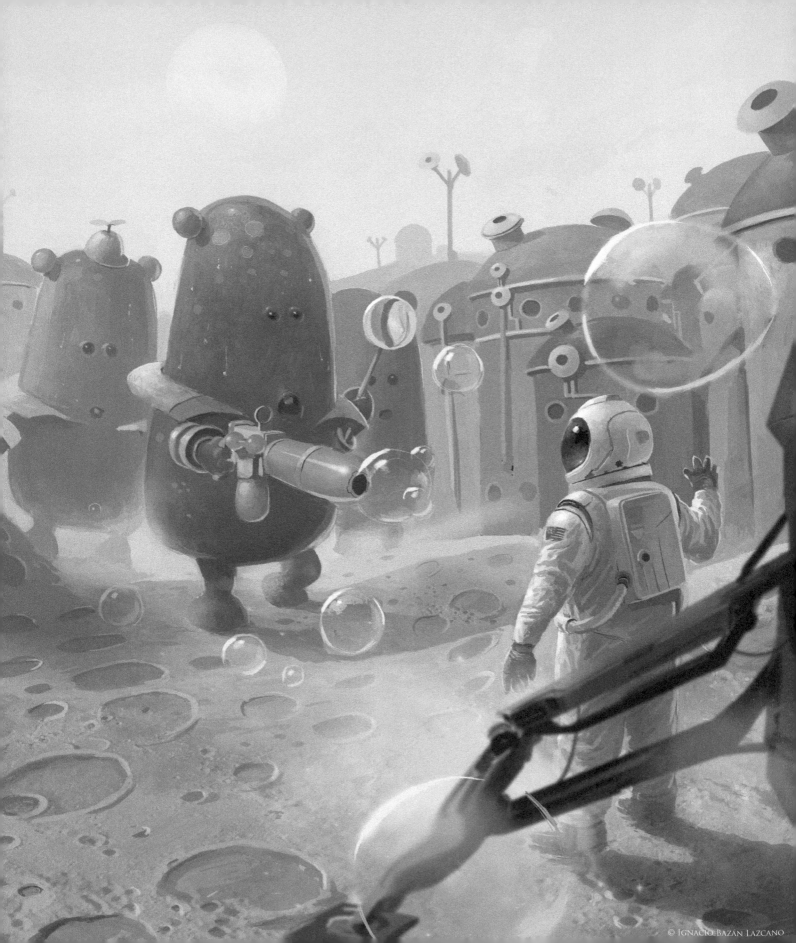

© Ignacio Bazán Lazcano

WELCOME
BY IGNACIO BAZÁN LAZCANO

JOB TITLE: Concept Artist – Timegate Studios
SOFTWARE USED: Photoshop

INTRODUCTION

It's been five years since I started working as a concept artist in the videogame industry. I had previously studied advertising, having obtained my university degree in 2005, but soon realized that being a publicist didn't suit me at all and so decided to make a radical change in my life. When I got my first paid job as a pixel artist in a videogame company, I joined the world of digital art. Since I was a small child I have drawn constantly, though always in a traditional way. For this reason, digital techniques were difficult for me at first, but soon I was able to grasp them due mainly to my previous traditional knowledge and experience.

Two years ago, while I was selecting some of my drawings for a personal portfolio, I realized that none of them related to a child's outlook and aesthetic. Most of them showed action, science fiction or historic subjects. It seemed to me that it was very important for my professional development to change style and be more versatile.

> **UNFORTUNATELY COLORS DO NOT ALWAYS APPEAR CORRECT WHEN THEY ARE OVERLAID, AND OFTEN LOOK TOO "DIGITAL"**

Fig.03

Fig.01

Fig.02

As first I focused on the aesthetics of Pixar's films as 3D films have been gradually winning the audience's attention for some years now. I have always liked 3D aesthetics, particularly those in Pixar's films; I'm really mad about them.

THE PAINTING

I began by making several sketches in pencil and ink, during my lunch hour. The first idea that came to me was a pair of cute extraterrestrials running about their alien planet. Afterwards, it occurred to me that they would probably fear a visiting astronaut (**Fig.01**).

When I begin drawing in Photoshop, I usually start with a grayscale version and then add color afterwards, which I find is quicker. Unfortunately, colors do not always appear correct when they are overlaid and often look too "digital". It is for this reason that I eventually repaint them to keep them warm and vivid. I use this technique on a daily basis when designing quick concepts but when making an illustration I apply the color directly after the drawing is finalized. Colors look better if we use them directly from the start, as if painting a traditional picture (**Fig.02**).

After establishing the basic colors, I began the next stage, which was to add volume to each element across the whole composition (**Fig.03**).

Before providing volume to an object, it's important to first know where the light is coming from. This information is very important to the whole painting process (**Fig.04**).

THE COLOR

Most people who wish to start working in the digital world enquire about the type of paint program they should use; e.g., Photoshop or Painter. More importantly, I think it is first necessary to understand how colors work and, once this is grasped, one can decide on the tool, be it digital or traditional.

I tried to paint this work with a warm color palette because I had decided that the aliens should live on a desert-like planet. This meant that each element had to be affected by the color of the environment.

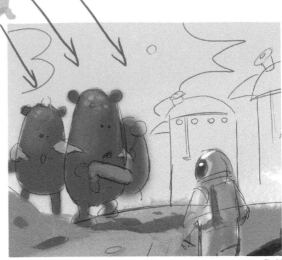

Fig.04

Fig.05

Fig.07

I put the astronaut in a white suit and, in order to make this feel part of the environment, I had to add yellowish-brown and gray colors. If I had only painted the character in white, it would not have integrated with the rest of the picture. Using the same criteria I created the other characters and background elements (**Fig.05**).

Fig.06

I decided that the aliens were to be red, and consequently I added oranges, browns and violets to them. One always has to remind oneself about light when giving volume to objects (**Fig.06**).

In this case the aliens stretched into the background and so I used less black to make them contrast with what was in the astronaut's proximity; an important factor in a painting (**Fig.07**).

When drawing the bubbles I considered the environment and took the colors into account again. Bubbles are transparent and yet, at the same time, reflect light like a mirror. To achieve the desired realism as well as the volume, I utilized both the light source and a backlight. All objects receive light and backlight to a greater or lesser

Fig.08

CARTOON

extent, depending on their material. Drawing a bubble is the easiest way to show how this principal works (**Fig.08**).

To make the background, I went from an orange color through to a bluish green, the orange being for the ground and bluish green representing the sky. In this way, by adding yellow and blue to the orange, I got a tuneful color range for the background. Moving within the color wheel with each color is always the best way to obtain good results.

Fig.09

DESIGN AND FINAL DETAILS

Having started with the character, I could then move on to designing the planet's buildings and structures. This way of working is frequently used in videogames and films. Often the design of the first object determines the aesthetic of everything else, thus accomplishing a coherent and consistent style throughout. This is a piece of advice worthy of consideration when undertaking any concept work.

The alien's aerials inspired me to create some chimneys (**Fig. 09**).

I finally added some blur to the closer elements as if they were out of focus. This effect allows us to fix our eyes on elements with a higher definition and at the same time increase the sensation of depth in the image (**Fig.10**).

CONCLUSION

What is important for an artist, and more so for an illustrator, is to be able to manage several aesthetics and adapt to different kinds of work. If you are versatile, you can face new challenges and not "pigeonhole" yourself into specific genres.

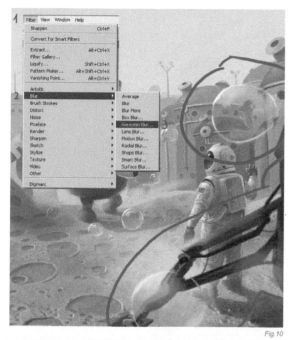

Fig.10

ARTIST PORTFOLIO

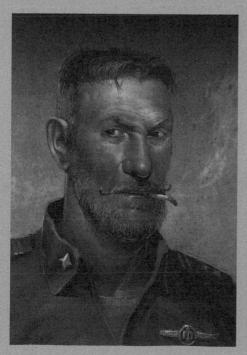

PRIMROBB'S THRESHOLD
BY MATT GASER

JOB TITLE: Art Director / Concept Artist – Stargaser Illustration
SOFTWARE USED: Photoshop

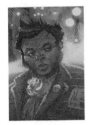

INTRODUCTION

When I start any painting it generally begins from the small sketch of an idea. I like to work in pen on marker paper and use this method to draw out ideas, the same way I guess an author writes the notes of what might later become a novel.

WORKFLOW

Fig.01 shows an initial sketch I came up with that planted the seed for this painting. I think about a year passed until I went through my sketches and came across this drawing and thought to myself, wait a minute … there's some potential here. When I created this painting I was working at a studio and used my lunch breaks to squeeze in some personal work, which was the case with *Primrobb's Threshold*. I scanned in the drawing the next day and began to build a composition in Photoshop for the sketch to rest inside. To begin with I always create a layer set to Multiply to lay down my values and color while maintaining the integrity of the drawing underneath (**Fig.02**).

The one thing missing was an environment. I knew I wanted the character to be in a field of some kind, but at this stage it wasn't working.

Fig.01

Fig.02

Fig.03

> **SOMETIMES YOU HAVE TO FEEL WHETHER IT'S THE RIGHT TIME TO CONTINUE A PAINTING OR NOT. SOME PAINTINGS EVOLVE AND BECOME A SUCCESS AND OTHERS CAN FAIL, BUT I STILL DIDN'T KNOW AT THIS POINT**

As you can see in **Fig.03**, I added some tree elements and a small person for scale and was beginning to develop a simple narrative and shapes that perhaps suggest an alien world.

It was at this stage that I left the painting (I got bored with it) and didn't come back to the image for another six months. Sometimes you have to feel whether it's the right

CARTOON

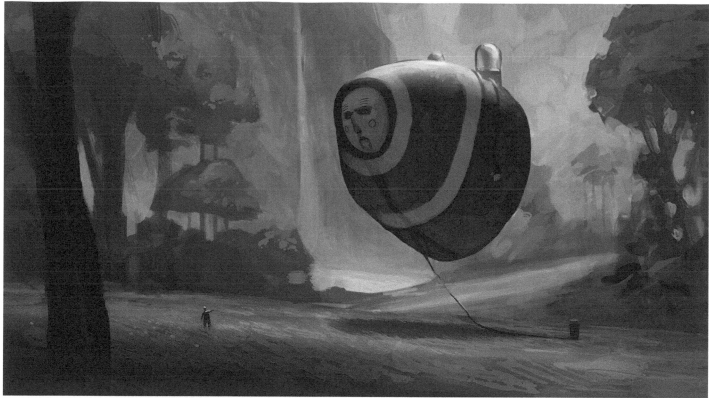

time to continue a painting or not. Some paintings evolve and become a success and others can fail, but I still didn't know at this point.

I came back to the painting with some fresh ideas and so I masked the main character from the background and threw in one of my old landscapes as a test backdrop (**Fig.04**). This took the concept in a whole new direction with more fantastic trees and a brand new color palette, and adding a tall, cascading waterfall brought some focus to the background.

Working hard each day during lunch (one hour a day), I continued to add new elements (**Fig.05**). Struggling to separate the main floating

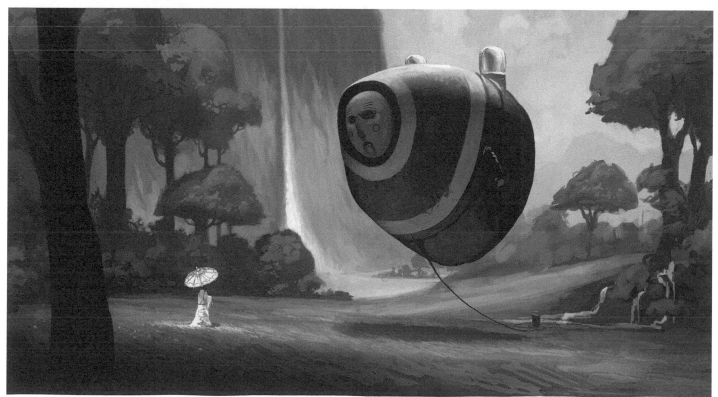

character from the background, I managed to isolate him with a strong silhouette. I added a shallow waterfall to the right of the image; I mean, if this guy is chained to a prison post, how is he going to drink if he gets thirsty, right? But the creek falls confused me because as I painted them I couldn't find a place for the water to go. Maybe it seeps into the ground, I thought; but no, that wasn't going to work. I was getting frustrated at this point. I also changed the character on the ground to a woman in some kind of kimono dress. When I painted in the umbrella I started to wonder about the narrative and if this could be a love story of some kind…

> ## " I ALSO IMAGINED THAT AS PART OF THE NARRATIVE, MAYBE THE MAIN CHARACTER WAS FRAMED FROM A CRIME HE DID NOT COMMIT… "

Finally I made all the adjustments and additional details that convinced me that the painting was finished. Starting with the creek falls, I managed to bring the water into the foreground, which leads the eye into the composition. I decided that if this was a love story then the floating character should perhaps be crying (scars of black tears down his face), because he's sad that he can't be with his lady friend (**Fig.06a – c**). I also imagined that, as part of the narrative, maybe the main character was framed for a crime he did not commit…

I peppered the main character with some details such as scratches and mud spots to add some aging. Finally I

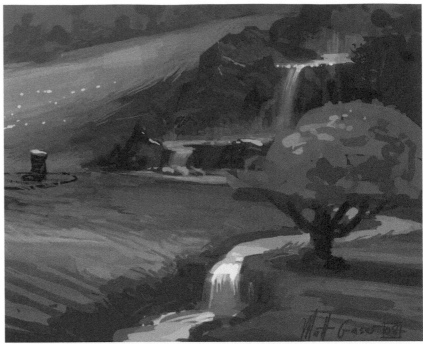

Fig.06a

Fig.06b

intensified the lighting to increase the contrast using Image > Adjustments > Brightness/Contrast and painted in any extra highlights that were necessary.

Then I was done and feeling great about the piece – yay!

CONCLUSION

Whenever I complete a painting I always look back and wonder what I could have done to improve the image or concept. In this case, I was very happy overall but wished I had spent more time on the background trees. In hindsight the trees back there to the right are loose and maybe too vague. However, this could still be remedied with a little more work.

I also learned that I shouldn't leave a painting for so long! I need to resume work on some of my other failed pieces and bring them to a satisfactory conclusion as I did for this one.

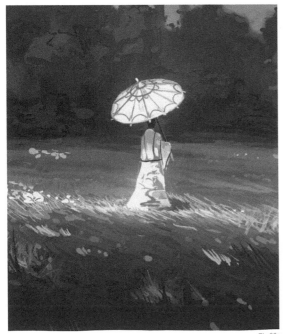

Fig.06c

CARTOON

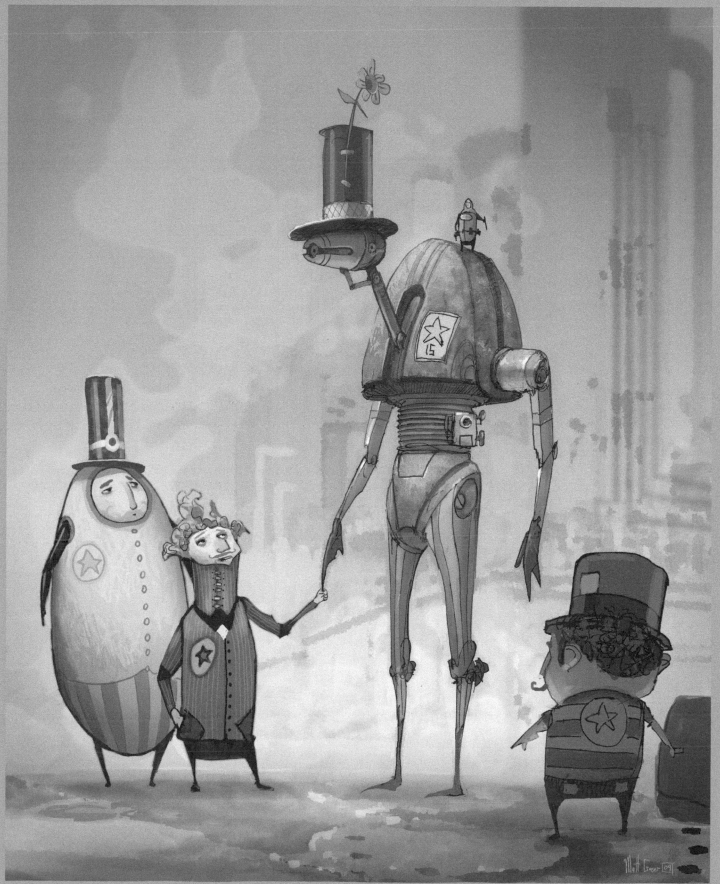

TWISTED DOLLS: THE BUTCHER'S BRIDE

BY REBECA PUEBLA PANIAGUA

JOB TITLE: 3D Character Artist

SOFTWARE USED: 3ds Max, Mental Ray, Hair and Fur, ZBrush, Photoshop

INTRODUCTION

The Twisted Dolls is a series of cute and sexy pinup dolls inspired by different decades and roles with an undefined style, resting somewhere between cartoon and realistic.

The Butcher's Bride is the second character of this series and is very different from the first doll (a lady in red and black and inspired by the BDSM culture).

For The Butcher's Bride I wanted to create a beautiful and innocent girl in a Victorian environment trying to escape something horrible. My inspiration for this scene was the pinups of the 1920s. There are many things representative of this period, including wavy red hair, dark

Fig.01

makeup, vintage clothes with tights corsets, the dramatic expressions of silent films, melancholic vampires, old-school tattoos and dark castles. A genre of comedy very typical of this period is called "cabaret" or "vaudeville".

MODELING

I started working with the base from the previous doll, Mistress Lili, since she has similar proportions. Whilst in the resting pose I applied a very basic setup to deform the model quickly and easily to get the correct pose. When this was more or less correct I was able to start modeling the clothes and details. I was lucky and found many interesting references of corsets that helped me a great deal.

Fig.02

I always try to create a really good mesh in 3ds Max before going into ZBrush because after finishing the model in ZBrush I collapse it. The reason for this is that I don't much like using displacement maps for a unique render or illustration. I will not animate the model and sometimes they cause me a lot of problems so I prefer to collapse the mesh and export to 3ds Max, which consequently makes it more complicated to change anything.

Fig.03

UVS MATERIAL SKIN - MAP CHANNEL 1

UVS MATERIAL TATTOOS - MAP CHANNEL 2

Fig.04

However, I am constantly changing the mesh to find the perfect form. Her tense body and extreme proportions balanced on long, shaky legs had to convey all her terror and fragility. The silhouette is really important to a good character and sometimes it is necessary to look again and again at the model, making small changes and having the patience to work towards a great result (**Fig.01**).

TEXTURING & SHADERS

The textures and shaders were very important for the clothes and tattoos. I wanted an opaque and pale skin for the bride, with very dark eye makeup and a little strawberry mouth. I didn´t want very realistic skin as she is a cartoony doll and preferred this to contrast with the clothes. The tattoos had to be numerous, colorful, look "old-school" and be dramatic (virgins, gravestones, snakes, etc.) (**Fig.02**).

I painted the tattoos and skin in Photoshop, but used photo references for the corset and laces because it seemed more realistic. With regard to the materials I used a Blend

Fig.05

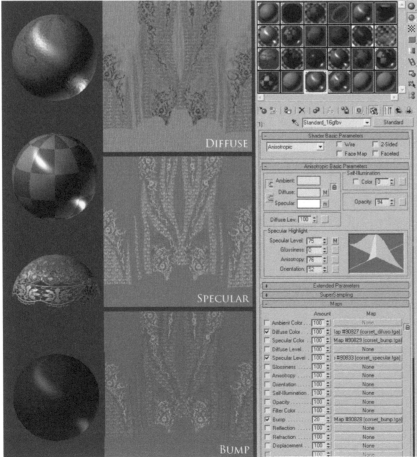

DIFFUSE

SPECULAR

BUMP

Fig.06

material with one material assigned to the skin and, one for the tattoos and a Mask to mediate between the two (**Fig.03**).

You can use different textures in the same area by utilizing more than one map channel, which is very easy. I used Unwrap UVW to create the UV coordinates, which I saved into Map Channel 1. I then unwrapped a new set of UVs for the tattoos, which I saved into Map Channel 2 and saved as a new file (**Fig.04**).

The corset was the most authentic part of this picture and I found numerous beautiful and detailed references. The modeling was far from straightforward though, especially the back, but the main problem was creating a realistic satin and brocade material (**Fig.05**). Some anisotropic highlights were perfect for achieving this effect (**Fig.06**).

> ## AT FIRST, THE IDEA WAS TO CREATE A SHADOW IN THE BACKGROUND INSPIRED BY NOSFERATU AND A LIGHT WITH A STRONG CONTRAST TO ADD MORE DRAMA, BUT THE BRIDE'S APPEARANCE SEEMED VERY ARTIFICIAL AND BROKE WITH THE TRADITION OF THE *TWISTED DOLLS* SERIES

Other items with a shiny material are her sweet, red high heels (**Fig.07**)

LIGHTING

The lighting was the part of the process that possibly went through the most changes. At first, the idea was to create a shadow in the background inspired by Nosferatu and a light with a strong contrast to add more drama, but the bride's appearance seemed very artificial and broke with the tradition of the *Twisted Dolls* series (**Fig.08**).

I did lots of tests to balance both parts but the results were not convincing. There either seemed to be too much contrast or the scene was very bright with the shadow of Nosferatu assuming more importance than the bride. I eventually decided on more traditional diffuse lighting using two photometric lights (**Fig.09**).

Fig.07

Fig.08

Fig.09

Then I created two columns and curtains to create a darker backdrop and add more depth to the background (**Fig.10**).

HAIR

Hair is always complicated and because of the curvy style and the way it parted I encountered problems with the antialiasing and red shader. The dark hair looked nice but the hair was clearer when blonde, and red seemed absolutely horrible, so I searched the internet for a solution and found a hair material for Mental Ray called MuhHair, which was perfect (**Fig.11**).

> ❝ I'M NOT SURE IF THIS IS A GOOD OR BAD THING, BUT SOMETIMES I GET CARRIED AWAY BY THE CHANGES THAT OFTEN ARISE FROM BETTER IDEAS, WHICH CAN BE UNEXPECTED ❞

An important consideration for this material is the activation of the checkbox labeled Use Fast Rasterizer, which can be found under Scanline > Render Algorithms of the Renderer. It is also important to change the filter type to Gaussian as this generally gives better results. In this case the Fast Rasterizer increased the render time too much and the Gaussian filter blurred the whole picture so I left the parameters as they were. The result was a good balance between a doll and a real person.

CONCLUSION

My final images are never exactly attuned with the original ideas. I'm not sure if this is a good or bad thing, but sometimes I get carried away by the changes that often arise from better ideas, which can be unexpected.

In this picture I wanted to portray "The Vampire's Bride" and instead made "The Butcher's Bride"; similar but at the same time different. The pose, environment, lighting and many other details have changed but the idea has remained more or less the same.

Fig.10

Overall it was a complicated image to create but I learned many things during the process, namely regarding lighting, shaders and hair.

I'm happy with *The Butcher's Bride*, but as always will aspire to do much better next time.

Fig.11

© REBECA PUEBLA

© Serge Birault

SASHIMI'S REVENGE
BY SERGE BIRAULT

JOB TITLE: Illustrator

SOFTWARE USED: Photoshop

INTRODUCTION

This image is another example of my indiscipline. My first idea was to create a pinup symbolic of the 1980s with very saturated tones and numerous reflections, as typified by the work of Hajime Sorayama. I wanted to include an octopus, which references Japanese mythology and also has an erotic connotation. All this seemed very coherent to me and I wanted to dedicate my illustration to the master of the pinup and airbrushing.

As often happens, I changed my mind rather quickly. Whilst looking for reference images for my set, I came across old oil paintings of beaches and ports. Their colors pleased me and so I decided to use them.

> " I MUCH PREFER CARICATURES AND TRY TO SLIGHTLY DEFORM THE ENTIRE BODY AS I CARE MORE ABOUT THE HARMONY OF THE CURVES THAN ABOUT THE ANATOMICAL ACCURACY "

Fig.02

Fig.01

Like many pinup illustrators, I usually don't really care about the set. I just choose a shade which will determine the ambient light. I often refine my color scheme across the entire image at the end of the painting process, but it didn't happen on this occasion and it was a nightmare…

SKETCH

I only spend a little time on this stage, just trying to see whether my composition is valid or not. At the beginning, I thought about putting a lighthouse behind the character but eventually rejected this idea and focused on the face. I found some pictures of Scarlett Johansson in which she seems surprised, and this was exactly the expression that I wanted to give my pinup.

As with all my images, the proportions of the young lady are absurd. I spent all my adolescence trying to reproduce photos, but it doesn't interest me anymore. I much prefer caricatures and try to slightly deform the entire body as I care more about the harmony of the curves than about the anatomical accuracy (**Fig.01**).

Fig.03

BACKGROUND

For once, I spent quite a long time on this part. If elements are very simple then sometimes the colors prove a real puzzle. After a few attempts, I finally decided on warm, slightly saturated colors. All in all, it was the opposite of what I had initially planned, but it provided an old quality that I liked (**Fig.02**).

THE SKIN COLOR

It is here that my troubles began, and they concerned coordinating the skin with the background. Eventually the dominant color became a very pale green with the darkest being a very dark magenta. Finding the intermediary colors was a real ordeal, but after several failures I reached a satisfying result (**Fig.03**).

THE PINUP

I work on the computer in the same way as I worked with my old airbrush and tubes of acrylic. The big difference is that now I am able to make mistakes.

I always begin with the face, which in my view is the most important part. The level of detail in the face will determine the level of detail across the entire image.

I began with a tint area for my average color palette. I then used a standard brush to set up my colors with a very low opacity (never more than 40%). Next I began to use the airbrush, also with a very low opacity (rarely more than 10%). This was the most time-consuming

Fig.04a

CARTOON

Fig.04b

part, upon which I spent a considerable amount of time. Furthermore, I created an incalculable number of layers that I was able to revert back to in case of any errors. Indeed, one of the major risks attributed to the airbrush is in obtaining a result that is too smooth and therefore not very realistic.

To finish off, I redid the main zones and the darkest areas, the airbrush tending to dull the tones. After obtaining a satisfactory result, I merged my layers and erased any superfluous areas before moving onto the whole body (**Fig.04a**).

Once the flesh color was complete, I created all of the missing elements (the swimsuit, the diving mask, the watch and the locks) (**Fig.04b**).

> ❝ THIS IS A BIT OF ARTISTIC LICENSE IN HOMAGE TO SORAYAMA. NO MATTER WHAT THE ENVIRONMENT, WHEN SORAYAMA USES CHROME, IT INVARIABLY REFLECTS A DESERT AND A BLUE SKY ❞

THE OCTOPUS

I repeated this same method, using a tint area and creating the volumes before adding the details with a low-opacity airbrush. Once again, I used a large number of layers (**Fig.05**).

Drawing suckers is a bit tedious and I didn't find very useful photographic references because I wanted deformed tentacles (**Fig.06**).

Oddly, the most delicate part of this image involved creating coherent reflections. In all honesty, the reflections on the tentacles are quite simply inaccurate.

They are supposed to reflect the sky, the color therefore aiming at the green and yellow. However, to be convincing, the reflections reflect a blue sky instead.

This is a bit of artistic license in homage to Sorayama. No matter what the environment, when Sorayama uses chrome, it invariably reflects a desert and a blue sky. It's the same for my tentacles, which don't reflect a green sky, but a real blue sky instead. You may ask yourself, why? It is simply because we are used to seeing these kinds of reflections, as demonstrated by Sorayama. It is sometimes necessary to be more realistic rather than to stick strictly with reality.

Contrary to what we might believe, there is a very slight gradation across the reflections. I then went on to finish the head of the octopus without any major difficulties (**Fig.07**).

Fig.05

Fig.06

Finishing

Since there is no longer a lighthouse in the background, I had a real problem with the composition. As a solution I had the idea to include a harpoon wedged under her arm, spearing a fish. The composition once again became viable and consequently the eye was led around the picture space in a logical and fluid manner. I created the harpoon horizontally and then rotated it afterwards to make it easier to draw (**Fig.08**).

> **WORKING WITH SUCH A PARTICULAR COLOR RANGE WAS A REAL CHALLENGE AND ULTIMATELY I HAD TO PAINT AS THOUGH I WAS USING MY OLD AIRBRUSH**

Fig.07

Fig.08

Fig.09

Adjustments

Usually, I spend considerable time on this part but, here, it took all but ten minutes at most. I just needed to harmonize all the colors (**Fig.09**).

Conclusion

Finally, my lack of discipline proved to be efficient for once. Working with such a particular color range was a real challenge and ultimately I had to paint as though I was using my old airbrush and assuming there could be no final color adjustments at the end. Even though I'm satisfied with the result, I think that I will not do this again in a hurry; more than 70 working hours for a single illustration is not very profitable!

S-BIRAULT-2009

© Andrew Hickinbottom 2009

HOTERU NO AOI
BY ANDREW HICKINBOTTOM

JOB TITLE: Character Modeler

SOFTWARE USED: 3ds Max

INTRODUCTION

I have a strong interest in Japan. I like pinup art and find Asian girls very beautiful. Put these facts together, and you get the reasoning behind this image! I wanted to make an alluring, interesting and subtle nude pinup, without being tacky or showing too much, and to see how far I could push a facial caricature, yet still keep it appealing and attractive. I saw some photos of a girl on a Japanese cosplay website that became the core inspiration convincing me to do this. She had a really interesting and unusual face with small, round eyes, a broad nose and simple rounded features, and she was also very pretty.

> ❝ I TWEAKED THE BODY TO GIVE HER LITHE, SLIM PROPORTIONS AND A NAVEL ❞

WORKFLOW

The face (the most important part) came first. I started off with a box cut down the middle and added a symmetry modifier so I only needed to work on one side. Using the Cut and Connect tools, as well as manual vertex manipulation, I gradually developed the head. The position of the eyes and mouth were established with holes in the base topology and then built up around them using the Cut tool. **Fig.01** shows the modeling progress.

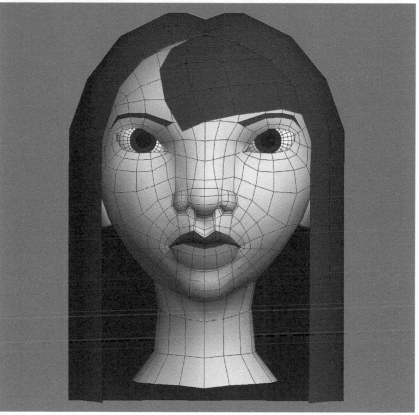

Fig.01

Fig.02

I added some eyes and made a basic hair shape in order to frame the face and visualize it better. I chose not to model ears as you would never see them. Polygon colors were added to the lips and eyebrows to help define them, and I tweaked the overall face proportions until it looked like **Fig.02**.

The body was next. I started with a tall cylinder and added vertical edge loops to define the hips, breasts and waist. Using the same techniques when refining the head, I developed the body shape as shown in **Fig.03**.

I went back to the head and adjusted the features some more. I joined the neck to the body and made some simple, thin arms and hands. I didn't model her legs because her thighs would be the lowest visible part of her anatomy.

I tweaked the body to give her lithe, slim proportions and a navel. I chose not to finalize the model or add more definition until she was posed. As the model was only ever

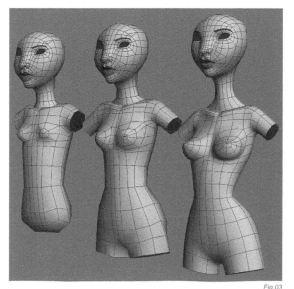

Fig.03

"I MADE SEVERAL TEST POSES TO DETERMINE THE MOOD, COMPOSITION AND THEME OF THE IMAGE"

designed to be for a one-off image, I decided not to add detail to things you would never see – hence the lack of legs and a bum.

I quickly skinned the mesh to a biped so I could create some pose tests and check the proportions. **Fig.04** shows her in a relaxed pose just after skinning. The hair is still basic as the final pose will dictate how it looks.

I made several test poses to determine the mood, composition and theme of the image, as seen in **Fig.05**. Skinning flaws and geometry intersections were ignored for the moment. I thought about early situational ideas such as standing in a doorway, sitting in a bath, lying on the floor, etc. and the way I could incorporate the lighting into the scenes.

Fig.04

I thought that the doorway pose would work so I developed it further, adding basic lights into the scene. A traditional Japanese-styled room would create an interesting balance of light due to semi-transparent sliding paper doors, warm wooden tones and natural

Fig.05

CARTOON

light from outside. **Fig.06** shows the progression of this idea, culminating in a rough, untextured mockup of how the final render could look.

The Japanese room idea seemed a bit clichéd and stereotypical, and the girl's character wasn't how I imagined. I went for the other choice that I had liked – the girl leaning against a hotel window looking out at a city skyline. The diagonally split composition, the tactile feeling of the cold glass, the feeling of isolation, the balance of warm and cold lighting and the reflection play made it seem much more interesting. I tried overcast, night time, sunny and rainy moods to see which lighting setup gave me the results I wanted. **Fig.07** shows some of these tests.

> " I DETAILED HER HAIR AND
> PUT A STRAND OF IT IN
> THE HAND BY HER FACE
> TO HELP LEAD THE EYE IN
> THE COMPOSITION "

Now that I had decided on the theme, lighting and pose, I was able to finish the character. I gave her some simple diffuse and specular textures (**Fig.08**) and modeled some eyelashes. The modifier stack on her skinned and posed body was collapsed and turned into an Editable Poly. The vertices on the mesh were then tweaked to iron out any flaws in the skinning such as pinching on the arm joints,

Fig.06

Fig.07

Fig.08

lumps on her hips, elbow volume, etc. I detailed her hair and put a strand of it in the hand by her face to help lead the eye in the composition.

Fig.09 shows a turnaround of the final textured and lit model. Note the cold light coming from behind (the window) and the warm light coming from inside the hotel room (a lamp).

Fig.09

The environment was very simple – just a corner wall with a window. The background cityscape was a blurred photo I took of the view from a Tokyo hotel room I stayed in a few years ago. I added rain to the window using a combination of polygonal, refractive raindrops and a slightly refractive texture map to distort the glass. I had intended to re-light the scene perhaps using Mental Ray, but the basic Scanline test lighting had evolved to a stage where I actually used it for the final image. I found it much easier to control and it rendered very quickly, enabling quick adjustments.

Shadow-mapped spotlights formed the cold overcast exterior light and the warm interior lamplight, and three Omni lights with falloff were placed to create fake bounce and ambient lighting. I used six lights in total.

Fig.10 shows the final scene shaded grey with wireframes.

For the final comp, I multiplied an Ambient Occlusion pass to the raw render and added a few layers in Photoshop to adjust the levels, add vignetting and to bloom the image slightly.

CONCLUSION

I struggled to come up with an interesting name for the image. I ended up calling it *Hoteru no aoi* – it means "hotel blue" in Japanese, or, as I'd like to put it, "hotel blues". It took a little longer than I expected to create due to the various directions taken before deciding on the final theme, but I was very happy with the results. I wanted to create a sexy, subtle nude pinup of a slim Asian girl and I thought it worked out pretty well. I think I could have pushed the facial and body proportions a bit more, but that could have risked making her less appealing.

Fig.10

Cartoon

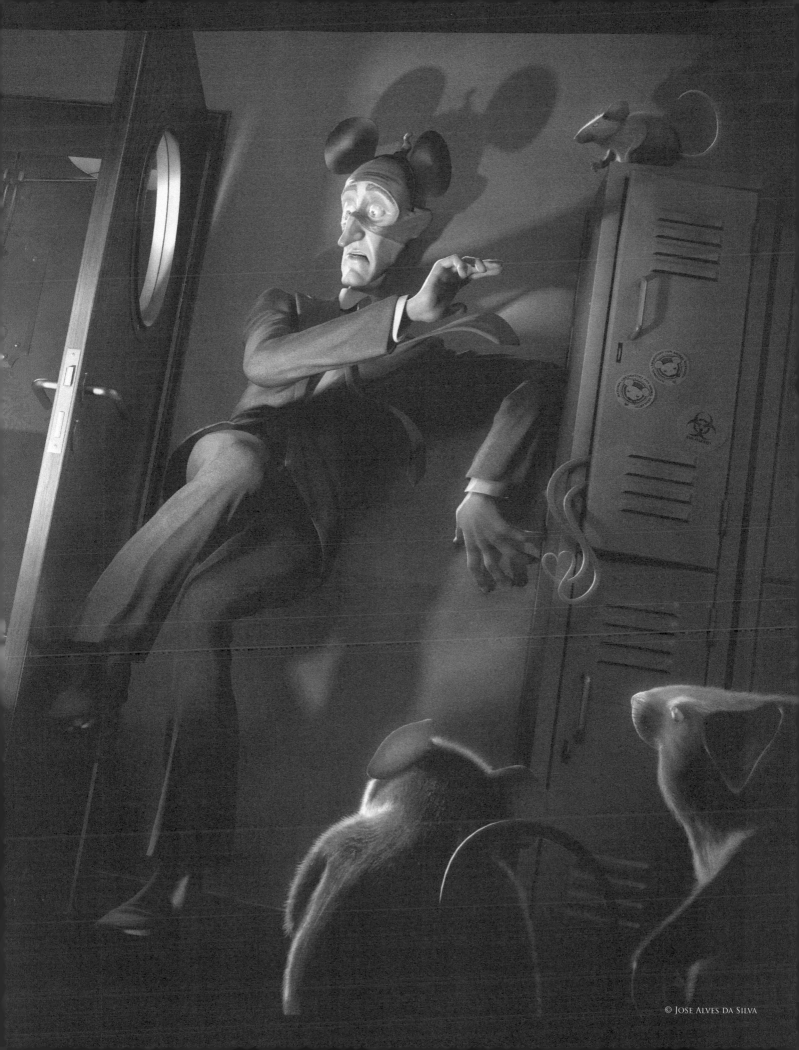

MOUSE LOVE
BY JOSE ALVES DA SILVA
JOB TITLE: Freelance Artist
SOFTWARE USED: 3ds Max, V-Ray, ZBrush, Photoshop

INTRODUCTION
This image was created for the XXIV CGSociety Challenge under the theme "Secret Agent". It was my first time participating and my main goal was to test my skills and hope to get some advice from the "gurus". There were a lot of sleepless nights but the enthusiasm of my fellow challengers really boosted my adrenaline levels and kept me going. I really have to thank them for that!

The image had to accomplish two goals: it needed to scream "secret agent" as well as tell a great story. I therefore started on the quest for a good story...

Fig.01a

Fig.01b

> ## AS A PARADOX I ALSO INCLUDED A RIDICULOUS MASK ON HIS HEAD, THUS UNDOING HIS COVER AS A "SECRET" AGENT

THE STORY – PART I
I wanted to come up with something original, but also something that referred to a lot of preconceived ideas, so I collected a bunch of images of the most famous agents to use as references.

A highly clichéd situation in a secret agent film would be facing the threat of a world-dominating menace. I thought it would be great if I could take these stereotypical elements and give them a humorous twist. I wanted a serious yet ridiculous agent; the antihero type.

THE AGENT CHARACTER – PART I
I started sketching the character and came up with a middle-aged secret agent based on certain clichés: stylish suit, dark glasses and a straight pose. As a paradox I also included a ridiculous mask on his head, thus undoing his cover as a "secret" agent (**Fig.01a – b**).

THE AGENT CHARACTER – ZBRUSH
I created an anatomically correct low polygon face and

Fig.02

experimented with the proportions of the facial features. As participating in this challenge was all about having fun, I got carried away and started detailing the face way too soon and sculpted the mask on the same mesh as the head. The head topology was not adjusted to the mask so I had problems when I had to separate the face from the mask (**Fig.02**).

Then I started to work on the body in 3ds Max. I only created the parts of his body/suit that defined his silhouette: coat, shirt collar, trousers, hands and shoes. When I was satisfied with his overall proportions, I exported the body into ZBrush in order to pose it. The mesh was divided into different subtools and polygroups to select/isolate body parts easily. Using the Transpose tool I then posed the model, which is much faster than having to rig the model (**Fig.03**).

Fig.03

Fig.04

THE STORY – PART II

I thought it would be comic if the antagonist of our highly trained agent was an apparently harmless small creature – a mouse. The little rodents are known for their reproductive ability. Why not turn it into a funny way to conquer the planet?

The story could get better if things were not so black and white. Mice have been victims of human exploitation through animal research. What if those mice were freeing themselves from captivity and just trying to get their destiny back in their hands? That gave me a place to set the action – The National Laboratory for Animal Research (**Fig.04**).

THE SCENE

3ds Max has the ability to preview shadows and screen space occlusion in real time. This allowed me to study the composition, lighting and shadow placement without rendering. I modeled some basic meshes representing a mouse, a flashlight and boxes as placeholders for props.

I ended up with a composition following the traditional "thirds rule" in which two elements stand out: the agent

Fig.05

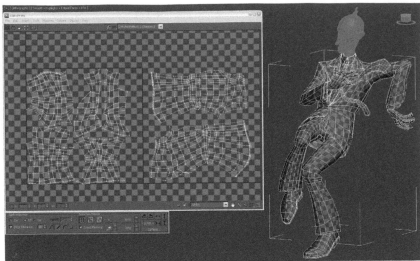

Fig.06

and the world domination plan. I tried to illuminate these areas and create some contrast (**Fig.05**).

Regarding color, there are two distinct areas: a saturated red office area reinforcing the evilness of the mice's plans and a dark blue area outside the office, emphasizing the undercover role of the agent, broken by the revealing light of the flashlight.

THE AGENT CHARACTER – PART II

In 3ds Max I added more edge loops to the mesh to prepare for the sculpting of folds across the suit and created the UVs while the polygon count was still low and easier to tweak (**Fig.06**).

In ZBrush I worked on the facial expression and detail of the clothes, trying to sculpt radiating lines emanating from

> MY APPROACH TO LIGHTING WAS TOTALLY UNREALISTIC AS I DIDN'T NEED THE LIGHTS TO BEHAVE IN A PHYSICALLY CORRECT MANNER. THEY WERE SIMPLY USED AS A VEHICLE TO DRAW ATTENTION TO THE FOCAL POINTS IN THE COMPOSITION

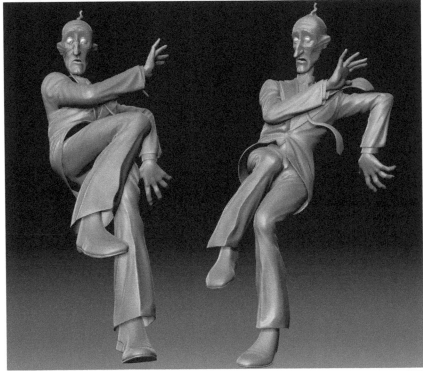

Fig.07

the tension zones and adding volume and wrinkles to the relaxed areas (**Fig.07**).

The hands and head were polypainted inside ZBrush and the vertex colors were converted into a texture. The specular map was also painted inside ZBrush (**Fig.08**).

Using the Decimation Master plugin, the polygon count was reduced while preserving the surface detail and UVs. The model was reduced from 3.2 million polygons to 150 000, without any apparent loss of detail (**Fig.09**).

LIGHTING & MATERIALS

My approach to lighting was totally unrealistic as I didn't need the lights to behave in a physically correct manner.

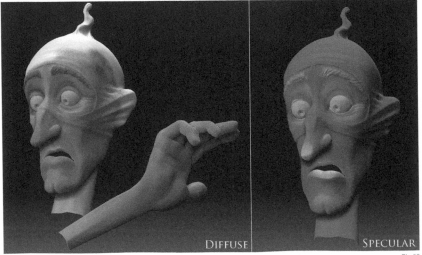

DIFFUSE SPECULAR

Fig.08

They were simply used as a vehicle to draw attention to the focal points in the composition. Inclusions and exclusions kept the lights from affecting objects that would distract from this goal. Certain lights didn't cast shadows or affect Global Illumination, which was the case with the characters' rim lights.

The same unrealistic approach was used for reflections. Huge light boxes with self-illuminated materials that did not generate light were positioned to produce nice colored reflections in specific parts of the image (**Fig.10**).

THE MICE

To create the crowd of mice, I modeled a single, low-polygon mouse. In ZBrush I sculpted the flow of the fur as I knew I wouldn't have time to render it in 3D. To achieve some variation amongst the crowd, I defined five poses that were rotated, scaled and mirrored, as well as creating different tails. Luckily, all white laboratory mice are very similar to one another and so were able to share the same materials (**Fig.11**).

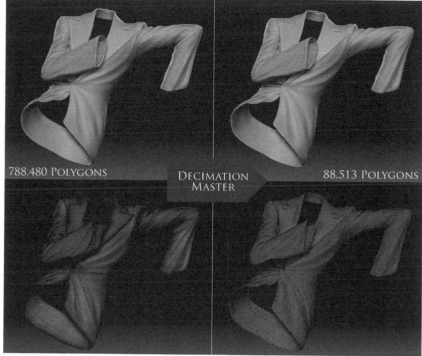

788.480 POLYGONS DECIMATION MASTER 88.513 POLYGONS

Fig.09

Fig.10

The mice assumed different appearances in the scene. In the red, office they looked white and cute and in the corridor they looked dark, with red, glowing eyes suggesting an aura of evilness. This was important as they could be seen as either aggressors or victims.

POST-PRODUCTION

I used four render passes in all: main render, rim lights, occlusion and masks (**Fig.12**).

In Photoshop, I placed the rim lights layer on top of the main render and set the blending mode to Linear Dodge to combine both layers. I set the occlusion pass to

Fig.11

Multiply to enhance the connection between the 3D elements and the addition of some dirt. The masks layer proved handy for selecting individual elements and color correcting them. Smoke, glows, the volume light of the flashlight and dirt marks on the walls were all painted.

> ❝ I CANNOT STRESS
> ENOUGH THE
> IMPORTANCE OF WORKING
> SIDE BY SIDE WITH SO
> MANY TALENTED ARTISTS ❞

As it was impossible to make 3D fur within the time frame, I created a "fur" brush and painted over the 3D render, picking colors from the base image whilst trying to maintain the effect of the rim lights (**Fig.13**).

CONCLUSION

I really feel that this challenge forced me to go beyond my limits. I cannot stress enough the importance of working side by side with so many talented artists. I will cherish this challenge as a great experience and recommend everyone to join this rollercoaster ride (**Fig.14**).

BASE · OCCLUSION · RIM LIGHTS · MASKS

Fig.12

NO FUR · WITH FUR

Fig.13

Fig.14

© Jose Alves da Silva

© Alexey Egorov (Alex E)

NIGHTMARE CREATORS
BY ALEXEY EGOROV

JOB TITLE: Freelance Designer
SOFTWARE USED: Photoshop, Wacom

INTRODUCTION

All kinds of nightmares, even minor ones, have been bothering peoples' minds throughout the history of mankind. But we shouldn't be afraid of them – it will just propagate them further. We should learn to live with them, laugh at them and perhaps drink warm milk before going to bed. You will see that your nightmares will become bored with you and ashamed of not being as scary as they would wish. This is essentially my introduction.

First of all, I should say that I've been into painting this way for only four years, with two of these spent drawing with a mouse instead of a tablet.

> " WHEN I START A NEW PICTURE IT FEELS LIKE A KIND OF HOLIDAY BECAUSE I DON'T KNOW WHAT IS GOING TO HAPPEN IN THE END "

I spent whole my life working in publishing, but I always longed to have some spare time to draw and do illustrations. Now I'm happy because I can say that I'm a full-time illustrator. I wanted to be a mining engineer when I was young and I guess all those impressions and experiences are with me forever. During that period,

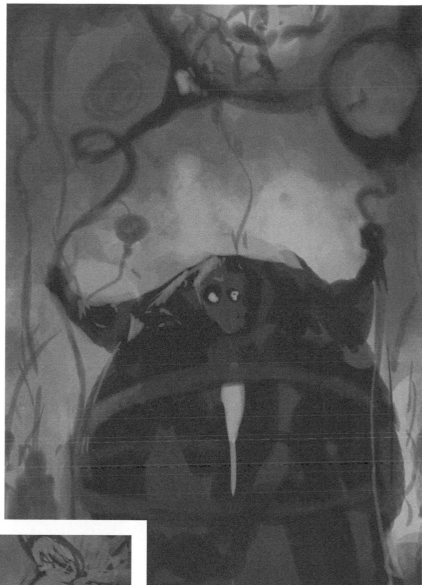

Fig.01a

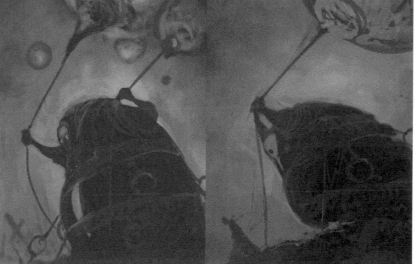

Fig.01b

whilst descending deep underground, I completely lost contact with the outside world, the light and fresh air. As a result my youth was full of impressions that have remained with me and can be seen in my art. Perhaps this is why my works are so dark and gloomy; however, I cannot work in any other way, so I try to make illustrations more interesting and mysterious.

WORKFLOW

When I start a new picture it feels like a kind of holiday because I don't know what is going to happen in the end. As for this picture, the process of creating it was long and

Fig.02

painful as it took about a month. I usually have several pictures in production at the same time. This is indicative of my normal work day, almost every day. Even when I'm taking a break I always find myself doing some sketching.

During the early stages of this picture I wanted to make the simplest of monsters – fat, ugly and terrible – just for fun. Then I got an idea about dreams and I have always wanted to make an image based on this: monsters as ugly as the dream itself. This idea was exciting and hard to visualize and I had been waiting for some direction for several nights. I initially saw the picture in a bluish tint but then I realized that our dreams have no color (**Fig.01a – b**). What I mean by this is that we often have no recollection about the color. In most cases we only remember the plot, what it was about, and sometimes

Fig.03

THE IDEA BEHIND MY PICTURE IS THAT MY ❝❝HEROES ARE DREAM MAKERS WHO CREATE❞❞ AND DEVELOP VARIOUS NIGHTMARES, WHICH ORIGINATE FROM WITHIN THEMSELVES

only a few details, unfortunately. This is why I rejected any variation in color and decided to show my heroes in a monochromatic picture, thus making it more mysterious and scary (**Fig.02a**).

The idea behind my picture is that my heroes are dream makers who create and develop various nightmares, which originate from within themselves. The leading monster has his own little helper who, despite being less skilled, is needed to create one more nightmare. The monsters are ready to explode at any time because of the dangerous library of nightmares they contain (**Fig.03**).

I specifically made the background vague to show the nightmare creators in a better position. You can also see that there is some light from the moon – how could I draw a picture about dreams without the moon? You will also notice a lot of atmospheric clouds; a "must have" for every night sky. The stones upon which the creators stand were made in an interesting way, but I ensured that they did not overshadow my heroes (**Fig.04**).

Fig.04

I guess I should say some more about making the trees. I tried to make them as simple as I could, but colorful at the same time, completing the huge space with their fantastic structure. I tried to make them stylized, with their branches looking more like antlers or elongated claws. And of course I put a night bird on the branch to observe all the interesting acts going on around him. I have always thought of trees as being animated, feeling their breath in the forest many times. I thought it would be really great if I worked on this theme (**Fig.05**).

I find it fascinating when I draw; losing all sense of time, I become a part of my picture. It always happens to me and it seems like I'm at the epicenter of my creative work with the only proof of the real world being in music. At the end of another track I am again back in the real world at my desk. Drawing and music for me are like the air, allowing me to breathe and experience the world around me, rather like the gills on a fish. Whilst I was making this picture I was mainly listening to ambient music.

Every time I finish working on a new picture I start to feel sad, always regretting breaking up with the heroes and worlds I have just created. I then have but one hope: to wait for the arrival of a new day and looking forward to creating something new.

Fig.05

Artist Portfolio

The 2010 Digital Art Masters

Alexey
Egorov

Astron-66@mail.ru

Eduardo
Peña

edpena@uniandes.edu.co

http://chino-rino2.blogspot.com

Jason
Seiler

http://www.jasonseiler.com

Andrée
Wallin

andree.wallin@gmail.com

http://www.andreewallin.com

Elise
Frappier

elise_frappier@hotmail.com

Jeffrey
Simpson

jeffsimpsonkh@hotmail.com

http://www.surrealsushi.com

Andrew
Finch

afinchy@gmail.com

Eric
Zhang

bigtaking@gmail.com

http://www.cgeric.com

Jiema

reaperex@163.com

http://cutjie.cgsociety.org

http://www.leewiart.com/space/393

Andrew
Hickinbottom

chunglist2@btinternet.com

http://andyh.cgsociety.org

Fabricio
Moraes

fab.moraes@hotmail.com

fabmoraes.cgsociety.org

Jose Alves
da Silva

joalvessilva@netcabo.pt

http://zeoyn.cgsociety.org

Anto Juricic
Toni

Monty.band@gmail.com

http://anto-toni.cgsociety.org

Gábor
Kis-Juhász

kisjuhasz.gabor@gmail.com

http://www.rota-art.com

Justin
Yun

justinjyun@gmail.com

http://www.bluecanvas.com/
justinyun

Chase
Stone

chasesc2@gmail.com

http://chasestone.cgsociety.org

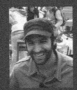

Ignacio Bazán
Lazcano

i.bazanlazcano@gmail.com

http://www.neisbeis.deviantart.com

http://www.ignaciobazanart.com

Kekai
Kotaki

Kekai.k@gmail.com

http://www.kekaiart.com

Dr. Chee Ming
Wong

chee@opusartz.com

http://www.opusartz.com

Irvin
Rodriguez

hola@irvin-rodriguez.com

http://irvin-rodriguez.com/

Loïc e338
Zimmermann

info@e338.com

http://www.e338.com

Christer
Wibert

Christer.Wibert@gmail.com

http://wibben.cgsociety.org

István
Vastag

dy@rendernet.hu

http://dy217.cgsociety.org

Lois van
Baarle

loishh@gmail.com

http://loish.net

David Moratilla
Amago

dmoratilla@gmail.com

http://www.davidmoratilla.com

Jack
Zhang

Zhangziwen1101@hotmail.com

http://jackzhang.cgsociety.org

Marcin
Jakubowski

marcin@balloontree.com

http://www.balloontree.com

THE 2010 DIGITAL ART MASTERS

MAREK
DENKO

marek.denko@gmail.com

http://www.marekdenko.net

PASCAL
ACKERMANN

3dwokus@gmail.com

http://pascal.ackermann.free.fr

TOMASZ
JEDRUSZEK

info@morano.pl

http://www.morano.pl

MARIUSZ
KOZIK

lacedemon@gmail.com

http://www.lacedemon.info

REBECA PUEBLA
PANIAGUA

rebecapuebla@hotmail.com

http://rebecapuebla.artworkfolio.com/

TOMASZ
STRZALKOWSKI

t.strzalkowski@space.pl

http://tomstrzal.cgsociety.org/
gallery

MATT
GASER

mgaser@mac.com

http://www.mattgaser.com

RICHARD
ANDERSON

flaptraps@flaptrapsart.com

http://www.flaptrapsart.com

VALÉRIE
VILLEUNEUVE

poissons44@hotmail.com

MAURICE
PANISCH

hello@maurice-panisch.de

http://maurice-panisch.de

ROBH
RUPPEL

robhrr@yahoo.com

http://www.robhruppel.com

VIKTOR
FRETYÁN

radicjoe@yahoo.com

http://radicjoe.cgsociety.org

MICHAL
LISOWSKI

maykmail@tlen.pl

http://michallisowski.com

RODRIGO LLORET
CRESPO

Rodrigo.Lloret@gmail.com

http://www.rlloret.com

VITALY
BULGAROV

vbulgarov@hotmail.com

http://www.bulgarov.com

MICHAL
SUCHÁNEK

info@michalsuchanek.cz

http://www.michalsuchanek.cz

RUDOLF
HERCZOG

rudy@rochr.com

http://www.rochr.com

WEI-CHE
(JASON) JUAN

jasonjuan05@gmail.com

http://www.jasonjuan.com

http://jasonjuan.blogspot.com

MIGUEL ALBA
GUTIÉRREZ

mikealgu@gmail.com

http://www.maginar.com

SERGE
BIRAULT

serge.birault@hotmail.fr

http://www.sergebirault.com

YIĞIT
KÖROĞLU

yigit@yigitkoroglu.com

http://www.yigitkoroglu.com

MIN
YUM

minyum@gmail.com

http://www.minart.net

SIMON
DOMINIC

si@painterly.co.uk

http://www.painterly.co.uk

NEIL
MACCORMACK

Neil@bearfootfilms.com

http://www.bearfootfilms.com

STÉPHAN
BRISSON

stefbrisson@hotmail.com

http://cgstef.cgsociety.org

INDEX

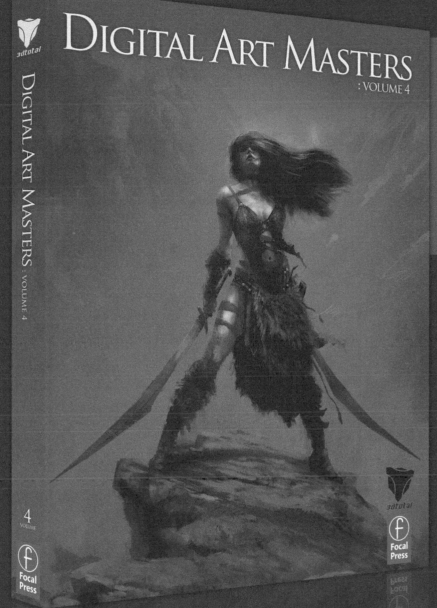